Conversations with the Collection

Conversations with the Collection

Edited by
Katherine M. Bourguignon
Peter John Brownlee

Terra Foundation for American Art
Chicago | Paris

Early Abstract and Modernist Painting

*All full-page image details in this publication
are shown at 1:1 scale (actual size).*

A digital companion to *Conversations with
the Collection* features exclusive content,
including deep-zoom images and other rich
media resources, all of which can be accessed
online at *conversations.terraamericanart.org.*

Elizabeth Glassman
President & CEO
Terra Foundation for American Art

This is not your typical collection handbook—at least not the kind you are likely to find in a museum gift shop. Whereas those publications serve as a guide to art on view in the galleries, here we present Terra Foundation artworks that you might encounter on someone else's walls, perhaps at the Pinacoteca in São Paulo, the National Gallery in London, the Shanghai Museum, or the Art Institute of Chicago. Allow me to explain: while the foundation possesses nearly 800 paintings, works on paper, and sculptures of historical American art, we do not have a permanent, dedicated exhibition space. For more than a decade, we have modeled ourselves as a "museum without walls," and as such our collection has been in museums, and in front of audiences, around the world.

Daniel J. Terra (1911–1996) pursued American art passionately, starting in 1971 with the purchase of three oil sketches by John Singer Sargent. The son of Italian immigrants, Terra's love of country and ideas about national identity fueled his relentless drive to collect distinctive works and to share the artistic heritage of the United States by creating several museums. First there was a small museum in Evanston, Illinois (1980–1987), followed by a larger one on Michigan Avenue in Chicago (1987–2004), and by a partially concurrent second museum in Giverny, France (1992–2009), down the lane from the home and studio of Claude Monet.

These museums exemplified Terra's emphasis on the importance of experiencing original works of art—a guiding principle that continues to inspire the work of the Terra Foundation. In 2005 we expanded our mission and ventured in a bold new direction, presenting American art to audiences across the globe rather than relying on them to come to us. We established a robust grant program that advances research, exhibitions, academic programs, and publications worldwide. To the surprise of many, we also chose to keep the collection.

Whereas the life of an individual collector has a single narrative arc, the life of a collection takes many trajectories. It assumes various shapes, and its significance shifts as it is recontextualized over time. So we continue to refine and grow the collection from Terra's original holdings, giving it new shape and inflection. In fact, this handbook features thirteen new acquisitions made between 2006 and 2018. The collection resides at the core of our endeavor, stimulating a nearly inexhaustible array of opportunities. For example, Terra Collection Initiatives take shape as collaborative

exhibitions with partner institutions such as the Musée du Louvre, the Art Gallery of New South Wales, and the National Museum of Korea. By placing works of art in front of audiences internationally, these exhibitions engender meaningful cross-cultural dialogues. They situate works of American art outside of their native context, and in so doing, elicit different responses that demonstrate the fluid nature of cultural identity.

Terra Collection Initiatives are entrepreneurial undertakings, always generative in nature and experimental in spirit. They stimulate the examination of collection objects through new lenses and forge fresh connections with diverse audiences. Sometimes these projects extend over several years and assume multiple forms, from single-painting exhibitions to large "first-ever" surveys, and from major loan shows to focused exhibitions, all with associated educational offerings. Terra Collection Initiatives are also catalysts for deeper research and writing. We often convene scholars from various parts of the world to share ideas, confront national distinctions, question traditional methodologies, and pry away preconceptions. In the spirit of these gatherings, we have invited many of the scholars with whom we have worked to contribute to this handbook. Just as we encounter different languages in each collaboration, so, too, will you find in this volume new perspectives on works of art in our collection from a multitude of voices.

Ably orchestrated by our Chicago-based registrar Cathy Ricciardelli, the Terra Foundation's dynamic approach is led by our two curators: Peter John Brownlee, working in the Chicago office, and Katherine Bourguignon, in Paris. They act as curators and scholars, educators and diplomats. My deep appreciation and applause to them both for their innovative approaches in identifying the most engaging and rewarding partnership opportunities to showcase the foundation's collection. Over the years they have cultivated large global networks of curators and professors, colleagues they engage to probe larger questions in American art. Their creative exhibitions connect people worldwide and inspire vigorous international exchange. For a list of our many Terra Collection Initiative projects, see page 297.

Embedded in the Terra Foundation mission is a belief that art has the power both to distinguish cultures and to unite them. Each work of art in this volume facilitates ongoing conversations that extend across time and space, as well as national borders. We hope that the next time you encounter an American work of art—be it in Philadelphia, Paris, Prague, or Perth—you enjoy it and take a closer look. And maybe, just maybe, it might be one of ours.

Acknowledgements

The editors would like to thank the 36 authors from around the world who participated in this conversation with objects from the Terra Foundation's collection. We appreciate their thoughtful input and value the unique insights they brought to the dialogue. Special thanks to François Brunet, Sarah Burns, David Peters Corbett, Frances Fowle, Chris McAuliffe, and Sarah Monks for their thematic essays, which evolved through long-term (and long-distance) conversations. Thanks also to Elizabeth Glassman for her leadership and vision, to the Board of the Terra Foundation for American Art for their enthusiastic support, and to all our colleagues at the Terra Foundation, past and present, especially: John Davis, Charles Mutscheller, Catherine Ricciardelli, Francesca Rose, and Veerle Thielemans.

The majority of the artists' biographies and interpretive essays for the paintings included in this handbook were first prepared for presentation on the Terra Foundation's website by independent art historian Wendy Greenhouse. These texts were updated and adapted for inclusion in this publication by Julie Boulage, Curatorial Associate; Julie Warchol, Curatorial Associate (until 2017); Taylor L. Poulin, Curatorial Associate; and Sarah Wheat, Curatorial Research Assistant.

We also appreciate all the conversations we had with designers and web developers, who helped us conceptualize and shape this book and its digital companion. We thank them for their many good ideas, their diligence, and their good cheer. A very special thanks go to Julie Warchol, Julie Boulage, Shari Felty, and Taylor L. Poulin for all that they have done to make this publication possible.

Sarah Monks
Lecturer in Art History,
University of East Anglia, UK

Introduction

Some ramshackle cottages, a few happy cows, and a lot of scrubby turf—William Groombridge's *View of a Manor House on the Harlem River, New York* (Fig. 1) is not perhaps the most striking picture with which to begin a discussion of painting in the early years of the United States. Offering a stretch of apparently unexceptional terrain, it seems a picture to overcome en route to the greater glories of later American landscape painting and of the metropolis that would come to occupy Manhattan. Only its relatively large size and that sky—more expansive and impressive the longer we look at it—give any clue that this humble landscape painting might have things to say.

For Groombridge's painting, and early American painting more generally, reward closer consideration less as evidence for what is to come in the history of American art than as pictorial attempts to deal with contemporaneous issues and realities. In this sense, the term "early American" can be unhelpful, obscuring the fact that these paintings were, of course, the contemporary art of their own time. For the artworks addressed in this essay, all painted in northeastern states (or their precursor colonies) during the late eighteenth and early nineteenth centuries, the issues and realities of their historical moments are also those of modernity: historical experience and "historicity" (a sense of the present moment within history); the navigation of communal identities and subjective experiences; the role of art within a world of technological, economic, and political change. Even if Groombridge's image now seems unrecognizable to us as a view of Manhattan, and few of the concrete realities of early American life remain, the issues raised by these works remain pressing today. Present realities are always linked to past ones, as early Americans understood, despite long-standing myths of America as a place of virgin soil, self-reliance, wholesale reinvention, and no second acts.

In 1793, when he painted the Terra Foundation's picture, Groombridge (1748–1811) was in his mid-forties and had just arrived in New York after an artistic career in England as undulating as the topography of Manhattan Island.[1] Born in Kent, he had started to show his landscapes and portraits in London during his mid-twenties, but critical response was mixed: for some, his views "of the most remarkable structures, and situations in Great Britain" were "not unworthy the notice of the best painters,"[2] while others found his "tolerable Landscapes" to have limited appeal.[3] Spells in debtors'

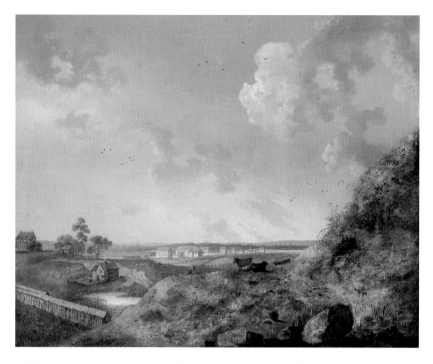

1 **William Groombridge (1748–1811),** *View of a Manor House on the Harlem River, New York,* **1793.** Oil on canvas, 39 ¾ × 49 in. (101 × 124.5 cm), Terra Foundation for American Art, Daniel J. Terra Collection, 1992.37

prisons testify to his professional difficulties,[4] and the loss of his wealthy patron in a riding accident probably left him with few prospects, as his book of sonnets on themes of melancholy and despair, published in 1789, suggests.[5] His migration to America four years later would have been a chance to start afresh.

Unfortunately for Groombridge, there were few patrons for landscape painting in America, and he took to selling his works by public raffle, which might explain why his palette became more vivid and his handling of paint more bold.[6] Inklings of this transformation can be found in *View of a Manor House*, where the modest subject is the pretext for a sustained and energetic display of painterly artifice, highlighting the artist's presence upon this (to him) new terrain.

What *is* this painting's subject matter though? At sunset, we look northeast from an elevated position across some uncultivated pasture, a muddled patchwork of enclosed land, and a quiet riverscape. Apart from the large house at the far left and the distant church steeple to the right, there are few landmarks to identify the location.[7] Yet comparison with historical images suggests that, as the label on the reverse of the canvas claims, this is a view across the Harlem River, from Manhattan

toward the Bronx.[8] As his *View of Maidstone, Kent* (c. 1770, Government Art Collection, London) shows, the view across the water toward a distant steeple, complete with cattle, farmer, and shaky perspective, was a formula that Groombridge had previously applied to his English landscapes. Those draw heavily on the influence of the British landscape painter Richard Wilson (1714–1782), who applied the pictorial conventions of Old Master landscape painters such as Claude Lorrain (c. 1600–1682) to British terrain.[9] Groombridge followed both Wilson's example and Lorrain's in his depiction of north Manhattan, staging the landscape from foreground to background through successive receding planes, visual pathways and destinations, and the changing tones of aerial perspective.

That said, Groombridge's image is no pastoral idyll. Down by the riverside, awkwardly positioned in the no-man's land of the painting's midground, lie roughly a dozen sunlit buildings. Judging by the smoke from their chimneys, some are probably homes while others suggest the rural barns, storehouses, mills, and slave quarters that still dotted most of the island. The relationships of these buildings to each other, to the oddly shaped parcels of land before them, or to the houses we see in the left foreground, are unclear. This is a landscape structured by separate, possibly competing, small-scale interests; a haphazard settlement whose ideal unit would seem less the partly visible grand house on the left with its hillside prospect than the timber cottage tucked away among the escarpments below. Like the lone figure determinedly going about his business, this cottage and its tightly fenced smallholding offer an emblem of self-interest, self-sufficiency, and their corollary—isolation.

The exuberantly painted sky and variegated weeds of the patchy hillock—a conventional motif of uncultivated nature within late eighteenth-century picturesque landscape imagery—distract us from this fragmented social landscape. Groombridge devoted significant space and energy to these areas, which offer the comforting visual pleasures of humble nature, glowing sunset, and painterly brushwork. But there remains a strangely intrusive, insistent form at the bottom left: a blank gray wall of uncertain height and function. Reading the image from left to right, we stumble on it every time. It is a piece of fortification, a reminder that this area had been the site of violent and decisive warfare during the first months of the American Revolution (1775–83).

Less than two months after the Declaration of Independence in July 1776, and following the heavy defeat of the Continental Army at Brooklyn, British troops captured the city of New York and advanced toward the forts established in upper Manhattan by George Washington. After a series of battles (all but one, defeats for the American cause), Washington retreated with his troops through New Jersey to Pennsylvania. Though the tide later turned in Washington's favor, Manhattan and its surroundings remained

an area of British occupation, confiscation, and destruction, as well as American (including Mohican) resistance for the remainder of the war—nearly seven years.

Groombridge's painting therefore places us in what had recently been a war zone. Somewhere behind us would have stood the forts that guarded the Hudson River, and before us would have been further fortifications overlooking the Harlem River. Material detritus from the war covered the area into the twentieth century.[10] Yet only that gray wall to our left, and the seemingly ruined state of one of the white houses on the shore, suggest a history of conflict. The location's specific and momentous historical significance remains almost unspoken. It is possible that the artist knew little of this specific history, though he would obviously have been aware of what his composition fully avoids: New York City, some ten miles away, any thought of which is impeded by the picturesque device of the verdant slope to our right.

Quiet and/or ambivalent about the effects of modern history upon the American landscape, Groombridge was more forthcoming with his claims to artistic presence and to the painterly representation of a present moment, as his subtle invocation of enshrined artistic precedents, the amount of canvas given over to the representation of the sky, and the alternately smoothed and gestural quality of his brushstrokes all suggest. Perhaps the deeper meanings of his new surroundings, in the still emergent United States of America, had yet to be understood. In its emphasis instead on presence and the present, Groombridge's painting is comparable to the works of earlier, self-consciously colonial artists. The master of this mode was John Singleton Copley (1738–1815), whose *Portrait of a Lady in a Blue Dress* (Fig. 2) and *Portrait of Mrs. John Stevens* (1770–72, see page 29) offer bravura displays of both the material realities enjoyed by some colonial subjects and the power of the artist's eye and hand to depict them. Copley's colonial-era portraits are never simply records of things seen, however—they are also expert pictorial constructions of nuanced subjectivity, in which his sitters often seem to be caught between emotional states. In the *Portrait of a Lady in a Blue Dress*, psychological depth is conjured by the tension between the near-profile view of the sitter's head and the near-frontal presentation of her upper body, the latter twisted in our direction as if competing with the head for our attention, especially at her bust, where a huge individual pearl surrounded by fleshy pink ribbon seems to face directly toward us. The conflict between gender and selfhood, between public meaning and private experience—increasingly understood to be the lot of modern women—is given visual form by Copley. This conflict is further manifest in the tension between her facial expression (eyes seemingly lost in thought, the signs of a smile playing upon her lips) and the lace band tied tightly around her neck as if reining in the individuality suggested by her face.

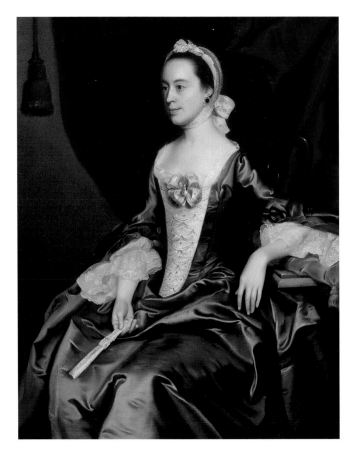

2 **John Singleton Copley (1738–1815),** *Portrait of a Lady in a Blue Dress,* **1763**.
Oil on canvas, 50 ¼ × 39 ¾ in. (127.6 × 101 cm), Terra Foundation for American Art,
Daniel J. Terra Collection, 1992.28

This dual engagement with forms of inner experience and art's power
to articulate them would be instrumentalized in the early nineteenth
century, as art was called upon to shape subjectivities toward the common
good of specifically "American" communities. For artists as diverse as
the rural Quaker preacher Edward Hicks (1780–1849) and the highbrow
urbanite Washington Allston (1779–1843), who both worked during the
second quarter of the century, painting promised to transform its viewers.

Hicks's religious beliefs largely condemned art as a luxury; the one
permissible end of painting, in his view, was moral and spiritual reforma-
tion. *A Peaceable Kingdom with Quakers Bearing Banners* (Fig. 3), one of sixty-
two versions of this subject he produced over three decades, seeks that
end through a visual allegory of Old Testament scripture, specifically Isaiah
11:6, "The wolf also shall dwell with the lamb and the leopard shall lie
down with the kid; and the calf and the young lion…, and a little child shall

lead them." This prophesy foretells the peaceful coexistence that will follow from religious observance. But Hicks does more than simply illustrate this passage: he deploys the material properties of paint with care, even love. Scripture is the excuse for his detailed depiction of fur, bark, cloth, and grass, using a variety of brushstrokes and painterly techniques. And yet, for many Quakers, painting was "a link in the chain of anti-Christian foibles next to music and dancing."[11] If Hicks was to use paint as the vehicle for its own elevation into spiritual truth, that transformation had to be dramatized. He therefore allowed paint's "base" state some free play, so that the inherent conflict in Quaker belief between paint's rich materiality and its revelatory potential could be overcome. This may explain Hicks's practice of inscribing (sometimes covering) the solid frames of his paintings with phrases that seek to distill the work's meaning. The frames are integrated into the paintings they surround, much as religious strictures might curb the sensory pleasures of the viewers to whom the paintings are addressed, though the thick golden paint and stylized form of their inscriptions suggest that such pleasures and their potentially negative influence were hard for a painter to avoid.

Influence had been an important dynamic in Hicks's life. He had learned to paint as a thirteen-year-old apprentice in a carriage-making

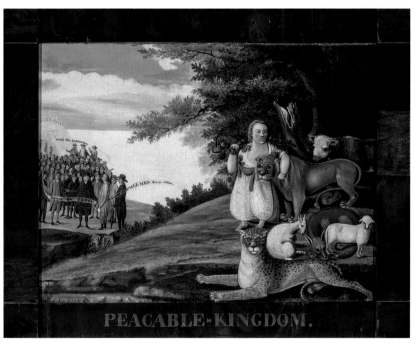

3 **Edward Hicks (1780–1849), *A Peaceable Kingdom with Quakers Bearing Banners*, c. 1829–30.** Oil on canvas, 17 ⅝ × 23 ⅝ in. (44.8 × 60 cm), 1993.7

workshop, where he had also learned to swear, drink, and submit to "licentious lewdness."[12] In his memoirs, he credited the religion of his Quaker foster parents with pulling him back from the brink and providing him with a solid community and a strong moral framework.

Quakerism is founded on the belief that every individual can forge a direct relationship with God. Believers are effectively their own priests, administering to their souls under the combined influence of direct experience of God ("the Inner Light"), Bible study, a purified way of life, and the speeches of fellow worshippers and unpaid preachers—hence the religion's proper name, the Society of Friends. By his early thirties, Hicks had become renowned for his ability to explain Christian doctrine "in a clear and *forcible* manner, to large assemblies of different denominations." From 1827 (shortly before the Terra Foundation's *Peaceable Kingdom* was painted), his sermons disseminated the radical beliefs of his cousin Elias Hicks (1748–1830), who argued that Christ's primary meaning was not as the man whose suffering compelled religious obedience, but as a *symbolic* model for the "Christ Within" each believer, accessed through individual encounters with the Inner Light. This reinterpretation of Christ's role caused a schism within the Society. It also placed unprecedented emphasis on self-regulation and self-salvation. Little wonder then that Edward Hicks's sermons fervently promoted self-interrogation, humility, commitment to God, and vigilance against living in "a lukewarm and libertine condition." He addressed himself particularly to wayward souls—"the returned prodigal, the sinner awakened to a sense of his guilt."[13]

Communication is central to Quaker life, and it was as communication that Hicks's "excessive fondness" for painting was permissible.[14] The clarity of his *Peaceable Kingdom* paintings, along with the inscriptions on their frames, indicate his intention of delivering influential messages, in this case the prophetic significance of Isaiah 11:6. For Christians, the "child" in that passage is a prefiguration of Christ, and for Hicks, Christ was a spiritual model to be internalized by believers, hence the figure's seemingly adult features (even five o'clock shadow). Hicks's understanding of Christian doctrine as a source for individual guidance and interpretation also explains the latitude he took in his *Peaceable Kingdom* pictures with the prophecy's animal and human cast. On the left of the Terra's painting, we see a large gathering of Friends, united on the path to heaven. Above them appear Christ, the Apostles, and angels bearing a banner promoting direct communion with God and universal peace. Among them stand William Penn (the seventeenth-century founder of Pennsylvania) and Elias Hicks, bridging the Society's past and present, as well as George Washington, the great unifying figure of the new nation.[15]

Beyond this potent symbolism, the painting's highly worked surfaces and attentiveness to detail suggest an artist for whom the act of

representing the natural world might also have been a form of worship. Visual truth and religious truth serve each other everywhere in Hicks's picture. The forceful upward strokes which form the jagged splinters of the broken tree to the right underline its role as a sign of the rupture which had occurred among the Quakers, just as the dark green leaves that seem to grow from the tree's healthy offshoot indicate the vitality of new energies. A similar story is told below, where Hicks depicted a fissure in the terrain, carefully suggesting its geological strata and fringe of yellowing turf. This turf contrasts with the lush grass immediately before us; like the storm clouds above, which have parted to reveal glowing pink and heavenly blue, or indeed the central iconography of beasts at peace with each other and with man, division and its resolution in fresh harmony are shown as productive processes, at once natural and divine. The profusion of natural detail helps articulate the picture's central promise: that current tensions presage a healthy and peaceful future for the Society of Friends, on earth and in the heaven to which members are seen ascending at the left-hand edge. That the fulfillment of this promise requires ongoing inner vigilance is suggested by the leopard in the foreground. A wild jungle creature, its fierce red eyes stare directly at the viewer as its whiskers bristle with alertness. Yet the leopard also appears here as a symbol of self-control, stretched across the foreground, calm and collected. Only by adopting such an attitude, it seems, checking animal impulses with the kind of determined grip that the child maintains over the lion at his side, might we join the vision of heaven beyond.

Hicks worked outside the art worlds then proliferating in America's northeastern cities, including nearby Philadelphia. His techniques and motivations are distinct, if not always divorced, from nineteenth-century art's central institution, the art academy.[16] There, a vision of art was promoted in which the articulation of internal and external truths required a sustained (and ideally direct) relationship with a quite different authority: European artistic precedent, specifically classical antiquity and the Italian Renaissance. Yet in the urban academy, as in the Quaker meetinghouse, art was increasingly understood as a means to transcendence, for those viewers attuned to its meanings. In the case of Washington Allston, this sense of transformative possibility arose within the wider reconception of art and literature that took place during the cultural transition now known as romanticism. For professional artists and writers during the first decades of the nineteenth century, the primary function of art became the instigation of individual aesthetic experience, rather than the promulgation of public ideals through history painting, as had been argued since the seventeenth century. This redirected painting's role in public life toward the refinement and recuperation of private sensibilities blunted (it seemed) by the cares of modern life.

Aesthetic experience and its recuperative powers are the subject matter of Allston's *Lorenzo and Jessica* (Fig. 4), which depicts a moment from William Shakespeare's drama *The Merchant of Venice*. In a quiet and magical interlude immediately after Shylock's trial, we find ourselves transplanted from the hot and hectic Venetian courtroom to the cool twilight gardens of the villa to which Shylock's daughter Jessica has eloped with her lover, Lorenzo. The couple playfully argue over the associations of night: for Lorenzo, it is the time for true love's expression; for his new wife, it is the time for romantic betrayal. She is restive and anxious, and Lorenzo commands musicians to play before uttering the soliloquy whose opening line is inscribed on the reverse of Allston's painting.

> *How sweet the moonlight sleeps upon this bank!*
> *Here we will sit, and let the sound of music*
> *Creep in our ears. Soft stillness and the night*
> *Become the touches of sweet harmony.*
> *Sit, Jessica. Look how the floor of heaven*
> *Is thick inlaid with patens of bright gold.*

In the penumbral gloom, we can just discern, from left to right, the structure of the villa, the couple, and the distant silhouette of the city. Jessica's twisted, upright pose and downward gaze melt into the calm repose of her husband, who looks (like us) across to the horizon, his most active element the feather in his cap, which lifts with the cooling breeze. Only his hand gesture indicates his exemplary, didactic status in the scene: "Sit, Jessica."

In the play, Jessica's protestation that "I am never merry when I hear sweet music" is received by Lorenzo as evidence of her emotional depth, as he bids her look and listen. Given time, aesthetic experience is transformative, soothing wild feelings and savage hearts. Art has a unique power to refine the subjective worlds of those able to see it. Shakespeare's scene was an appropriate source for Allston. After graduating from Harvard, he had sold his inheritance (his slave-owning family's South Carolina rice plantation) to fund his artistic education in Europe, initially in England and then in France and Rome. Between 1800 and 1818 he lived and worked mostly abroad. By the time he resettled in Boston, he was almost forty years old. Though his artistic reputation preceded him (he had been elected an Associate of the Royal Academy), it had yet to be proven in the eyes of American patrons and critics. This was a challenge for an artist of Allston's sensitive, "poetic" character—and his fortunes were mixed: while some of his canvases enjoyed considerable success, he abandoned others (most

4 **Washington Allston, *Lorenzo and Jessica*, 1832**. Oil on artist's board, 15 × 18 in. (38.1 × 45.7 cm), 2000.3

famously, his enormous and much-anticipated *Belshazzar's Feast*) for fears about their public exposure.

Lorenzo and Jessica is an example of the kind of work most appreciated by Allston's contemporaries. It is one of a sequence of paintings from the 1820s and early 1830s that center on single or paired figures (typically female), shown in states of reverie and reflection within natural settings, often as if listening to music. Many of these paintings are "cabinet pictures" of a size appropriate to intimate domestic display (just eighteen inches wide, *Lorenzo and Jessica* is the smallest of Allston's exhibited works), and used many slow-drying layers of thin glazes that result in singing tones, subtle gradations, and soft suggestive effects.[17] Their size, their portrayal of quiet leisurely repose, and their emphasis on pure aesthetic, sensory, and emotional experience made them popular among Boston's wealthy merchants, for whom art had come to be seen as an antidote to life in the rapidly industrializing American city. *Lorenzo and Jessica*, for example, was bought for a notable sum (around $20,000 in today's money) by the tycoon Patrick Tracy Jackson, one of the so-called Boston Associates whose fortunes were made by investing in the region's burgeoning industries.[18]

The literary and artistic references of Allston's more suggestive pictures appealed to Boston's cultural elite. As a poetical prompt to the imagination, inviting us to inhabit the emotions of the lovers as they marvel (like us) at the luminous sky above, *Lorenzo and Jessica* invokes the metaphorical imagery and suffused coloristic manner of sixteenth-century Venetian artists such as Titian (c. 1485/90–1576) and Giorgione (c. 1477/8–1510). In so doing, the painting offers its viewers that valuable commodity—thought rare in 1830s America—"art." Combining this historical influence with an identifiably modern attempt to suggest emotional and aesthetic responsiveness, such as might be experienced when listening to music with a lover at twilight, his work received close critical attention from other artists and writers, including Ralph Waldo Emerson (1803–1882) and other transcendentalists of the 1820s and '30s. For one such writer, who returned repeatedly to these works, Allston's scenes of quiet reverie represented "a new class of pictures" that had "unlocked streams of thought and feeling, which, as unuttered presentiment, had burdened me before."[19]

Offering close encounters with history, belief, and feeling, paintings produced in early America navigated currents that belie their present-day reputation as mere precursors to the more self-consciously "American" art that developed in the years around and after the American Civil War (1861–65). From Copley's closely observed sitters to Allston's aesthetic reveries, early American painting emphasized present experience while revealing the shifting role of art within the rapidly changing nation.

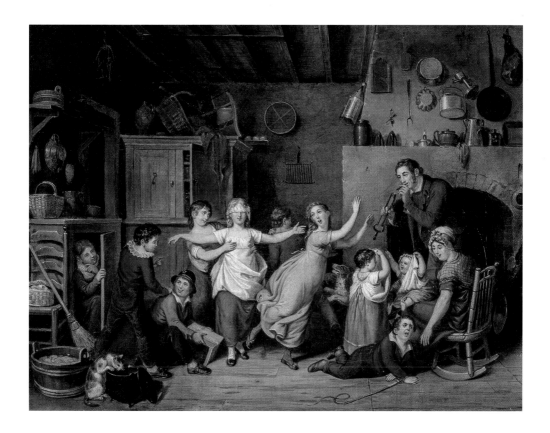

John Lewis Krimmel (1786–1821)
Blind Man's Buff, 1814

> Oil on canvas, 16 ⅝ × 22 1/16 in. (42.2 × 56 cm),
> Terra Foundation for American Art, Daniel J. Terra
> Collection, 1999.82

Born in the south German duchy of Württemberg, John Lewis Krimmel immigrated in 1809 to Philadelphia, where he became the first artist to take his imagery from American daily life. *Blind Man's Buff*, typical of his interior genre scenes, focuses on a children's game in which a blindfolded child tries to catch and identify other players. Compositions, character types, and subjects inspired by the works of Scottish artist David Wilkie (1785–1841), as well as seventeenth-century Dutch and contemporary German genre painting, influenced Krimmel's domestic rural scenes. These were popularized largely through engravings. His vivid representations of mundane life struck a chord with contemporaries. Accessible and affirmative, works such as *Blind Man's Buff* expressed Americans' search for a national identity in the republic's early years.

The portrait of Mrs. John Stevens (Judith Sargent Murray) by John Singleton Copley marks the meeting of two emblematic figures in the establishment of American cultural identity at a key point in time, just before the American Revolution (1775–83) and the creation of the United States of America. Copley was without doubt the most significant painter in Boston during the 1760s. When his painting *A Boy with a Flying Squirrel (Henry Pelham)* (1765, Museum of Fine Arts, Boston) was exhibited in London in 1766, it confirmed the idea that a major artist, trained exclusively in colonial America, was now to be reckoned with. A letter reported that the great English painter Joshua Reynolds (1723–1792) himself had said that Copley could become one of the greatest painters in the world provided that he came to study in Europe. This praise was heaped upon the young Bostonian at a moment when the compositional style of his portraits was evolving.

Painted just a few years later, the portrait of young Mrs. Stevens testifies to the preeminent influence of Reynolds, whose 1760s portraits were known in colonial America through mezzotint and engraved reproductions. The English painter tended to blur the boundaries between portraiture and a style of historical painting sometimes inspired by mythology. In *Lady Sarah Bunbury Sacrificing to the Graces* (1763–65, Art Institute of Chicago) Reynolds clothed his model in a seemingly classical dress, knotted simply under the bosom, without corset or petticoat, a style completely foreign to the fashion conventions of the 1760s. He placed her in a classical architectural setting before a tripod and a statue of the Three Graces, directly inspired by classical antiquities.

Copley may have been familiar with Reynolds's composition through a mezzotint executed by Edward Fischer and published in 1766; certainly at the end of the 1760s, Copley painted women's costumes with a certain classical appearance. The portrait of Mrs. Stevens is simpler than Reynolds's painting but includes accessories that are discreetly classical, such as the dress and the basket of flowers held in her right hand. The landscape background also evokes pastoral antiquity.

Copley often complained in his private correspondence about the lack of culture among his patrons, but young Judith Sargent, who had recently wed John Stevens, was a member of colonial America's educated elite, and it is likely that the artist would have discussed iconographic choices with her. The modern dress and conventional setting he often used to evoke the lifestyle of more typical clients are absent here.

Copley adopted an identical setting for two portraits from 1767 and 1773 of Rebecca Boylston, whose intelligence and refinement he also appreciated.[1] Reynolds's *Lady Sarah Bunbury* served as a model not only for Copley but also for the English artist Richard Samuel (active 1770–1787), whose group portrait *The Nine Living Muses of Great Britain* (1778, National Portrait Gallery, London) depicts distinguished British women within the intellectual circles of London life during that era.[2] To some extent the future of Judith Sargent Murray as an intellectual and a woman of letters appears to have been heralded in the iconography of her portrait by Copley.

Guillaume Faroult, *Senior Curator,*
Musée du Louvre, Paris, France

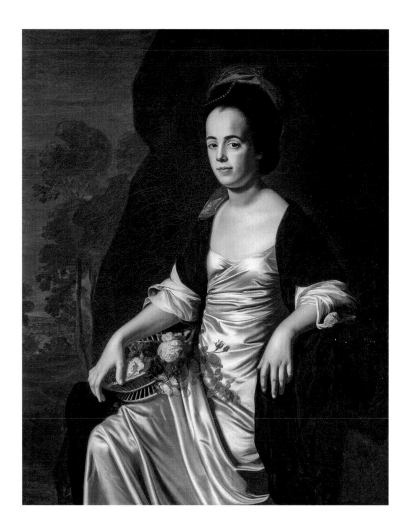

John Singleton Copley (1738–1815)
***Portrait of Mrs. John Stevens (Judith Sargent,
later Mrs. John Murray)***, 1770–72

> Oil on canvas, 50 × 40 in. (127 × 101.6 cm),
> Terra Foundation for American Art, Daniel J. Terra
> Art Acquisition Endowment Fund, 2000.6

America's first significant native-born artist and
the finest portraitist of the colonial period, John
Singleton Copley created hundreds of likenesses
of America's leading political figures, merchants,
entrepreneurs, and society women that effec-
tively evoke both social position and individual
character. His portrait of the eighteen-year-old

Judith Sargent (1751–1820) was most likely painted
to celebrate her marriage in 1769 to her first hus-
band, John Stevens, a prominent merchant. The
young subject's uncorseted silk dress and blue over-
gown accentuate her feminine contours. Her fash-
ionable, sophisticated appearance is enhanced by
a lavender silk turban draped with pearls. The
basket of roses on her lap symbolizes the promise
of a fruitful marriage. As befits a wedding portrait,
the likeness makes no direct reference to the pre-
cocious intellectualism that later distinguished
Sargent. Her serious gaze, however, suggests her
future role as one of the country's first leading
women writers and feminists.

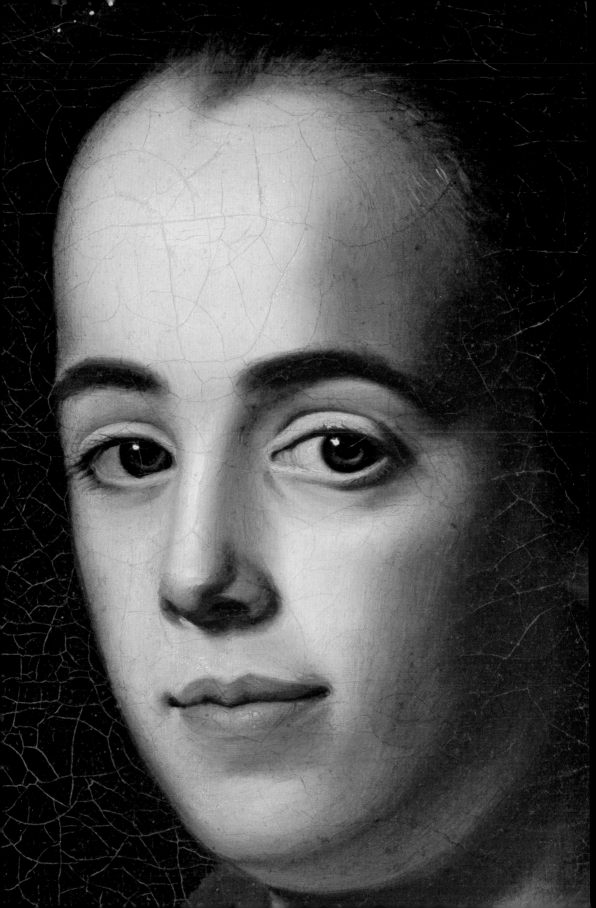

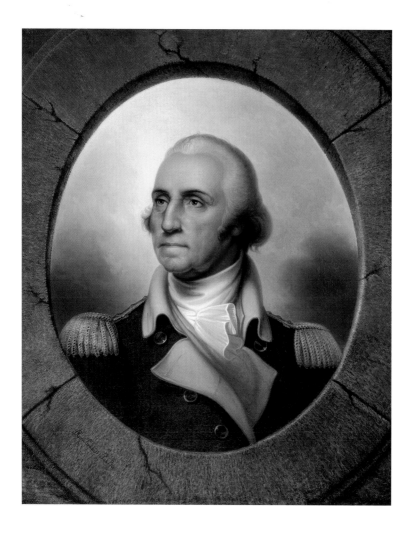

Rembrandt Peale (1778–1860)
George Washington, Porthole Portrait,
after 1824

> Oil on canvas, 36 ¼ × 29 ³⁄₁₆ in. (92.1 × 74.1 cm),
> Terra Foundation for American Art, Daniel J. Terra
> Collection, 1992.53

A founder of the Pennsylvania Academy of the
Fine Arts, Rembrandt Peale was a prominent
portraitist during the first half of the nineteenth
century. He is best remembered for his "port-
hole" portrait of George Washington, of which
he produced some eighty versions. Enclosed
within an illusionistic oval painted frame of

cracked masonry, Washington gazes serenely
into the distance. This is a heroic, idealized
depiction of the first president of the United
States that seeks to transcend the man's actual,
physical reality—thus combining portraiture
with history painting. Peale's understanding
and appreciation of neoclassicism are evi-
dent in the austere quality of the face and the
reference to classical ancient architecture.
The painting also reflects the influence of the
then current "sciences" of physiognomy and
phrenology, which posited that an individual's
innate character could be read in facial fea-
tures and head shape.

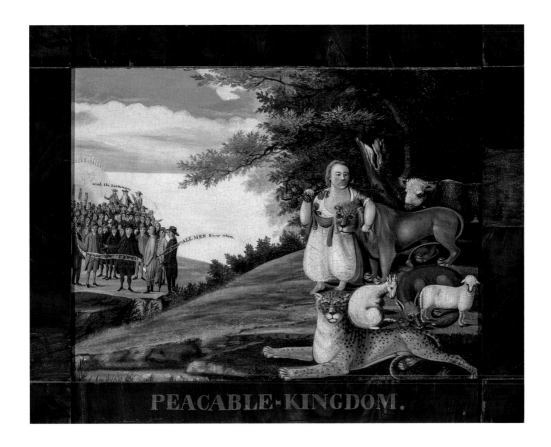

PEACABLE-KINGDOM.

Edward Hicks (1780–1849)
***A Peaceable Kingdom with
Quakers Bearing Banners***, c. 1829–30

> Oil on canvas, 17⅝ × 23⅝ in. (44.8 × 60 cm),
> Terra Foundation for American Art, Daniel J. Terra
> Collection, 1993.7

One of the best-known self-taught artists in
early-nineteenth-century America, Edward
Hicks was a Quaker minister who painted
primarily religious and moral subjects. This
work is one of more than sixty allegorical rep-
resentations by Hicks of the peaceable kingdom,
an Old Testament prophecy (Isaiah 11:6–9)
of peace among natural enemies. A figure
bearing grapes—an emblem of salvation—leads
a companionable assortment of animals out of a
dark wood and into a tranquil landscape. In the
distance, Christ and the Twelve Apostles crown a
mountain; below them, swirling banners bearing
messages of peace encircle a gathering of Quakers.
Hicks incorporated the Quakers to express his
sympathies with a breakaway faction led by his
cousin, the charismatic preacher Elias Hicks, who
is pictured in profile, holding a handkerchief as
a reference to his heavy perspiration during vig-
orous preaching. The painting both justified the
secession of the so-called Hicksites and expressed
the hope of amicable reconciliation among all
God's creatures.

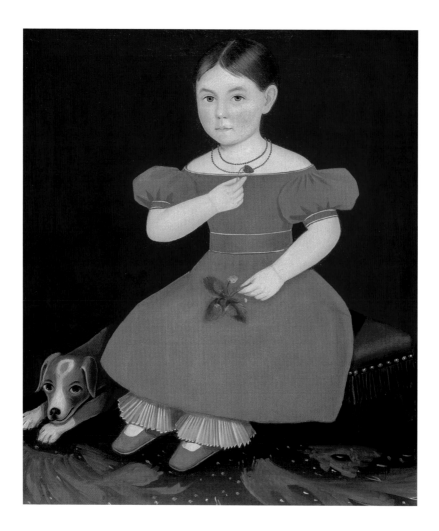

Ammi Phillips (1788–1865)
Girl in a Red Dress, c. 1835

> Oil on canvas, 32⅜ × 27⅜ in. (82.2 × 69.5 cm),
> Terra Foundation for American Art, Daniel J. Terra
> Collection, 1992.57

A primarily self-taught artist, Ammi Phillips
was one of many itinerant painters who created
portraits for members of America's growing
provincial middle classes in the early and
mid-nineteenth century. Likely painted in
Connecticut or New York, *Girl in a Red Dress*
is one of five portraits of children wearing the
same distinctive frock. Phillips captured the

unidentified young sitter in a formal pose,
holding a strawberry-plant sprig in one hand
and a single ripe berry in the other. Following
the tendencies of high style portraiture, early
nineteenth-century American portraits also
frequently included symbolic objects: here the
recumbent dog represents fidelity of character,
and strawberries symbolize youthful vitality.
In an era when both young boys and girls
wore dresses, the coral necklace identifies the
wearer as female. Portraits of children such
as this one were especially popular at the time
as statements of families' prosperity, social
status, and future aspiration.

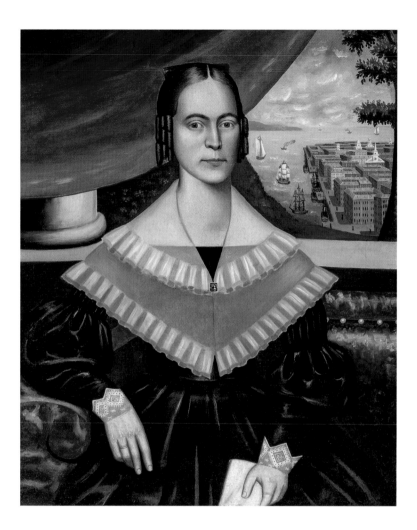

Erastus Salisbury Field (1805–1900)
Portrait of a Woman said to be Clarissa Gallond Cook, in front of a Cityscape, c. 1838

Oil on canvas, 34 ¾ × 28 ⅜ in. (88.3 × 72.1 cm),
Terra Foundation for American Art, Daniel J. Terra
Art Acquisition Endowment Fund, 2000.4

Early in his long career, Erastus Salisbury Field was an itinerant portraitist in Massachusetts. He often received commissions to paint likenesses of several members of a single family, such as the Gallonds. This painting is virtually identical to his 1838 portrait of the sitter's sister Louisa Gallond (Shelburne Museum, Vermont). Clarissa and Louisa were married to brothers in the Cook family, merchants who owned a Hudson River schooner. Although women were typically portrayed alongside natural elements emblematic of virtue and piety, here Field presented Clarissa before a prosperous port city. Her bright-eyed expression conveys her firm command of the domain depicted and suggests that she may have been active in her family's business. Field's portraits, such as this one, were emblematic tributes to the status and character of America's burgeoning merchant class.

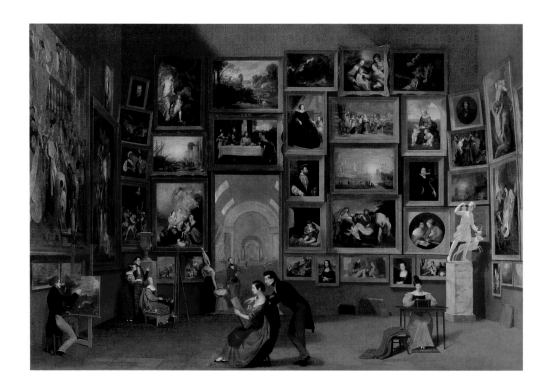

Samuel F. B. Morse (1791–1872)
Gallery of the Louvre, 1831–33

Oil on canvas, 73 ¾ × 108 in. (187.3 × 274.3 cm),
Terra Foundation for American Art, Daniel J. Terra
Collection, 1992.51

Besides being the inventor of the electromagnetic telegraph, Samuel F. B. Morse had a distinguished career as a painter and art educator in New York in the early and mid-nineteenth century. While serving as the first president of the National Academy of Design, then America's foremost art school and exhibition venue, Morse traveled to Europe to study masterpieces. In Paris, he began his most ambitious painting, *Gallery of the Louvre*, a visual guide to the highlights of Europe's premier art collection, and a painted treatise on artistic training. He intended the painting to inform Americans about Europe's artistic heritage and to inspire them to build on its legacy as they developed the young nation's cultural identity. Morse completed the painting in New York in 1833, but its public reception was discouraging. Today, however, *Gallery of the Louvre* is recognized as a key work in the development of American art.

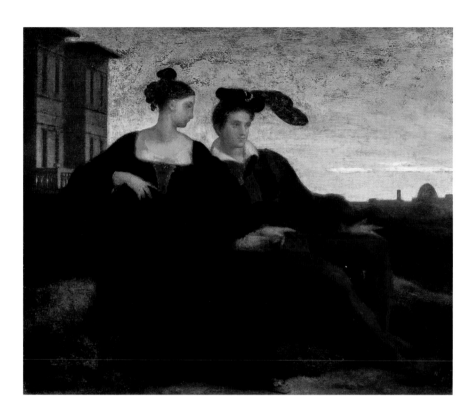

Washington Allston (1779–1843)
Lorenzo and Jessica, 1832

Oil on artist's board, 15 × 18 in. (38.1 × 45.7 cm),
Terra Foundation for American Art, Daniel J. Terra
Art Acquisition Endowment Fund, 2000.3

Washington Allston was one of America's first successful academically trained artists. He is especially notable for blending the legacy of European traditions with the contemporary cultural movement known as romanticism. Painted late in Allston's career, *Lorenzo and Jessica* demonstrates his admiration for the art of the Venetian Renaissance and his taste for literary themes. Based on act 5, scene 1 of William Shakespeare's *The Merchant of Venice* (first published in 1600), it depicts the solitary newlyweds reclining together on a bank. Isolating the two characters from the context of the play, the painting ignores the themes of vengeance and racial strife central to Shakespeare's original work. Instead, it portrays the pair as a classic embodiment of romantic love. The interplay of rich shadows and softened forms creates a contemplative, intimate, and somewhat mysterious atmosphere that suggests Allston's dreamy, idealized interpretation of the Italian Renaissance.

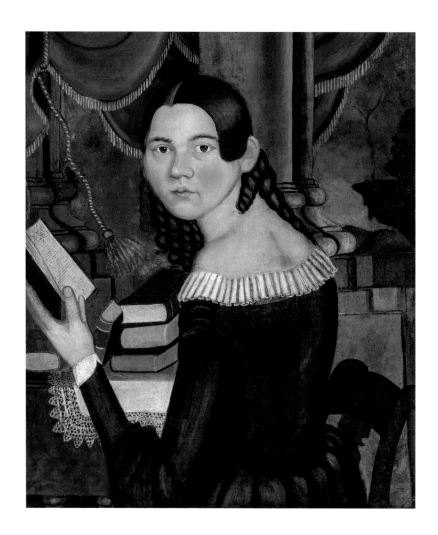

Jonathan Adams Bartlett (1817–1902)
Portrait of Harriet, c. 1840

Oil on canvas, 28 ¼ × 23 ¹³⁄₁₆ in. (71.8 × 60.5 cm),
Terra Foundation for American Art, Daniel J. Terra
Collection, 1992.14

Jonathan Adams Bartlett spent most of his life
in Maine, working as a farmer, carpenter, and
self-taught portraitist. *Portrait of Harriet* presents
the artist's younger sister, Harriet Cushman
Bartlett, dressed in an elegant black gown and
seemingly interrupted while reading. She is
seated by a table piled with volumes before a
backdrop of columns, drapery, and a pastoral
landscape. The awkward anatomy and perspec-
tive are characteristic of portraits by self-taught
early-nineteenth-century artists, but with its elab-
orate background and provocative pose, Bartlett's
portrait suggests the sophisticated aspirations
of painter and sitter alike. Little is known about
Harriet, but this painting hints at her intellectual
aspirations. In American portraiture, women
reading books sometimes signals piety, but the
abundance of reading matter in this portrait seems
to confirm the subject's interest in literature.

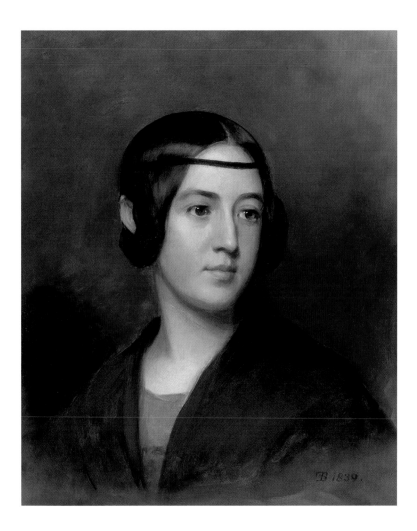

Thomas Sully (1783–1872)
Portrait of Blanch Sully, 1839

Oil on paperboard, 24 × 20 in. (61 × 50.8 cm),
Terra Foundation for American Art, Daniel J. Terra
Art Acquisition Endowment Fund, 2000.2

A longtime denizen of Philadelphia, Thomas Sully was one of the most prolific and successful American portrait painters of the early nineteenth century. His daughter Blanch, the apparent favorite of his six children, often modeled for him as a surrogate for female subjects between sittings. In 1837 she accompanied her father to London, where she modeled for his two full-length likenesses of the newly crowned, teenaged Queen Victoria. Two years later, Sully painted this bust portrait of Blanch. She is shown with her head turned to the left, a graceful pose that shows off her slender neck and fashionable hairstyle. Sully left the background indistinct, thus concentrating our attention on his beloved daughter's placid oval face. The fluid brushwork, delicate features, and dreamy gaze of the subject are typical of the artist's flattering portrayals.

François Brunet
Professor, Université Paris Diderot
(Paris 7), France

Introduction

The prominence of landscape pictures in the Terra Foundation's collection is a reflection of the singular, probably unparalleled development of this genre in American painting and visual culture more generally from the late eighteenth century to the present day. This essay addresses a few remarkable paintings dating from the genre's heyday in the nineteenth century, and particularly the period around the American Civil War (1861–65), when the movement known as the Hudson River school was at its climax. This traditional appellation, with its connotations of benign, sentimental reverence for an untamed nature bathed in primeval light, cannot do justice either to the complexities of American landscape art in the period or to the continued relevance of landscape pictures today. As the coincidence with the Civil War suggests, the taste for landscape was never independent of larger currents of American history, especially the ongoing debate on the nation's relationship to the land and its diverse, contradictory values—strategic, patriotic, economic, domestic, religious, scientific, philosophical, experiential, environmental. In the twenty-first century, although landscape has subsided as the premier genre of American painting, the land and its image remain sites for a bewildering variety of visual practices, from Hollywood sets and picture postcards to land art, topographical photography, eco-poetics, geographical documentary, geo-localized visualization, advertising and business concerns of all kinds, as well as a variety of activist efforts. Even as contemporary artists and critics deconstruct the "high landscape" of the nineteenth century and its perceived affinities with the ideologies of Manifest Destiny or Nature's Nation, its enduring appeal testifies to the continuing significance of visions of the land, the social realities they transfigure, reveal, or disguise, and the prospects for escape, refuge, or reform they offer.[1] The following pages suggest some of the complexities of this relationship between landscape and history.

For a starting point I use *Notes on the State of Virginia*, a major early description of American land by Thomas Jefferson (1743–1826). Published in 1785 in response to a questionnaire by the French diplomat François Barbé-Marbois (1745–1837), this text embodies an economic and political approach to the state of Virginia, including a consideration of its indigenous population's history and a blueprint for the social and institutional organization of American democracy. It is not a treatise on

landscape—the word does not appear in the book. As historian James P. Ronda writes, the appreciation of nature and the beautiful is a "secondary" concern for Jefferson: he "did not merely describe rivers; he judged them" in terms of utility, i.e., navigability.[2] Yet he did not refrain from aesthetic judgment, albeit as a secondary and momentary consideration. In Query IV ("A Notice of its Mountains?"), discussing the geological history of the Blue Ridge and the marks of "disrupture and avulsion" displayed by rock piles on the edges of the Shenandoah Valley, Jefferson pauses to note the "different character" of the "distant finishing which Nature has given to the picture." The mountain "being cloven asunder, she presents to your eye, through the cleft, a small catch of smooth blue horizon, at an infinite distance in the plain country, inviting you, as it were, from the riot and tumult roaring around, to pass through the breach and participate in the calm below." "Here," concludes Jefferson, "the eye ultimately composes itself; and that way too the road happens actually to lead."[3] This passage reveals an incipient interest in landscape as a separate value, amid a utilitarian and policy-driven description of the land. Many landscape pictures of the nineteenth century embody visions that similarly arise from temporary retreats, abstractions from the constantly evolving and often disruptive events of history. The gaze moves beyond the foreground, through a cleft, toward a smooth horizon, and obtains a moment of calm contemplation away from the "tumult" of the here and now. The vision of a higher, more serene realm evoked by landscape is only momentary, however, for the road leads on and calls the viewer back to practical prospects.

Although topographical views and pictures of local interest were already common by 1800, it was not until the 1820s, with the singular influence of the English-born painter Thomas Cole (1801–1848), that the type of vision recorded by Jefferson began to take shape in painting, eventually fostering a larger taste for landscape and its cultivation. *Landscape with Figures: A Scene from "The Last of the Mohicans"* (Fig. 1), one of Cole's first pictures inspired by Hudson Valley scenery, presents a deep, strongly contrasted vista of a densely forested, mountainous landscape seen in receding grounds, highlighted toward the center by streaks of sunshine pouring through a stormy sky. A shaft of light falling on the foreground reveals a rocky outcropping, framed by tortured tree shapes in autumn garb which functions as a picturesque stage for the "scene." This is the climactic moment of American author James Fenimore Cooper's (1789–1851) just-published novel, *The Last of the Mohicans*, which inspired three further paintings by Cole. On the rocky center stage stands the American pioneer hero Hawkeye, aiming his rifle at the Huron chief Magua, who hangs from a cliff edge at right as he tries to flee after brutalizing his British captive. Cora Munro, seen in

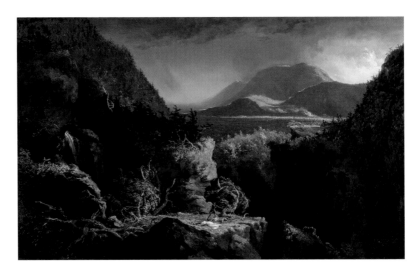

1 **Thomas Cole, *Landscape with Figures: A Scene from "The Last of the Mohicans,"* 1826.** Oil on panel, 26 ⅛ × 43 ¹⁄₁₆ in. (66.4 × 109.4 cm), 1993.2

a white dress, lies dying on the ground next to her beloved, the Mohican Uncas. This action on the rock, however, occupies a very small portion of the canvas, which is not large, so that the characters are tiny and the details hardly legible without reference to the novel. The vast, wild landscape engulfs the figures. As Terra Foundation curator Peter John Brownlee notes, the captivity narrative, which Cooper's romance reimagined as a more abstract epic of American history, is overwhelmed by "the greater dramatic sublime of the natural world."[4] Indeed the split structure of the view confines narrative and visual complexity to the extended foreground, which abruptly breaks into a majestic and serene background, with the flat valley bottom receding at the left of a massive range of rounded hills toward a distant horizon where the sky is clearing. As in Jefferson's description, this distant horizon is where the eye "composes itself," and where the road "happens to lead." But which road? Leading where? Landscape takes us into history, although after the last of the Mohicans has died, the question of whose history remains uncertain.

This work by the painter who soon came to be recognized as the founder of the "native" American school may function here as a program of sorts, albeit paradoxical, for the extraordinary expansion of landscape art that followed. The landscape is awesome, though its exact locale is unspecified and not easily identified. The Hudson River setting it celebrates combines elements of the picturesque, the beautiful, and the sublime, thus offering a lesson in the aesthetics of landscape; but the topography is largely imaginary. As an invitation to cultivate a taste for

the wilder aspect of American scenery, which Cole promoted in painting and in his landmark essay of 1836, it is rather generic and more representative of European ideas than concrete American sites and circumstances.[5] The anecdote it claims to illustrate comes out of a work of literary fiction, which itself, though credited with inaugurating a landscape tradition in American literature, offered highly stylized renditions of places like Lake George and Glens Falls, and was similarly concerned with a "quest for nationality"—an intellectual competition with European models—above and beyond its attachment to American landscapes. The very fact that this picture presents itself as illustrative—as a painting "after" a novel—would seem to defeat Cole's own claim for the visionary, reformative, and purifying value of landscape. Its overt narrative motif—the demise of Native American civilization—is more explicit about the historical origin of the American "new land" than any of the paintings that follow. As a composition of massive natural shapes superimposing a drama of light, color, and volume on the tiny figures of Uncas and Cora, it inaugurates a form of art that for at least half a century would glorify landscape over history, while consistently signifying this history, even if indirectly, and the need to cultivate a taste for landscape as a bulwark against the perils of human affairs.

The pictures I discuss below were painted decades after *Landscape with Figures*, in the short span of time between 1864 and 1876; they belong to the peak period of landscape art in America, between the immediate antebellum years and the Gilded Age. There are multiple contexts behind this boom in landscape painting, which the pictures mostly fail to register, at least explicitly—though in most cases investigation will uncover them.

Slavery and the plantation economy, abolitionism and the strife between North and South, and the devastations inflicted on the people and land south of the Mason-Dixon Line, so vividly recorded in narratives, prints, and photographs of the time, are conspicuously absent from Thomas Moran's (1837–1926) *Autumn Afternoon, the Wissahickon* (Fig. 2), probably the most striking among a series of brilliantly colored autumn views the Philadelphia painter devoted to a local creek in 1863–64. Although Moran's detailed view refers to a specific spot, the painting's rich, saturated palette and strong balance of lights and shadows, emphasizing nuances of foliage and reflections on the water, are reminiscent of Thomas Cole. Born in England, like Cole, Moran admired and emulated his forerunner, and was eventually recognized as his true heir. He belonged, however, to a later generation that enjoyed the benefits of professionalization and an expanding market for art in Philadelphia and other cities. Moran painted the Wissahickon views after visiting England to study the work of J. M. W. Turner (1775–1851)

and other contemporary masters; he would go again before embarking, in the 1870s, on expeditions to the Western frontier. Like other versions of the scene, *Autumn Afternoon* was painted on commission; it was his most expensive work at that time. Whether or not the painter, as art historian Diane Dillon suggests, had the war in mind when creating this virtuoso play of light on stream and foliage, with cows placidly wading in the calm, luminous water, and no sign of industrial modernity whatever, such a glorious image would certainly "have offered visual escape to eyes weary of war."[6] If indeed landscape painting was seen as an "escape" from the war, it is a testament to the curative virtues—or the distractive powers—of the genre. Those "weary eyes" would have been exposed to the unprecedented saturation of visual information that characterized American culture in the 1860s, which made the war, for patrons of art as for many others, a spectacle to be confronted or avoided.

Exactly contemporary and in certain ways comparable to *Autumn Afternoon* is the smaller canvas by Fitz Henry Lane (1804–1865) entitled *Brace's Rock, Brace's Cove* (Fig. 3), also one in a series of several similar pictures of the same spot made over a short period of time at the height of the Civil War—though this particular version of the cove and rocks near Gloucester, Massachusetts, differs from the others for unknown reasons. Similar to Moran, Lane attached himself intently to a site or area—in this instance his native Gloucester, at other times coastal towns in Maine—that offered rich potential for landscape as well as social

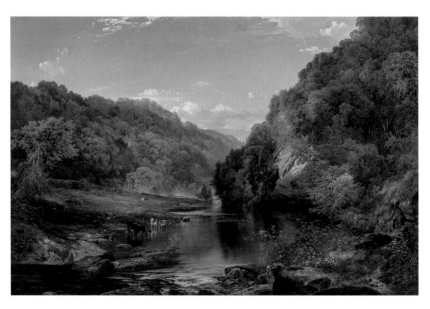

2 **Thomas Moran, *Autumn Afternoon, the Wissahickon*, 1864**. Oil on canvas, 30 ¼ × 45 ¼ in. (76.8 × 114.9 cm), 1999.99

3 **Fitz Henry Lane, *Brace's Rock, Brace's Cove*, 1864**. Oil on canvas, 10 ¼ × 15 ¼ in.
(26 × 38.7 cm), 1999.83

and financial support for pictures, painted or printed. What is obviously different is the style and mood of the painting. Lane was handicapped from youth and prevented from traveling. He made himself known primarily as a marine painter and it was for his concentrated, purified studies of light and hue in sky and sea, almost bordering on abstraction, that he later became identified with the style known as luminism. The palette of *Brace's Rock* is as subdued, restrained, and almost stark in its contrasts as Moran's is exuberant, although the orange sunset ray that illuminates the rock formation in the center also highlights a small shrub, at left foreground, and pebbles on the beach at right that are discreet reminders of Lane's affiliation with the Hudson River style. Yet here the eye is not drawn toward a vast prospect in which to find "composure," but confronted instead by the lack of depth—a limited horizon, the dark silhouettes of rocks almost barring access to the cove—and by the wreck at center foreground and the feeble tide behind it. Whether or not we should read Lane's insistence—especially marked in this version of the composition—on the decaying skeleton of a boat as a metaphorical emblem of the nation's dismemberment, certainly the painting, one of the artist's last, can be plausibly interpreted as a dark, yet quiet allegory of mortality. The repetition of this motif across several canvases again points to the taste of patrons who, toward the end of the Civil War, sought out landscapes of various styles and moods as malleable, supple expressions of American identity and its torments.

4 **Alfred Thompson Bricher,** *Lake George from Bolton's Landing,* **1867.** Oil on canvas, 27 × 50 ¼ in. (68.6 × 127.6 cm), Terra Foundation for American Art, Daniel J. Terra Collection, 1992.17

The remarkable ability of the landscape genre to adjust to shifting cultural needs and tastes over several decades is demonstrated by the resurgence in the East, immediately after the conflict's end, of a style of pictures in which the wounds of war appear all but forgotten, or at least yield to a form of pastoralism now fully consistent with the lifestyle of what the Norwegian-American sociologist Thorstein Veblen (1857–1929) called, somewhat later, the "leisure class." Consider Alfred Thompson Bricher (1837–1908)—born in New Hampshire, later resident in New York, and regarded as an important representative of the Hudson River school's second generation—and his painting *Lake George from Bolton's Landing* (Fig. 4). Bricher's wide, panoramic view depicts a location made famous by *The Last of the Mohicans,* and since the opening of rail service in 1849, a favorite holiday destination of New Yorkers and a choice topic for painters catering to the growing New York market. Even the subtle allusions to conflict tentatively identified in the Lane and Moran paintings are absent here. The composition echoes the classic formula, with a busy, rocky foreground flanked by solitary trees opening out onto a long perspective, guided by the gentle meanders of a stream toward the village of Bolton's Landing and then the far distance where, in a haze, lie the calm expanse of the lake and the large rounded tops of the Adirondack range. Around the center of the painting, at middle ground, are gathered markers of civilization: the forest has been cleared, there are cattle grazing, fences bordering the grass areas, a bridge crossing the stream, a plume of smoke suggesting life in the small town's dwellings. The "action" of the painting, however, at center foreground, revolves around two women in elegant excursion attire, one sitting and holding

a travel guide or sketchbook, the other in a long pale dress, standing and perhaps posing for her companion, each in an attitude of communing with nature.

The contrast with both the grand style of Cole's *Landscape with Figures* and the somber mood of Lane's *Brace's Rock, Brace's Cove* is striking. As in similar landscape pictures of this period, signs of history are visible but subdued, nowhere as pressing as they were in Cole's paintings of the 1830s. Just two years after the Battle of Appomattox Court House effectively ended the Civil War, and as the federal policies of Reconstruction in the South and conquest in the West were in full force, for Bricher and his New York upper-class market, landscape had become not just a rewarding genre of painting but a fully legitimate, self-contained, even self-reflexive cultural practice. No longer a momentary pause on the road or a respite from private or public grief, it was now the object and meaning of travel. Lake George would remain a sanctuary of landscape art for decades to come; during World War I (1914–1918) American photographer Alfred Stieglitz (1864–1946) and his circle made it again a privileged site for revelations of timelessness. In the decade or two after the Civil War, most successful landscape painters worked in or close to the East Coast settings where they grew up, lived, and found patronage. Though Boston and Philadelphia had their share of this durable phenomenon, the Hudson River school might more aptly be named the first New York school of painting, as art historian Angela Miller has demonstrated.[7] One consequence of the dominance of New York—state and city—and the East Coast generally in the taste for what we might call the genteel style of landscape is the relative absence of the western United States in its corpus.

It was during and immediately after the Civil War that the United States Congress passed several landmark acts giving a decisive push to westward expansion and popular conquest of "new lands," including the Homestead Act (allotting plots of land to settlers) and Railroad Acts (ceding large land grants to railroad companies to build transcontinental lines). In the field of landscape painting, the most vivid reflection of the great march westward lies in the work of the German-born artist Albert Bierstadt (1830–1902), who almost single-handedly created a genre of monumental mountain views, especially of the Sierra Nevada, along with epic scenes of emigrant wagon trains and romantic visions of pastoral Native Americans resting in timeless wilderness environments. As often noted, the numerous pictures of Yosemite Valley in Northern California that Bierstadt painted and exhibited during the Civil War, just as the site was declared a public recreation area, fed a redemptive rhetoric that obliterated the violence of war and conquest, and was largely compatible with the radical Republican ideology behind the Railroad Acts and "Go West"

campaigns. Still, if such rhetoric was associated with the entry of Western landscapes into American visual culture, this was primarily achieved in the 1860s and 1870s not by painters but by illustrators, engravers, photographers, and stereographers, first in California and then in the entire area of the Western frontier. After 1870, any attempt at incorporating Western scenery within the growing canon of New York–style landscape had to demarcate itself from this profusion of popular visual matter.

This would seem to be the case with the last picture discussed here, Worthington Whittredge's (1820–1910) *Indian Encampment* (Fig. 5), painted some time between 1870 and 1876 probably in the artist's studio in New York from sketches made on one of several trips he took to the West in the years after the Civil War. By this date Whittredge, who had started as a sign painter and a daguerreotypist before traveling to Europe to study in Düsseldorf, was one of the senior masters of the American landscape tradition, indeed one of the leaders of the New York school and president of the National Academy of Design, its semi-official home, from 1874–75. In later years his style would shift under the influence of the Barbizon school and then impressionism, but *Indian Encampment*, despite its small size, may be read as a kind of recapitulation of the genteel landscape tradition, its remarkable successes and its inherent paradoxes. The composition, structured around a creek meandering into a succession of mountain ranges that recede toward a distant waterfall almost exactly at center and then snowy caps on the horizon, is reminiscent of the classic formula inaugurated by

5 **Worthington Whittredge, *Indian Encampment*, c. 1870–76**. Oil on canvas, 14 ½ × 21 ⅞ in. (36.8 × 55.6 cm), 1999.151

Cole, except that the foreground is occupied not by the traditional rock and shrub but by a stream, muddy yet finely modeled and enhanced by delicate reflections. Along with this fine water texture, the subtle, softly sculptural treatment of light in differential hues of ochre aligns this picture with luminist tendencies. In mid-distance on the right side of the creek stand a group of tipis, some of their occupants highlighted by spots of bright red in their clothing, while to the left a small group of horsemen are in the process of crossing the water. This scene, whether based on actual observation during one of Whittredge's trips—which, he wrote, impressed him with a sense of Arcadia—or constructed by his imagination, strikes us as nostalgic, even untimely. The picture is contemporary with, yet apparently completely oblivious to, one of the most violent and most publicized moments in the long series of conflicts between the US government and Native American tribes in the second half of the nineteenth century, the Plains Wars, which culminated in the Battle of Little Big Horn in eastern Montana Territory in 1876. It is also out of line with contemporaneous imagery of the West delivered by press illustrations and survey photographs, which did not depict much Native American life, except in tightly controlled environments. Another landscape with figures, it references an ethnographic subject that, in spite of its realism, is more abstract and atemporal than Cooper and Cole's Mohicans. Whittredge's pastoral scene takes us out of history rather than into it, as it merges a Western setting and a Native American motif with the self-reflexive style of landscape art that had evolved and matured for fifty years in and around New York. Soon this style would decline, while Western and Native American motifs would rise in new configurations of landscape, associating ambitious painting with more popular imageries. A century and a half later, as the very concept of landscape has been thoroughly redefined, particularly under the influences of environmentalist thought and Native or non-white re-appropriation efforts, this style of landscape art may appear obsolete. Yet the nostalgic appeal of the pastoral that already permeated the American paintings of the 1860s and 1870s lives on, as evidenced by countless images of contemporary culture from wall calendar photography to pseudo-"Indian" rituals. For this reason, among many others, it is worth looking again at the great achievement of nineteenth-century American painters who defied the incipient nostalgia of landscape painting as a genre and employed it instead to articulate their own questions about the many meanings of land in America.

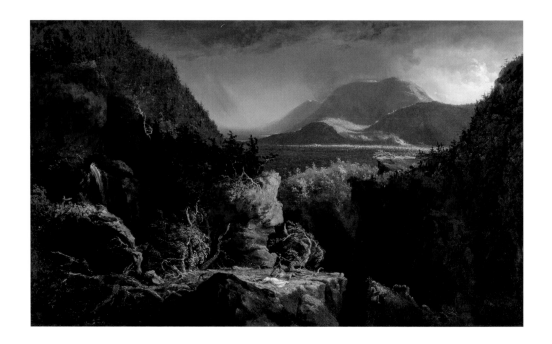

Thomas Cole (1801–1848)
Landscape with Figures: A Scene from
"The Last of the Mohicans**,"** 1826

> Oil on panel, 26 ⅛ × 43 ⁷⁄₁₆ in. (66.4 × 109.4 cm),
> Terra Foundation for American Art, Daniel J.
> Terra Collection, 1993.2

Famous for his unparalleled portrayals of
the American wilderness, Thomas Cole was
the founder of the Hudson River school. The
hallmark of this group of artists was a uniquely
American style of landscape painting that
combined nationalist pictorial rhetoric with
English aesthetic conventions. Commissioned
for display on the steamboat *Albany, Landscape
with Figures* depicts the tragic climax of James
Fenimore Cooper's popular novel *The Last of
the Mohicans* (1826). The heroine, Cora Munro,
clad in white, lies dying on a cliff beside Uncas, a
Mohican who is killed while attempting to save
her from Magua, a member of the enemy Huron
tribe. Hawkeye, the book's frontiersman hero,
raises his rifle toward Magua, who dangles pre-
cariously from the cliff. The grandeur of Cole's
mountainous, autumnal landscape overshadows
the dramatic narrative, reminding the viewer
that there are greater forces in the world than
human conflict and desire.

Landscape with Figures: Scene from "The Last of the Mohicans" is one of Thomas Cole's key contributions to the development of a uniquely American style of landscape painting based on the idea of the American wilderness. But the focus on Cole's role within American art history has prevented consideration of his work in the context of art developments in both American continents. During the same years that Cole was producing his scenes from James Fenimore Cooper's famous novel, the French-Brazilian artist Félix Émile Taunay (1795–1881) was also drawn to Cooper's use of the wilds of upstate New York as a setting for historical fiction. Both artists recognized an opportunity to bolster the status of landscape painting by infusing it with literary and historical references.

Cole's picture was one of a cycle of twelve canvases by seven artists commissioned for the upscale steamboat *Albany*, which plied the waters of the Hudson River during this period. Most of the contributing artists, including Cole, were members of the newly founded National Academy of Design in New York City. According to Kenneth Myers, Samuel F. B. Morse, president of the Academy, was responsible for the boat's pictorial program, which cleaved to the European academic "hierarchy of genres," but with a revealing difference: traditionally, history painting ranked supreme as the most intellectual and morally uplifting of genres, but half the paintings commissioned for the Albany were landscapes. Cole demonstrated the capacity of landscape to incorporate local notions of wilderness, and to dramatize contemporary issues such as the confrontation between native peoples and Euro-Americans.

Meanwhile, in Brazil Félix Émile Taunay was starting his career as professor of landscape painting at the Imperial Academy in Rio de Janeiro. Trained by his father, Nicolas Taunay (1755–1830), a member of the Institut de France, Félix, like Cole, recalibrated the taxonomy of genres, exploiting landscape as a vehicle for reflections on local history and national identity. The three paintings he exhibited at the Academy in Rio in 1831 all incorporated history into landscape. Two survive: *Guanabara Bay Seen from Snake Island* (1828, Instituto Ricardo Brennand, Recife, Brazil) and a *Historical Landscape of a Landing in the Largo do Paço* (1829, Imperial Museum, Rio de Janeiro). The third is unfortunately lost, but a detailed description remains: *Cora and Alice* depicted a scene from Cooper's novel in which the two daughters of a British military officer hiding in a cave with their Mohican allies sing a psalm—it is a visual argument for the power of art to unify people despite cultural or racial differences. Again like Cole, Taunay chose to represent the encounter between native people and colonizers in the wilderness. We don't know if he had any knowledge of Cole's use of the *Mohicans* novel, but he was undoubtedly looking to North America when he chose this subject.

In 2016 Cole's painting was shown at the Pinacoteca de São Paulo as part of the exhibition *Picturing the Americas: Landscape Painting from Tierra del Fuego to the Arctic*, where it offered a new context for understanding the impulses behind Taunay's lost painting.[1] However different the two works may seem, they indicate that both artists faced similar questions, inspiring researchers to investigate unsuspected connections across the American continent in the nineteenth century.

Claudia Mattos-Avolese, *Professor of Art History*,
Universidade de Campinas, Brazil

Rediscovered in the middle of the twentieth century after sitting forgotten in a Napa County farmhouse for forty years, William S. Jewett's first large Californian painting was cleverly but deceptively renamed *The Promised Land*, and emerged as one of the canonical images of nineteenth-century American art.

It had been commissioned during the peak years of the California Gold Rush by Andrew Jackson Grayson (1819–1869), at that time a "well known and highly respected merchant" in San Francisco, and portrays Grayson, his wife, and young son amid the primeval wilderness of the Sierra Nevada.[1] Jewett's picture has been notorious for both what it apparently shows and what it presumably conceals. Until the late 1980s, the painting was seen as a vision of the quintessential pioneer family, offering visual confirmation of the biblical rhetoric associated with Manifest Destiny. More recent scholars have argued that the absence in the painting of Native people, human settlements, or living wild animals naturalized the ethical quandaries endemic in the westward expansion of the United States.

I must confess that this postcolonial approach makes sense to me. As a Mexican scholar of nineteenth-century landscape painting, it is hard for me to ignore the fact that when Grayson arrived in California in 1846 that pristine land was still part of Mexico; it was ceded to the United States two years later in the Treaty of Guadalupe-Hidalgo, which formally ended the Mexican-American War. However, when I became interested in the history of art in California, I discovered that the painting's most appealing quality is not what makes it an easy target for generalizations, but the opposite.

Grayson was by no means the archetypal frontier man that his image has come to represent. One of the most remarkable early Anglo-Californians, Grayson was both scientifically and artistically inclined. He eventually migrated to Mazatlán, Mexico, where he became, in the words of the late-nineteenth-century historian Alonzo Phelps, the most "celebrated Mexican ornithologist."[2] The work he commissioned from Jewett in 1850, which a local paper described as "commemorative of the emigration of that gentleman and his family, to this country, from over the plains,"[3] is the first known attempt by an academic artist in California at making a large historic painting, still considered the grand genre by mid-nineteenth-century Western academic standards.

From the time of its conception, it was a public image—exhibited in Jewett's San Francisco studio before it was finished, and continuously one of the most popular artworks in the state until the late 1880s. Its rich yet puzzling details and its defiance of traditional painting categories—"combining both landscape and figures," as F. C. Ewer, editor of the *Pioneer* magazine asserted in 1854—did not go unnoticed. Some critics proclaimed it the first Californian *chef d'oeuvre* while others debated its historical accuracy and merits as a work of art, but it was widely recognized as a first—"truly and exclusively a California picture," Ewer remarked, continuing, "No country but this could produce such a scene."[4]

Despite having a secured place in the narratives of nineteenth-century American art history, *The Grayson Family* has yet to be studied thoroughly as a complex work of art that reveals and dissembles—a meaningful, if incomplete, expression of the multiethnic and multicultural society that produced it.

Alberto Nulman Magidin, *PhD candidate*,
Universidad Nacional Autónoma de México, Mexico City

William S. Jewett (1792–1873)
The Promised Land—
The Grayson Family, 1850

> Oil on canvas, 50¾ × 64 in. (128.9 × 162.6 cm),
> Terra Foundation for American Art, Daniel J. Terra
> Collection, 1999.79

William S. Jewett was one of California's first resident professional artists. This painting combines portrait, landscape, and history painting in a celebration of one pioneer family's achievement. It shows Andrew Jackson Grayson (1819–1869) with his wife and son pausing at the point in the Sierra Nevada Mountains from which, on their

1846 journey from Missouri to what was then Mexico, they first glimpsed the Sacramento Valley. Wearing a fringed buckskin suit over a formal shirt, Grayson leans on his rifle and gazes across the landscape. His fashionably dressed wife holds their son, whose ermine-trimmed gown indicates not only the family's eventual prosperity but also his stature as the scion of one of the state's founding families. The portrait, Jewett's first major commission in California, was deemed an immediate success by contemporary critics, and in the twentieth century was seen as representative of "manifest destiny," the nineteenth-century belief in the justified westward expansion of the United States.

John Frederick Kensett (1816–1872)
Almy Pond, Newport, c. 1857

> Oil on canvas, 12 ⅝ × 22 ⅛ in. (32.1 × 56.2 cm),
> Terra Foundation for American Art, Daniel J.
> Terra Collection, 1992.42

One of the most prolific and influential American landscape painters of the mid-nineteenth century, John Frederick Kensett is best known for his small-scale, luminous coastal scenes of Connecticut, Massachusetts, New York, and Rhode Island. While Kensett painted many scenes of Newport, Rhode Island, a popular northeastern tourist destination, *Almy Pond, Newport* uniquely portrays the seaside town as a pastoral community. The flat, expansive scene includes both the eponymous pond and Spouting Rock, two landmarks recognizable to locals and travelers alike. Animating the otherwise still scene, a farmer, his three children, and their black dog traverse the field toward grazing cows in the distance. The painting suggests a return to rural values and a reaffirmation of the pre–Civil War transcendentalist belief in the sacredness of nature. It also demonstrates Kensett's ability to imbue a specific local landscape with a broad cultural theme.

Frederic Edwin Church (1826–1900)
Our Banner in the Sky, 1861

> Oil paint over lithograph on paper, laid down
> on cardboard, 7 ½ × 11 ⅜ in. (19 × 28.9 cm),
> Terra Foundation for American Art,
> Daniel J. Terra Collection, 1992.27

Frederic Edwin Church is noted for creating
landscape paintings that blend realistic detail
with dramatic nationalism. Although it is a
small-scale composition, *Our Banner in the Sky*
boldly depicts the American flag as a transient
arrangement of sky, clouds, and stars seemingly
held aloft by the barren tree on the left. Church
created an oil sketch that served as the basis for
this work at the outbreak of the American Civil
War (1861–65), following the Confederate
attack on Fort Sumter, South Carolina in April
1861. The flag, lowered to signal the Union's
surrender to rebel forces, soon became a con-
tested national symbol. That June, Church was
commissioned to produce a chromolithograph
after his oil sketch, and the Terra Foundation's
version is one of several lithographs the artist
himself presumably painted by hand. The work
strongly resonated with Northern wartime
viewers, who enthusiastically embraced this
rallying image.

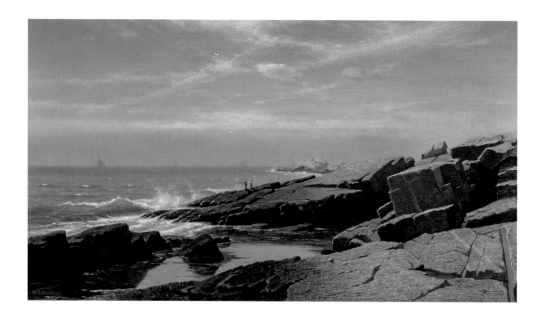

William Stanley Haseltine (1835–1900)
Rocks at Nahant, 1864

> Oil on canvas, 22 ⅜ × 40 ½ in. (56.8 × 102.9 cm),
> Terra Foundation for American Art, Daniel J. Terra
> Collection, 1999.65

William Stanley Haseltine, of the later Hudson
River school, is best known for his paintings
of America's northeastern coast. His works are
remarkable for their focus on rock formations,
a subject of considerable popular and scientific
interest in mid-nineteenth-century America.
Rocks at Nahant is one of a group of his paint-
ings that depict, in meticulous detail and under
various atmospheric conditions, the shore of
Nahant, Massachusetts. Smooth diagonal slabs
of reddish igneous stone and vestiges of prehis-
toric volcanic and glacial activity disrupt the
broad horizontal composition of ocean and sky.
Two diminutive figures and several sailboats on
the horizon lend a sense of scale to this juncture
of bare rock and sea. Influenced by the popular
theories of the Swiss-born Harvard scientist
Louis Agassiz (1807–1873), who saw in Nahant's
rocks evidence of a universal ice age, Haseltine
intended the image as an artful meditation on
geologic history anchored in contemporary
human time.

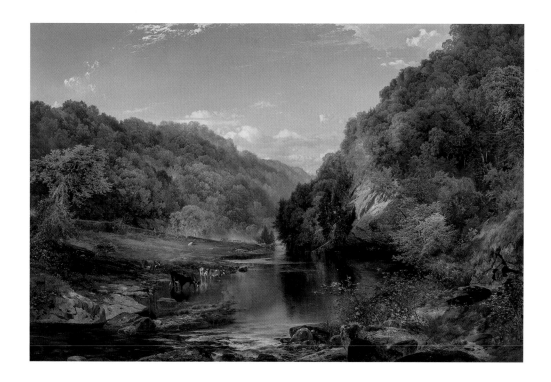

Thomas Moran (1837–1926)
Autumn Afternoon, the Wissahickon, 1864

> Oil on canvas, 30 ¼ × 45 ¼ in. (76.8 × 114.9 cm),
> Terra Foundation for American Art, Daniel J.
> Terra Collection, 1999.99

During his long, successful career, Thomas
Moran was best known for his grand-scale land-
scape paintings of the American West. Like other
Hudson River school painters, he combined
fidelity to detail with drama in a way that evokes
nineteenth-century America's wonder in nature
and eagerness to conquer it. In *Autumn Afternoon,
the Wissahickon*, an early work, Moran depicted

a creek that flows into Philadelphia,
Pennsylvania. Although the setting is not
far from the city, the artist created a bucolic
view that denies both encroaching urban-
ism and the not-so-distant conflict of the
American Civil War (1861–65). The painting
also reflects Moran's effort to assimilate
into a familiar scene the saturated color and
expressive light found in the work of the
English romantic painter J. M. W. Turner
(1775–1851), whose art he studied firsthand
in 1862. In this work, Moran drew upon a
landscape formula that is both naturalistic
and romantic.

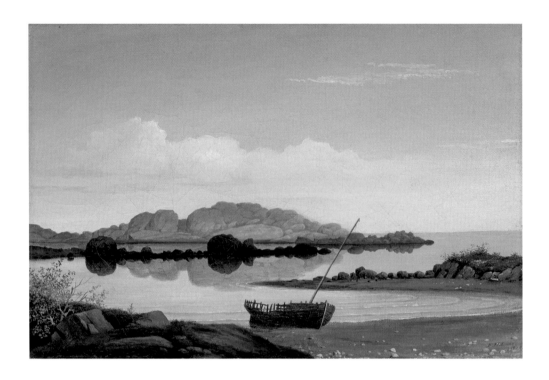

Fitz Henry Lane (1804–1865)
Brace's Rock, Brace's Cove, 1864

> Oil on canvas, 10 ¼ × 15 ¼ in. (26 × 38.7 cm),
> Terra Foundation for American Art, Daniel J.
> Terra Collection, 1999.83

In the mid-nineteenth century, Fitz Henry Lane pioneered a distinctive style of landscape painting that is characterized by serene depictions of America's northeastern coast bathed in crystalline light. *Brace's Rock, Brace's Cove,* one of his last works, is a haunting twilight scene of a notoriously dangerous group of rocks viewed from a cove near Lane's home in Gloucester, Massachusetts. In contrast to the luminous sky and water, the rocks and shoreline in the foreground are cast in darkness. Gently lapping waves and a skeletal, foreboding-looking small boat disrupt the otherwise placid seascape. The painting reflects the bleak outlook of a nation devastated by the American Civil War (1861–65), when shipwrecked vessels became a common artistic metaphor for the battles raging between North and South. Here, Lane masterfully exploits the expressive potential of light cast across a familiar locale in order to elicit an emotional response.

Based on a field study (*Brace's Rock, Eastern Point*, 1863, Cape Ann Museum, Gloucester, Massachusetts), Fitz Henry Lane's paintings of Brace's Rock near Gloucester largely relinquish the practical focus of an artist who had hitherto "earned his money . . . mostly by painting 'portraits' of vessels for sailors and ship-owners," as critic Clarence Cook wrote in 1854.[1] This particular picture is an anomaly, deviating mysteriously from the originating sketch and from the actual topography, offering instead the metaphysical import of liminal themes: land and sea, nature and carpentry, illusionism and artifice, serenity and doom, this world and the next.

A slowly swinging line of beauty marks the route by which the wrecked boat must have landed. Its mast cuts across this passageway and the tonally contrasting layers of rock and sea, energizing the tranquil scene whose horizon is lower, and sky larger, than in earlier iterations. Serenity is restored by the eerie reconciliation of conflicting formal qualities: brilliance and clarity, monumental and miniature scales, vaporous clouds that echo the shapes of solid rocks. The boat bears more than a passing resemblance to the wreck in Lane's *Dream Painting* (1862, Terra Foundation for American Art). Contradicting Thomas Cole's empirical emphasis on natural reflections in his 1836 "Essay on American Scenery," Lane's sea is an idealizing mirror; shadow and reflections flatten objects into things of conspicuous artifice that lack natural causation. The beached hull—crack-ribbed but still masted—defies easy explanation as a symbol: if wrecked at sea, how did it find its way to these placid sands? If abandoned, how had it not washed out to sea? The listing mast seems to radiate a force field, driving ripples of the ebbing tide into widening concentric ellipses, like waves from a radio tower.

The point of intersection between mast and horizon fixes the sight line, but in which direction? While retaining a familial resemblance to the other paintings based on his field study, this one offers a mirror image of their topography: the rock appears to show what would be its back when viewed from the cove, and sits on the left rather than the right; the panoramic beach is moved and seems, in fact, to follow the shape of an underdrawing on the canvas depicting the coast of Maine. Locals would know that this side of the rock could only be seen from the shore south of the cove, where granite cliffs plunge into the sea and where there is no place for an observing painter to stand. Yet only something like tall cliffs could explain the prolonged shadow stretching to the globular rosary of rocks and reflections in the middle distance: a dark brown spit engulfed by the cold yellow reflection of that fractured leviathan, Brace's Rock—enlarged, reversed, and upside down beneath the duck-egg blue sky.

The philosopher Maurice Merleau-Ponty (1908–1961) argued that once we disregard the content of empiricist vision, we are "free to acknowledge the strange mode of existence of the world behind us."[2] In fusing contradictory views, Lane's self-effacing brushstrokes and gyroscopic vision invoke an impossible post-mortem consciousness: a once familiar world from which the artist and his point of view are absent. Only the memento mori of the skeletal wreck is left to signify the extinction of human life and intimate a world beyond.

Richard Read, *Emeritus Professor*,
University of Western Australia, Perth

An awareness that exploitation of the Earth's natural resources was transforming the physical contours of the Americas began to show up in visual culture around the mid-nineteenth century. Environmental destruction was depicted explicitly in landscape painting, insinuating itself as a latent threat in representations of untouched wilderness, and was central to the ideas and work of Thomas Cole (1801–1848) and his followers.

Sanford R. Gifford grew up in the Hudson River Valley and, inspired by Cole, chose its terrain as a recurring subject. He was already a renowned painter in 1866, when *Hunter Mountain, Twilight* was displayed for the first time, at the forty-first exhibition of the National Academy of Design in New York. It was among the works representing the United States at the 1867 International Exposition in Paris.

Backlit at sunset, the mountain dominates the upper half of the composition, witness to the relentless flow of days, as suggested by the fading sun on the horizon and a rising moon and star in the firmament above. The cyclical nature of time is reinforced by the allusion to the seasons in the reddening leaves. It is the end of the day and likely the beginning of autumn, transitions through which Gifford evokes the ephemerality of human life. The rustic house at the fringes of the forest, the fence marking the property, and the man tending his cattle are all motifs taken from the pastoral painting tradition, which affirms the possibility of humanity harmoniously coexisting with the natural world. The grandeur of the landscape, accentuated by the small figure, attests to Gifford's great skill for creating sweeping vistas on compact canvases. The golden glow illuminating the center and the glint of a small creek reflecting the setting sun show his mastery of lyrical chromatic and atmospheric effects.

The foreground, however, is disconcerting: the serene domestic scene is visible to the viewer only because a forest has been cut down. Felled trees and stumps dominate the lower quarter of the painting, functioning almost as a *memento mori*. This painting has been interpreted as testimony to Gifford's opposition to the disastrous effects of human habitation, while also—given its date of execution—serving as metaphor for the devastation wrought by the American Civil War (1861–65).

Almost twenty years earlier, the theme of natural destruction had been taken up by the French-Brazilian painter Félix-Émile Taunay (1795–1881), then director of the Imperial Academy of Fine Arts in Rio de Janeiro. In a similarly segmented composition, *View of a Native Forest Being Reduced to Coal* (c. 1840, Museu Nacional de Belas Artes, Rio de Janeiro, Brazil), Taunay presents an idyllic vision of the tropical forest with its immense variety of interdependent species and, in the luxuriant shade, the natural springs that served as the water supply for Brazil's largest city. But on the left, this imposing and exuberant landscape is transformed into a scene of desolation, where rampant logging for charcoal has left a barren outline of mountains.

The way in which the "march of progress" across the Americas transformed the landscape was often overlooked in the nineteenth century, and painting of the time generally represented a world of harmony free from conflict. The works of Gifford and Taunay nevertheless attest to the danger some artists saw in that footfall.

Valéria Piccoli, *Chief Curator*,
Pinacoteca de São Paulo, Brazil

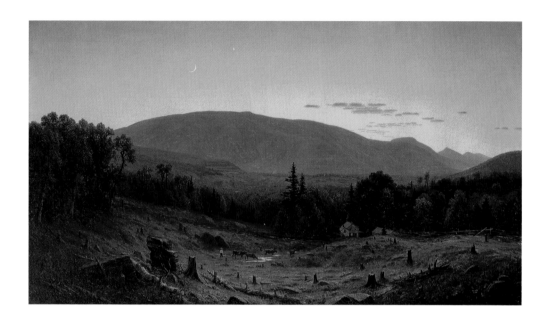

Sanford Robinson Gifford (1823–1880)
Hunter Mountain, Twilight, 1866

Oil on canvas, 30 ⅝ × 54 ⅛ in. (77.8 × 137.5 cm),
Terra Foundation for American Art, Daniel J. Terra
Collection, 1999.57

One of America's most accomplished landscape
painters, Sanford Robinson Gifford produced
luminous, atmospheric views of the northeast-
ern and western United States, Europe, Canada,
and the Near East. Set near his native Hudson,
New York, *Hunter Mountain, Twilight* depicts a
peak shrouded in a pale blue haze, silhouetted
against a glowing sky. Although the grazing cows,

cowherd, and house in the valley below
evoke calm domesticity, the tree stumps in
the foreground reveal how land develop-
ment degraded nature. The small farm has
been stripped of its hemlock trees to harvest
tannin, an essential ingredient in leather
tanning. In 1860s America, tree stumps
symbolized both the destruction of treasured
wilderness and the devastation caused by
the American Civil War (1861–65), during
which Gifford served in the Union Army. The
despoiled landscape he shows here expresses
both a sense of national mourning and an
emerging concern for nature conservation.

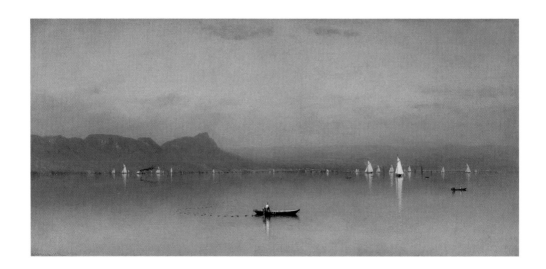

Sanford Robinson Gifford (1823–1880)
Morning in the Hudson, Haverstraw Bay, 1866

Oil on canvas, 14 ¼ × 30 ¼ in. (36.2 × 76.8 cm),
Terra Foundation for American Art, Daniel J.
Terra Collection, 1993.11

The most representative feature of Gifford's landscapes is the unifying effect of glowing natural light. *Morning in the Hudson, Haverstraw Bay* is one of his many images of this stretch of the river just north of New York City, an area that was both his birthplace and the original site of America's first native landscape painting movement, the Hudson River school. From a vantage point diagonally northwest across the river at its widest point, the view focuses on High Tor, a mountain towering eight hundred feet above the water. The numerous boats gliding along the river are visual counterpoints to the still perfection of the luminous water and sky, and hint at the Hudson's role as one of the nation's most vital avenues of transportation. A tranquil scene bathed in a diffused, cool morning light, it exemplifies Gifford's assertion that "landscape painting is air painting."

John La Farge (1835–1910)
Paradise Valley, 1866–68

Oil on canvas, 32 ⅝ × 42 in. (82.9 × 106.7 cm),
Terra Foundation for American Art, Daniel J.
Terra Collection, 1996.92

John La Farge was an influential painter, muralist,
stained glass maker, and writer. This early land-
scape painting depicts a view from the Paradise
Hills, outside Newport, Rhode Island, where the
artist vacationed in the post–Civil War years. A
verdant coastal pasture, animated with grazing
cows and sheep, stretches toward the Atlantic

Ocean. A solitary lamb, a Christian symbol of
peace, reclines on the green turf. With its gener-
ous scale and high horizon, La Farge's canvas offers
a pastoral vision of tranquility and also reflects his
growing interest in the compositional aesthetics
of Japanese art. La Farge painted *Paradise Valley*
outdoors, defying the traditional studio practice
of composing from sketches made on-site. The
work's detailed clarity reveals the influence of the
English critic John Ruskin (1819–1900) and his
doctrine of painting with exact fidelity to nature,
as well as La Farge's familiarity with then-current
scientific theories of visual perception and color.

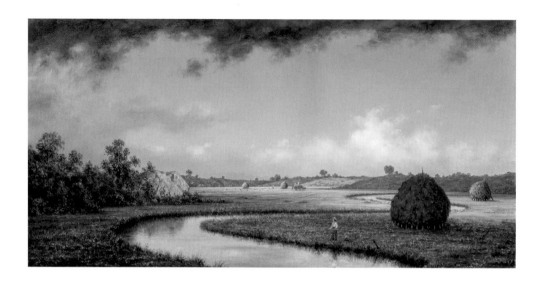

Martin Johnson Heade (1819–1904)
Newburyport Marshes:
Approaching Storm, c. 1871

> Oil on canvas, 15 ¼ × 30 ⅛ in. (38.7 × 76.5 cm),
> Terra Foundation for American Art, Daniel J.
> Terra Collection, 1999.68

Throughout his career Martin Johnson Heade created about 120 paintings of coastal marshlands in the eastern United States. Flat and fetid, marshlands defied the conventions of Hudson River school painting, but by the mid-1860s, Heade was among the many landscape artists who favored such atmospheric settings where land, water, and sky meet. In this painting a serpentine stream slices through a marsh animated with a fisherman and several farmers; the presence of haystacks suggests the bounty of agrarian life. Storm clouds cast the foreground in ominous shadow. The painting represents a fragile balance between man and nature, as saltmarsh haying was an urgent task performed at the mercy of the volatile weather and changing tides. In Heade's time, saltmarsh farming represented a vanishing way of life, since the young farmers were abandoning such traditional work to settle the American West. This work is a meditation on the fleeting beauty of nature and the value of rural labor.

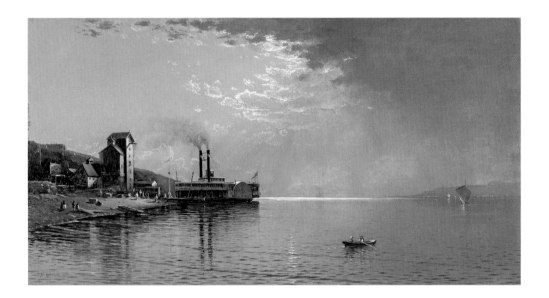

Alfred Thompson Bricher (1837–1908)
The Sidewheeler "The City of
St. Paul" on the Mississippi River,
Dubuque, Iowa, 1872

> Oil on canvas mounted on board,
> 20 ⅛ × 38 ⅛ in. (51.1 × 96.8 cm), Terra
> Foundation for American Art, Daniel J.
> Terra Collection, 1992.18

Alfred Thompson Bricher's coastal landscape paintings are characterized by low, flat horizons and pervasive light. When he traveled from the northeastern United States to the upper Mississippi River valley in 1866, the artist made sketches that would become the basis for studio paintings such as this one. The Dubuque merchant whose dry-goods store appears on the riverbank at left purchased the completed canvas. Bricher was equally attentive in his depiction of the sidewheeler, a type of steamboat well known on the Mississippi and Ohio rivers. *The Sidewheeler* pictures the expansive Mississippi under a glowing pink sky, framed by the riverbank and steamboat on the left and by sailboats, bluffs, and storm clouds on the right. The work demonstrates Bricher's embrace of the then-emerging American landscape painting style that favored tranquil scenes over the pictorial drama of the Hudson River school.

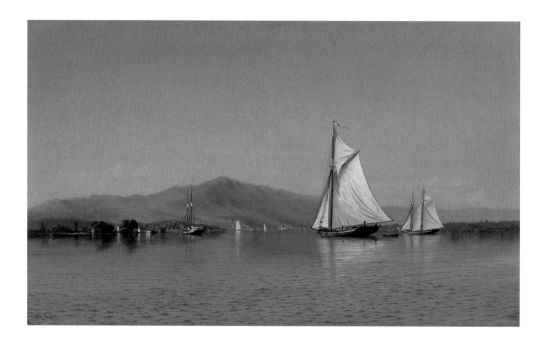

Francis A. Silva (1835–1886)
On the Hudson near Haverstraw, 1872

Oil on canvas, 18 ¼ × 30 ⅜ in. (46.4 × 77.2 cm),
Terra Foundation for American Art, Daniel J.
Terra Collection, 1993.16

Francis Augustus Silva painted coastal and river scenes of the northeastern United States that feature low horizons, delicate color, and crystalline light. *On the Hudson near Haverstraw*, one of many views of the river that the artist produced, demonstrates his concern for subtle light effects. The image captures the scene in late afternoon; the low sun highlights the vessels and tints both water and sky with a narrow range of pastel shades. Unified by its pervasive illumination, the painting is both precisely rendered and geographically specific, showing the town of Haverstraw on the far shore. Silva's serene painting reflects the evolution of the Hudson River school landscape tradition. While artists affiliated with it had mined the same region in earlier decades for vistas that celebrated the dramatic character of the American wilderness, Silva and his contemporaries favored tranquil, horizontal compositions with diffuse light and smoothly painted surfaces.

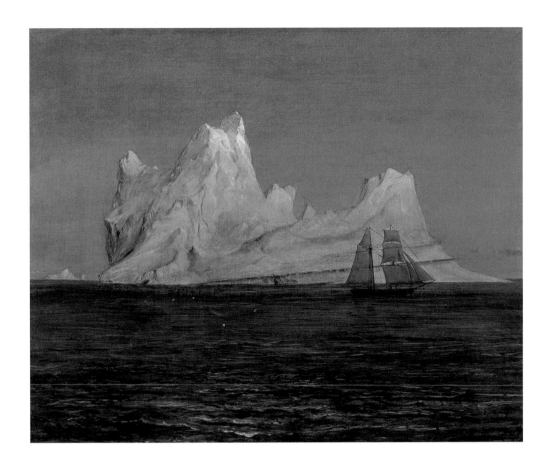

Frederic Edwin Church (1826–1900)
The Iceberg, c. 1875

Oil on canvas, 22 × 27 in. (55.9 × 68.6 cm),
Terra Foundation for American Art, Daniel J.
Terra Collection, 1993.6

Throughout his long career, Frederic Edwin
Church traveled to—and painted scenes
of—a range of exotic locales, from equato-
rial South America to the Arctic. This work
shows a schooner gliding by a shadowy
iceberg; the setting sun illuminates the
upper reaches of the frozen structure. The
ship's translucent sails suggest its apparent

fragility in contrast to the solid, towering
mass rising from the dark sea. The ice-
berg's jagged contours reflect the violence
of its formation, while the steep incline
of its terrace lines—the result of gradual
tipping as it melts underwater—signals
its inevitable demise. Church painted *The
Iceberg* from memory, nearly two decades
after his initial Arctic voyage, assisted by
his oil sketches of the region. The result-
ing work thus consolidates firsthand
observation and distant recall into an
evocative meditation on human frailty
and the relentless passage of time.

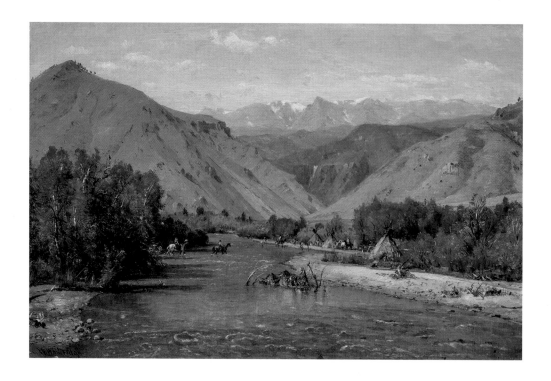

Worthington Whittredge (1820–1910)
Indian Encampment, c. 1870–76

> Oil on canvas, 14 ½ × 21 ⅞ in. (36.8 × 55.6 cm),
> Terra Foundation for American Art, Daniel J.
> Terra Collection, 1999.151

A well-traveled, versatile, and successful painter,
Worthington Whittredge produced many scenes
of the American West during his long career.
In the 1860s and 1870s, he made three trips to
the Western plains and the Rocky Mountains
of Colorado and northern New Mexico. Unlike
his contemporaries, who painted dramatic,
monumental views of the mountainous frontier,

Whittredge created intimate images of the
terrain. This canvas pictures a group of
Native Americans camped along a shallow
stretch of the Platte River in Colorado,
which flows toward the Rocky Mountains.
The fresh green foliage suggests the bounty
of late spring or early summer, and the
entire landscape is bathed in a beneficent
light. Although the artist was aware of the
violent conflicts between Native Americans
and Anglo-American settlers in the region,
his painting presents an indigenous commu-
nity as peaceful dwellers in nature, at a safe
remove from the presumably white viewer.

Sarah Burns
Professor Emeritus of Art History,
Indiana University, Bloomington, Indiana

Introduction

American genre painting as a category did not exist until a German immigrant using British models devised an influential template for representing American life in, and to, the young republic. Born in the south German duchy of Wurttemberg, John Lewis Krimmel (1786– 1821) in 1809 joined his older brother in Philadelphia, where—with little or no training—he soon found his métier in rendering scenes of daily life. Although in a number of works Krimmel celebrated Philadelphia's urban scene, he made his mark as a painter of rustic manners. These paintings traced their origins mainly to the work of British artists, most particularly David Wilkie (1785–1841), whose immensely popular tableaux found their way to America in the form of widely available engraved reproductions. Based on John Burnet's print after Wilkie's *The Blind Fiddler*, Krimmel's meticulous copy (Fig. 1) established the principal terms that would shape the pictorial vision of idealized American life and customs for decades to come. Thus, what became classic nineteenth-century American praxis had in the beginning nothing American about it. How and why did it catch on?

Wilkie's painting depicts a cottage interior, where an itinerant musician has stopped to play for a few pennies or perhaps something to eat. Beside him is his wife, tired and glum, holding an infant; their young son warms his hands at the glowing hearth. Gathered to enjoy the impromptu concert is the resident family, with a contemplative grandfather looking on, two little girls raptly gazing, the father snapping his fingers to amuse the baby on its happy mother's lap, an older girl who has temporarily abandoned her spinning, a quizzical dog, and a grimacing scamp pretending to play his own fiddle with a pair of bellows and a poker. The room is sparsely furnished, yet the family clearly has enough for its needs. There is an array of foodstuffs, along with children's toys, cooking implements, a large armoire, baskets and blankets, even a small collection of books next to the bust of a minister above the mantelpiece. Pious, industrious, and comfortable, this family casts the plight of the wandering fiddler into poignant relief.

Krimmel was faithful to Wilkie's original as transmitted through the black-and-white engraving, though he had of necessity to improvise the colors. When he exhibited the painting in 1813 at the Pennsylvania Academy, critical response was surprisingly warm, considering that the

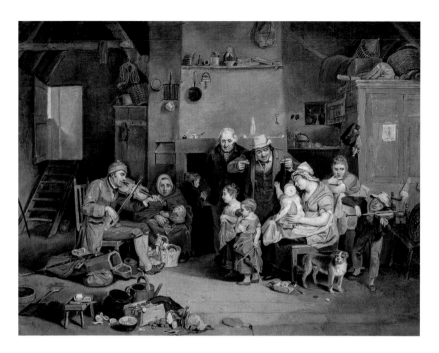

1 **John Lewis Krimmel (1786–1821), *Blind Fiddler*, 1812**. Oil on canvas, 16 ⅝ × 22 1/16 in. (42.2 × 56 cm), Terra Foundation for American Art, Daniel J. Terra Collection, 1999.81

work was, after all, only a good copy of another more famous painter's production. What roused critical enthusiasm was the recognition of a model for a truly American art capable of expressing national identity at a time in the formative years of the young republic when what it meant to be "American" was a question that had no clear answer.[1] As one writer put it at the time: "The subject is one of these that daily occur in the simple walks of common life; it is delineated with truth and elegance, and exhibits without affectation, the comforts and happiness of domestic life.... [Wilkie's] pictures are equally interesting to the learned and ignorant—they are faithful, chaste, and dignified representations of nature, conveying at the same time pleasure and instruction.... We believe his school of painting well fitted for our republican manners and habits, and more likely than any other to be appreciated at present."[2]

In appropriating Wilkie's subject and format, Krimmel played a key role in formulating an attractive and accessible model for representing purportedly authentic, everyday Americans as rural, domestic, naturally good, and happy with their lot. Further staking his claim to represent the real America, Krimmel exhibited his own *Quilting Frolic* (1813, Winterthur Museum, Garden and Library, Delaware) along with his copy of *The Blind Fiddler* at the Pennsylvania Academy of the Fine Arts in 1813. A far livelier

scene, it takes place in a similar, if somewhat more affluent, interior, where George Washington's portrait has replaced the minister's bust, and the fiddler is now black. Here, women tend to the domestic work or flirt innocently with young men, children act up, and the black fiddler, barely through the door, clearly knows his liminal place in white society.

If it struck any viewers as ironic that the Scotsman Wilkie's vision of peasant life provided the scaffolding for the German-born Krimmel's celebration of American country customs—especially during the ongoing War of 1812 *against* the British—no record of such reactions survives. Nor did it seem to concern any viewers that Krimmel (like Wilkie) liberally sugarcoated his visions of "republican manners and habits." Thus sweetened, such compositions worked to assuage contemporary anxieties that circled around the potential of unchecked social mobility and the rise of cities to empower the disorderly and potentially dangerous masses. In the country of Krimmel's imagination, change came slowly, if at all, for its inhabitants, who had attained comfortable "middling" status but desired nothing higher.[3]

The Wilkie/Krimmel template became a standard for rural genre scenes for the remaining decades of the antebellum era, when reassuringly peaceful, entertainingly moralistic, and often humorous visions of static American country life belied the turbulent realities of social change, political peril, and national expansion under the banner of Manifest Destiny.[4] In the work of Krimmel's heirs, notably William Sidney Mount (1807–1868), Francis William Edmonds (1806–1863), and Eastman Johnson (1824–1906), national identity remained firmly rooted in the American northeast.[5] If their paintings referred to contemporary conflicts, it was often in an oblique or coded fashion that left room for varying interpretations. This was very much the case with Johnson's *Negro Life at the South* (1859, New-York Historical Society), which was exhibited to great acclaim at the National Academy of Design in 1859, two years before the outbreak of the American Civil War. Representing a multigenerational group of slaves going about their activities in the backyard of a tumbledown house, *Negro Life* allowed abolitionists to deplore the wretched conditions of bondage while enabling pro-slavery advocates to see the slaves as content with their lot. One critic, however, made a surprising comparison: "The picture of 'Negro Life at the South' ranks with Wilkie's 'Blind Fiddler,' and is a kind of Art that will be always popular, so long as lowly life exists to excite and to reveal the play of human sympathy."[6]

Born in the small village of Lovell, Maine, Johnson performed a reverse of Krimmel's transatlantic career trajectory, training in Düsseldorf, Germany, as well as in The Hague and Paris. Equipped with sophisticated technical skills, he established himself in New York in 1859, and during the Civil War (1861–65) produced a succession of politically charged

scenes depicting slaves in their struggle for freedom.[7] Soon after the end of the war, in 1866, Johnson—who was well acquainted with the conventions of British genre painting—revived the Wilkie/Krimmel template and put it to fresh use in two versions of a painting titled *Fiddling His Way*. In the Terra Foundation's painting (Fig. 2), we see a dim cottage interior, where an older, bearded man plays for a family group: mother, baby, pipe-smoking father, three boys, and an older daughter with a broom. Everyone listens as if enchanted; only the baby breaks the spell as it squirms and reaches out toward the musician. In the other version (Fig. 3), larger and more fully elaborated, there are additional figures, a more detailed inventory of the furnishings—plain and rustic—and a decided switch: the fiddler is a young black man, neatly dressed and very serious.[8]

The fiddler's race changes everything, including the implications of the title. The young man is on his "way"—but to where? Seated near a door, he (like Krimmel's black fiddler in *Quilting Frolic*) is clearly on the edge. It is telling, too, that a trapdoor lies at his feet—perhaps an allusion to the Underground Railroad that aided (and hid) escaped slaves on their way to freedom in the North. In 1866 this young man is on the move, but unlike the desperate fugitives of the antebellum decades, he is free. Yet he is a vagabond without a home. What, the painting asks, is now his place (and that of all freed slaves); where does he belong? Is he on his

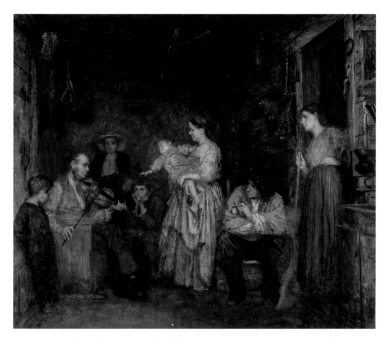

2 **Eastman Johnson (1824–1906),** *Fiddling His Way,* **c. 1866**. Oil on artist's board, 20 ⅞ × 24 ⅞ in. (53 × 63.2 cm), 1999.8

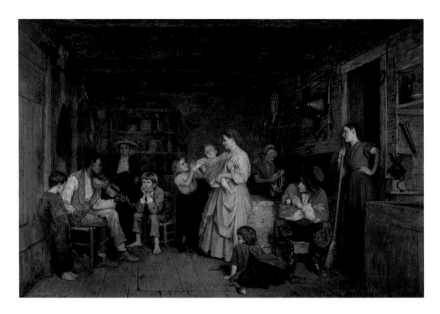

3 **Eastman Johnson (1824–1906),** *Fiddling His Way*, **1866**. Oil on canvas, 24 ¼ × 36 ½ in.
(61.6 × 92.7 cm). The Chrysler Museum of Art, Norfolk, Virginia, Bequest of Walter P. Chrysler Jr.,
89.60

way to a brighter future, or, at a time of postwar political turmoil and con-
flict, to a dead end?[9] The question remains unanswerable, but Johnson
had by then come to his own dead end with the black American's dilemma.
After 1866, he turned to the nostalgic, rustic New England scenes that
would bring him renown in the 1870s.[10] While the "black" version of the
painting points the way to an uncertain outcome, the "white" version
looks back to a vanished idyll of peace and harmony.

Only a year or two later, Lilly Martin Spencer (1822–1902) painted
Home of the Red, White, and Blue (Fig. 4), which like Johnson's painting
(but with a different set of questions) is a reflection on the unsettled
postwar social landscape. Born in England but raised and trained in Ohio,
Spencer moved to New York in 1848 in order to advance her career. A
rarity in a heavily male-dominated field, she was the family breadwinner,
specializing in comic and sentimental images of the domestic realm and
its inhabitants: mothers, children, servants. In *Home of the Red, White, and
Blue*, however, the women are not darning socks or baking pies.

In the center of Spencer's busy composition stands a mother (a self-
portrait) in lacy white flanked by her two daughters, the elder in rosy red,
the younger in rich blue. The three form a strong, brilliantly lit triangle.
Behind them is a placid grandmother in paler shades of the same color
triad, and on the far right is a female servant holding an infant decked out
in patriotic ribbons. At the far left, a grandfather enjoys a dish of berries,

while the *paterfamilias*, a crippled Union veteran, sits in the shade with crutches propped against his chair. Finally, an Italian organ grinder has just arrived, accompanied by a little barefoot girl with a tambourine. As the organ grinder's monkey begs, the younger daughter, holding a coin, shrinks back against her mother's skirts, while her distracted little brother offers the unkempt stranger a glass of milk.

The adult women in the center all wear golden thimbles on their middle fingers, the mother's pointing directly down toward an American flag at the bottom edge of the composition. The flag lies in two pieces: stripes in a rumpled heap, starry field reposing on a regal purple footstool. Closest to the picture plane is a sewing basket filled with thread, scissors, a pin cushion, and loops of golden, tasseled braid. The message is unambiguous: women, and not men, will stitch up the wounds of war and mend the nation's fractured union.

In suggesting that women would play a vital role in healing the country, Spencer's painting celebrates a newfound agency. During the Civil War, the boundaries between home and the outside world steadily fell away as women by necessity took the places of the men who had gone to battle, hundreds of thousands of them never to return alive.[11] Women sewed flags, made shirts, rolled bandages, worked in government arsenals, ran family

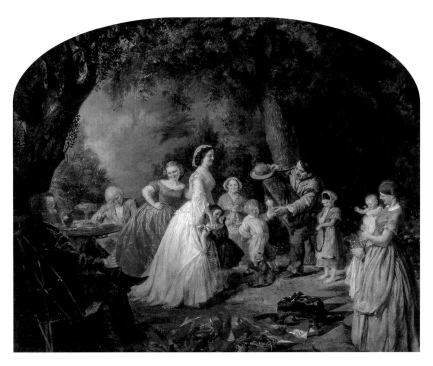

4 **Lilly Martin Spencer (1822–1902)**, *The Home of the Red, White, and Blue*, c. 1867–68. Oil on canvas, 24 × 30 in. (61 × 76.2 cm), 2007.1

farms, filled bureaucratic positions, nursed the wounded, oversaw the great sanitary fairs that raised money to improve conditions for Union troops, and even disguised themselves as men so that they, too, could be soldiers.[12] Working-class urban women had long labored outside the home, but now their middle-class sisters joined the ranks of the employed, fueling feminist hopes that women's voting rights and full participation in public life would soon follow. Sidelined, the men in *Home of the Red, White, and Blue*—one elderly, one maimed—have only bit parts to play in the new order.

Spencer's women are ready to take on the world. But the world has already come to them in the form of the Italian organ grinder and his little crew. How have these shabby figures wandered into this sheltered middle-class garden? During the postwar years, the increasing flow of impoverished Italian immigrants into the United States had become a major source of alarm. Poorly educated tenement-dwellers, many of them begged for money by playing their barrel organs or violins on the street. To the native-born, they appeared shiftless and threatening. Just as Johnson's black fiddler—on his way somewhere else—is clearly not at home in the rustic northern farmer's kitchen, Spencer's itinerants do not fit in. Are they welcome in the land of the red, white, and blue, or, as indigent aliens, do they represent a danger to the fragile stability of post-war America? Spencer does not say, and indeed, nothing in the picture is resolved. The flag lies in two pieces; women, for all their symbolic agency, are still confined to the domestic realm. At once allegory and genre painting, *Home of the Red, White, and Blue* portrays a postwar landscape of change, where optimism and anxiety lie in uneasy balance.[13]

Before the war's end, genre painter William Sidney Mount produced his very first still life, *Fruit Piece: Apples on Tin Cups* (Fig. 5), and donated it to New York's 1864 Metropolitan Fair, a benefit for the United States Sanitary Commission's war relief effort. The composition consists of two vividly realistic apples, solid and shiny, atop a pair of upended tin cups. Other than a small spray of green leaves to the left, there is nothing else in the dark and indeterminate space where the objects rest. Elemental in its simplicity, Mount's painting is a departure from conventional American still lifes of the day, typically cornucopian extravaganzas of heaped and cascading fruits and flowers in fancy porcelain bowls or silver compotes—luxury artifacts intended for the dining rooms of the well-to-do. Mount's imagery, by contrast, is so simple and humble that it might be more at home in the office of some regimental quartermaster. Yet it is rich in symbolism.

In the nineteenth century, particularly in the North, the apple was ubiquitous and so abundant that Ralph Waldo Emerson (1803–1882) dubbed it "our national fruit."[14] As art historian Diane Dillon has written,

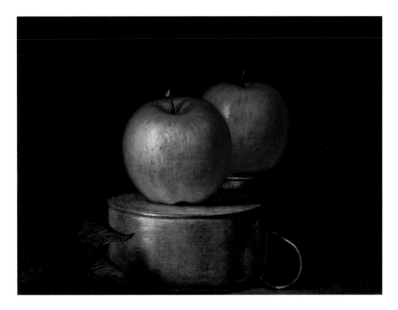

5 **William Sidney Mount (1807–1868),** *Fruit Piece: Apples on Tin Cups,* **1864**.
Oil on academy board, 6 ½ × 9 ¹⁄₁₆ in. (16.5 × 23 cm), 1999.100

Yankee soldiers longingly associated the apple with home; sometimes they even made mock apple pies in their army-issue tin dippers, like those on which the two pieces of fruit repose in Mount's painting. The austerity of Mount's design serves as metaphor for the austerity of life in the field and at the front, where rations were at best meager. The fingernail impression in the foremost apple and the wear on the cups' surfaces are human imprints that stand in as surrogates for absent soldiers, who, like the apples, were "plucked in their prime and shipped out."[15] The apples— long associated in Christian cultures with Adam, Eve, and the legend of the Fall—suggest something else too about ordinary soldiers' wartime lives. Like the unlucky pair who first ate from the tree of knowledge of good and evil, the unseen soldiers have fallen from innocence into dire experience.

The trauma of the war—that incalculably dire experience—prompted a retreat in American culture into dreams of lost youth and innocence reborn. Many artists catered to such longings by manufacturing wistful images of rural life in an idealized antebellum past. One of the most successful of these was John George Brown (1831–1913), whose immensely popular scenes of charming country children found an eager and receptive audience in the 1870s. Born in England, Brown immigrated to New York in 1853 and studied at the National Academy of Design. Taking a cue from American Pre-Raphaelites such as Thomas Charles Farrer (1838–1891), he perfected a highly naturalistic manner that gave vivid life to his wholesome rustic idylls.

The Cider Mill (Fig. 6) well represents Brown's winning style. In it, we see five little girls in an orchard. Each one is about to take a big bite out of a freshly picked apple. More apples lie in their laps, in a basket, strewn thickly on the ground. Dappled with spots of sunlight, the girls wear colorful stockings, short dresses, and pinafores. They sit perched on a sled that has been raised onto a board platform slung across a couple of sawhorses. Behind them stand several large barrels, and beyond is a stand of corn, brilliant yellow-green in the light.

The girls seem to embody the sweetness and light of childhood innocence. Yet given the subject—"little Eves in an abundant Paradise," as scholar Martha Hoppin puts it—there may be a sly subtext here.[16] Five little Eves certainly promise more trouble than just one, and a literal fall might actually be imminent, given the combined weight of five solid little bodies, plus the heavy sled, supported only by those flimsy-looking boards. Then there are the barrels, presumably for storing the cider from the unseen mill. Consumed by adults and children alike in the earlier nineteenth century, cider was mildly alcoholic. Predictably, the drink became a target

6 **John George Brown (1831–1913), *The Cider Mill*, 1880.**
Oil on canvas, 30 × 24 in. (76.2 × 61 cm), Terra Foundation for American Art, Daniel J. Terra Collection, 1992.19

7 **Winslow Homer (1836–1910),** *Apple Picking*, **1878**. Watercolor and gouache on paper, laid down on board, 7 × 8 ⅜ in. (17.8 × 21.3 cm), 1992.7

for the reformist temperance movement that gathered a new head of steam in the postwar decades.[17] Brown's girls are eating apples, not tugging from a jug. But they are self-absorbed, self-indulgent, unsupervised. What will happen when they grow up? Will they become proper wives, or independent and therefore threatening women? Underneath the sunny surface lurks a hint, perhaps, of anxiety.

Winslow Homer (1836–1910) also took up rustic subjects in the 1870s. A Bostonian who started out as an illustrator, Homer had been an artist-reporter during the Civil War. In the late 1860s and early 1870s, he turned to modern American life and modern American women, as in *Croquet Scene* (1866, Art Institute of Chicago), which depicts two stylish young women and a young man playing the newly popular game. But by the middle of the seventies, Homer had begun a steady retreat from present-day fashion, turning instead to pastoral imagery far removed from the excess, corruption, violence, and extreme social inequities that marked and marred America's Gilded Age. *Apple Picking* (Fig. 7) is one of some thirty drawings and watercolors that Homer produced in the summer of 1878, working in the open air at his friend Lawson Valentine's Houghton Farm near Mountainville, New York. It incorporates the same basic

elements as Brown's *Cider Mill*—fresh young country girls, a basket, an orchard, brilliant color and light—but as means to a very different end.

Two children stand arm in arm in full sunlight that bounces off their sunbonnets and jackets with almost blinding intensity. Before them is a band of deep green shade; behind, in duskier greens, the orchard. Above the figures dangle branches loaded with crimson fruit; red accents also dot the girls' garments and the trees further back. There is no overt commentary here, no symbolism, story, allegory, moral, or sentiment. Homer treats the two girls as dispassionately as he does the grass or the trees. The passion in the painting is funneled into the artist's act of looking, the process of transcribing visual sensations into washes, streaks, dabs, and lines of vibrantly contrasting, luminous hues. Anything not painted in the open air, Homer declared, was simply and palpably false.[18]

Brown's *Cider Mill* postdates Homer's *Apple Picking* by a couple of years. Brown may well have looked to Homer for inspiration: the two were friendly acquaintances and had studios in the same building on Tenth Street in New York City. In *The Cider Mill*, Brown backlit his figures just as Homer did, and he used the same device of down-ward-dangling apple branches. But where Brown looked backward, to the established conventions of genre painting—that is, ordinary people going about their daily lives in an unchanging social order—Homer moved beyond them, his art developing more and more into a record of the artist's unique and original vision. Even though he broke the mold, Homer capitalized nonetheless on the old dream of American country charm and its intrinsic goodness. His children, wrote one critic in the 1870s, were "wholesome, hearty, and artless youngsters" reveling in "the freedom of their out-of-door existence."[19] At one with nature, they would never change, never grow up, never leave home, never vote. In an anxious age of relentless social turmoil and progress—then and now—what could be more appealing?

William Sidney Mount (1807–1868)
The Trap Sprung, 1844

> Oil on panel, 12 ⅞ × 17 ⅟₁₆ in. (32.7 × 43.3 cm),
> Terra Foundation for American Art, Daniel J.
> Terra Collection, 1992.52

William Sidney Mount, whose subjects were almost exclusively rural scenes and portraits, is considered America's first major genre painter. His *The Trap Sprung* shows two boys—one wearing a torn, shabby jacket and the other a thick, velvet-trimmed coat—approaching a closed animal trap. The well-dressed boy carries a rabbit caught in another trap. Commissioned by the Philadelphia book publisher E. L. Carey, the painting was reproduced as an engraving in a popular periodical; it illustrated a short story about a country boy and a city boy searching for a pet rabbit for a disabled girl. Underlying that narrative, however, was a veiled message: Mount's painting was created a few years after the Panic of 1837, when the conservative Whig Party, symbolized by the rabbit, blamed the opposing Democrats for the nation's economic troubles in order to "trap" voters for their cause. *The Trap Sprung* was thus understood as an image of rural life with political resonance.

William Sidney Mount (1807–1868)
Fruit Piece: Apples on Tin Cups, 1864

> Oil on academy board, 6 ½ × 9 ¹⁄₁₆ in. (16.5 × 23 cm),
> Terra Foundation for American Art, Daniel J. Terra
> Collection, 1999.100

Rejecting a European-based affinity for grand historical scenes, the New York artist William Sydney Mount painted subjects drawn from everyday life that often carried veiled political messages. *Fruit Piece: Apples on Tin Cups*, one of his very few still lifes, illustrates this approach. The apparent simplicity of the composition—two ripe apples, set on a pair of overturned cups— belies a complex symbolic discourse concerning the American Civil War (1861–65). The humble tin cup, part of a Union soldier's equipment, represents the army, while the apple, a fruit so associated with America's northern colonies that it became a national emblem, stands for the United States. By juxtaposing these objects, the artist suggests that Union forces literally support the country. Mount's seemingly mundane subject delivers a compelling political message and addresses the larger theme of national identity and allegiance.

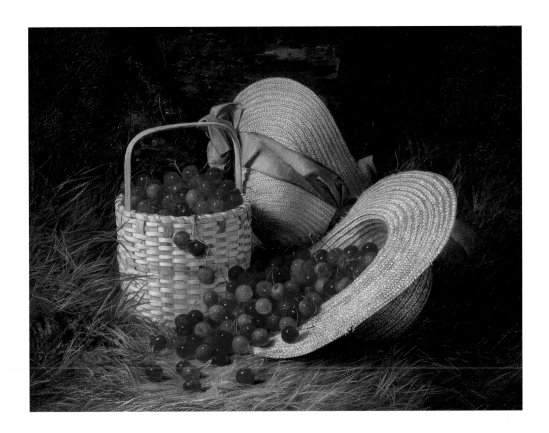

Robert Spear Dunning (1829–1905)
Harvest of Cherries, 1866

> Oil on canvas, 20 × 26 ½ in. (50.8 × 67.3 cm),
> Terra Foundation for American Art, Daniel J.
> Terra Collection, 1999.48

A founder of the Fall River school of still-life painting, based in his home state of Massachusetts, Robert Spear Dunning produced illusionistic works that carried forward a tradition from the pre–Civil War period. *Harvest of Cherries*, one of his earliest still-lifes, depicts an abundance of the shiny red fruit spilling from a basket and a man's straw hat set juxtaposed with an overturned woman's bonnet. The painting evokes a moment of carefree leisure with overtones of courtship. In its precise rendering of natural forms and textures, it is reminiscent of both seventeenth-century Dutch art and nineteenth-century British Pre-Raphaelite art. Here, however, the sensual appeal of the subject is countered by a moralizing reflection on people. The slight tears in the brim of the man's hat contrast with the flawless cherries—traditionally associated with virtue—as if to emphasize human shortcomings compared to nature's perfection.

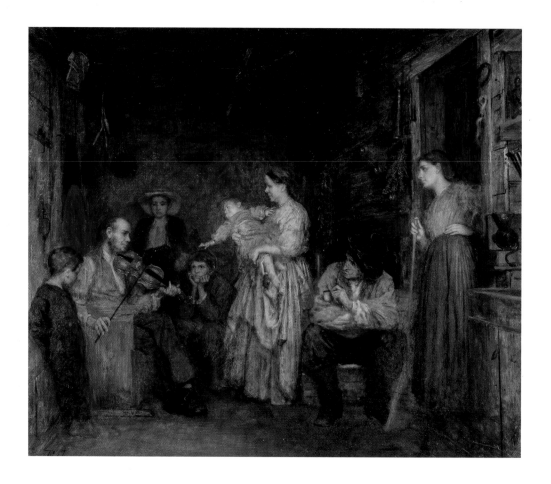

Eastman Johnson (1824–1906)
Fiddling His Way, c. 1866

Oil on artist's board, 20 ⅞ × 24 ⅞ in. (53 × 63.2 cm),
Terra Foundation for American Art, Daniel J. Terra
Art Acquisition Endowment Fund, 1999.8

Eastman Johnson's genre subjects range from scenes of genteel leisure in the comfortable homes of bourgeois city dwellers to traditional rural pursuits such as communal harvests and husking bees. *Fiddling His Way* depicts an itinerant musician entertaining a family in a dim rustic interior. Johnson drew on firsthand studies of Dutch seventeenth-century masters and his training under the French painter Thomas Couture (1815–1879) to render objects and figures emerging with indefinite contours from shadowy, confined spaces. One of two works with this title painted in the same year, *Fiddling His Way* differs from the larger version, in the Chrysler Museum of Art, Norfolk, Virginia, in several respects; most notably, the figure of the fiddler in the latter iteration is an African American. Scholars have suggested that the Terra Foundation's work might have been the study for the Chrysler Museum's painting.

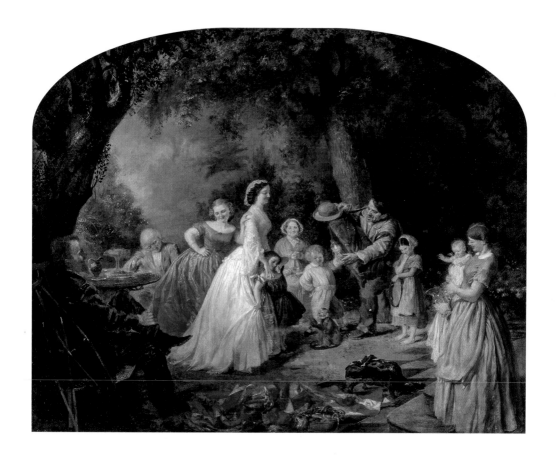

Lilly Martin Spencer (1822–1902)
The Home of the Red, White, and Blue,
c. 1867–68

> Oil on canvas, 24 × 30 in. (61 × 76.2 cm),
> Terra Foundation for American Art, Daniel J.
> Terra Art Acquisition Endowment Fund, 2007.1

One of America's leading genre painters, Lilly Martin Spencer created images of middle-class domesticity that address shifting gender roles in nineteenth-century society. She couched *Home of the Red, White, and Blue*, an allegory of the state of the nation following the American Civil War (1861–65), in a benign scene of outdoor family recreation. The composition focuses on the three central female figures—Spencer, dressed in white, and two of her daughters—as they enjoy the antics of an organ grinder and his monkey. Relegated to the periphery are elderly family members, a nursemaid and baby, and a wounded Union Army veteran. Spencer and her teenage daughter wear thimbles on their fingers; they have been interrupted from their task of stitching together a battered American flag, a symbol of the physical and psychic devastation the war had wrought. The painting suggests that the future of a nation ravaged by conflict lies in the capable hands of women.

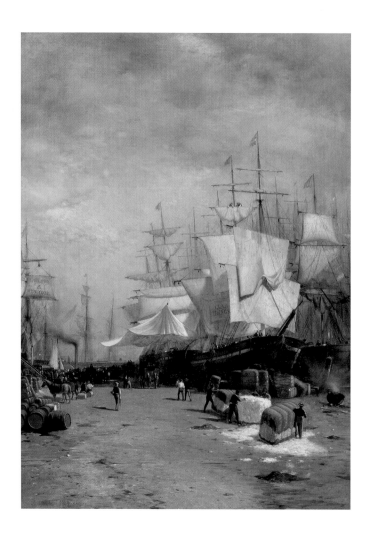

Samuel Colman Jr. (1832–1920)
Ships Unloading, New York, 1868

> Oil on canvas mounted on board, 41 5/16 × 29 15/16 in.
> (105 × 76 cm), Terra Foundation for American Art,
> Daniel J. Terra Collection, 1984.4

During the 1860s, the landscape painter Samuel Colman Jr. demonstrated a particular talent for painting vessels along the Hudson River in New York. This image focuses on the packet-boat cargo ship *Glad Tidings* (seen at center), which transported cotton from the United States to Britain from 1856 to 1874. The work may have been commissioned to commemorate transfer of the ship's ownership from William Nelson to his son, William Nelson Jr., in 1868. It combines Colman's interest in maritime scenes with characteristics of his early manner, which are indebted to the Hudson River school for their exacting details and broad vistas. A study in contrasts, Colman's view of the bustling wharf pairs vessels powered by sail and steam. The juxtaposition of oil barrels at left with large bales of cotton on the right memorializes the once-thriving enterprise of cotton production that soon would be supplanted by new commodities such as petroleum.

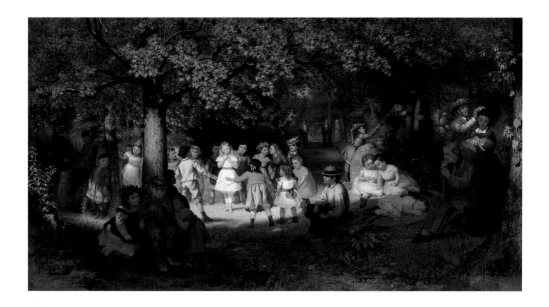

John George Brown (1831–1913)
Picnic Party in the Woods, 1872

Oil on canvas, 24 ⁵⁄₁₆ × 44 in. (61.8 × 111.8 cm),
Terra Foundation for American Art, Daniel J.
Terra Collection, 1994.1

Devoting his long and productive career to depictions of American children in both rural and urban environments, the British-born artist John George Brown made paintings replete with narrative and moral content. In *Picnic Party in the Woods*, several figures representing various ages are engaged in summertime leisure activities, a device Brown presents as an analogy of human life. Shown as in a theater production, they evoke the Shakespearian conceit of the world as a stage and its inhabitants advancing through the "seven ages" of man. At the center, a group illuminated by full sunshine is playing the popular Victorian game Oats, Peas, Beans, and Barley Grows. Influenced by the Pre-Raphaelites, who advocated exacting fidelity in representations of nature, Brown's detailed image of happy children also encourages a spirit of regeneration and unity following the American Civil War (1861–65).

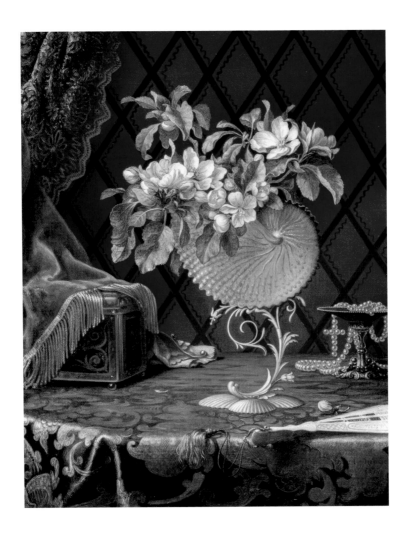

Martin Johnson Heade (1819–1904)
***Still Life with Apple Blossoms
in a Nautilus Shell***, 1870

Oil on canvas, 21 × 17 in. (53.3 × 43.2 cm),
Terra Foundation for American Art, Daniel J. Terra
Art Acquisition Endowment Fund, 1999.7

Known primarily for his American landscape
images, Martin Johnson Heade produced an
abundance of decorative still life and tropical-
flower paintings throughout his career. In *Still
Life with Apple Blossoms in a Nautilus Shell*, an
array of luxury objects surrounds a spray of apple
blossoms displayed in a large seashell vase.
The composition is characterized by contrasting
patterns that hint at its metaphorical content.
On the left, the rigid lines of a fancy box counter
the curving shapes and velvety textures of a
gold-fringed cloth. The string of pearls and ivory
fan at right accentuate the soft, luminous
texture of the damask fabric draping the table.
Subtly alluding to the growing material wealth
of the industrializing North, these contrasts
suggest the contradictions and conflicts underly-
ing American society during the Gilded Age.

Still lifes evidently meant a great deal to Martin Johnson Heade, as he painted some 300 of them—nearly half his oeuvre. The works appear at times obsessive, the artist returning repeatedly to the same motif with slight permutations, as is the case for his several dozen renditions of apple blossoms. These pale and evanescent flowers typically announce the spring season but also promise a transformation into autumn produce—a promise that goes unfulfilled in Heade's interior world, where the branches are prematurely cut from their trees before they bear fruit, and are transported into closed Victorian parlors.

Heade's interior still lifes are some of the strangest American paintings to emerge from the decades following the Civil War. Vibrant, domineering flowers loom awkwardly in stubby, undersized vases or impossibly attenuated, lacy vessels. Bulbous frosted jars glow murkily from within, contributing to the matte, muffled atmosphere suggested by the surrounding velvet drapes. Objects appear uncannily swollen, upsetting expectations of scale with their spatial incongruities. Light is changeable, sometimes harsh and direct as it pierces darkened interiors, sometimes more diffuse and caressing. A surfeit of patterns, textures, objects, and saturated colors often overwhelms the senses, creating murmuring and suggestive contrasts that compete for attention with the central bouquet. These plangent arrangements can seem anxious, too eerily perfect, pushed to some higher coefficient of materiality.

Still Life with Apple Blossoms in a Nautilus Shell is one of the most elaborate and insistent of these compositions, with its careful arrangement of luxury objects encircling the vase. Each surrounding element is tantalizingly cut off by the painting's edges, and in the case of the enameled casket, much of it is obscured by the thick blue cloth. The ivory fan teases similarly, its blades parted only enough to reveal a tiny portion of its colorful decoration. There is a perceived heaviness throughout, as surfaces are covered: the velvet over the box, the rich damask hiding the tabletop, the white lace curtain overlapping the diaper-patterned wallpaper, which in turn, conceals the wall itself. Lessons in gravity abound in the cascade of gilt fringe, the drape of the silk thread attached to the fan, or the catenary of the pearl necklace hanging from the lip of the tazza.

In contrast to these partially viewed, downwardly oriented items, the luminous glass and metal vase and its spray of apple blossoms expand to fill the available space, its burgeoning contour uninterrupted by any neighbor. Here there is movement and dynamism, with the slender tendrils of the base arcing in one direction (a single metallic bud gesturing toward its fallen organic sibling) and the growth rings of the nautilus countering that curve. The vase is ghostly and two-dimensional, but the leaves and blossoms unaccountably explode in three dimensions; it seems scarcely possible that they could sit within their flattened, delicate container. While the intimate objects of the lady's glove, necklace, and fan evoke the hand, neck, and face of an unseen human protagonist, in the end it is the hovering apple blossoms that truly animate the painting.

John Davis, *Provost and Under Secretary for Museums and Research*,
Smithsonian Institution, Washington, DC

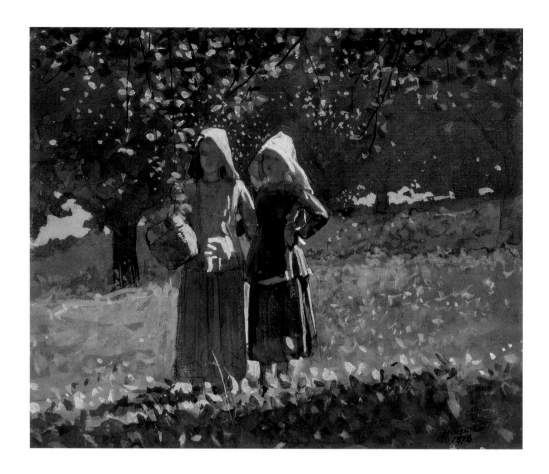

Winslow Homer (1836–1910)
Apple Picking, 1878

> Watercolor and gouache on paper, laid down
> on board, 7 × 8 ⅜ in. (17.8 × 21.3 cm), Terra
> Foundation for American Art, Daniel J. Terra
> Collection, 1992.7

The much-admired American painter Winslow
Homer used his art to document contemporary
outdoor life and explore people's physical and
emotional relationships to nature. He painted
Apple Picking at Houghton Farm in the Hudson
River Valley. The watercolor depicts two girls,
dressed in rustic clothes, posed together in a
sunlit apple orchard. The contrast between
bright sun and deep shadow on their attire
and their surroundings demonstrates the art-
ist's exceptional ability to convey the effects
of natural light. Devoid of sentimentality,
Homer's vision engages in the contemporary
fascination with childhood, a symbol of both
national regeneration and lost innocence in
the wake of the American Civil War (1861–
65). The scene lacks the carefree exuberance
of depictions of youth by other artists of that
period. Instead, these young apple pickers
gaze into the distance, looking precociously
wise and aware.

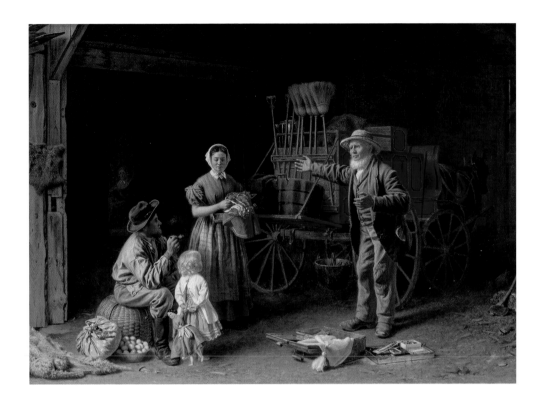

Thomas Waterman Wood (1823–1903)
The Yankee Pedlar, 1872

> Oil on canvas, 28 × 40 in. (71.1 × 101.6 cm),
> Terra Foundation for American Art, Daniel J.
> Terra Art Acquisition Endowment Fund, 1998.3

In his portraits and genre paintings, Thomas Waterman Wood combined realism and moralizing narrative to document American life during the mid- and late nineteenth century. *The Yankee Pedlar* presents a moment of negotiation between a persuasive peddler, who offers manufactured and luxury goods, and a cautious yet eager farm family, accustomed to the barter exchanges more typical of agrarian life. As a Vermont native, Wood was familiar with such transactions in the northeastern United States. His model for the Yankee peddler was a celebrated tin salesman known as "Snapping Tucker" from Calais, Vermont. Based on a veritable fixture in midcentury rural culture, Wood's peddler reflects a figure of the past for America's rising urban population. In an era of evolving, complex economic relations and competitive commercialism, the Yankee peddler personified ideals of thrift, hard work, and plain dealing associated with a simpler time and a vanishing way of life.

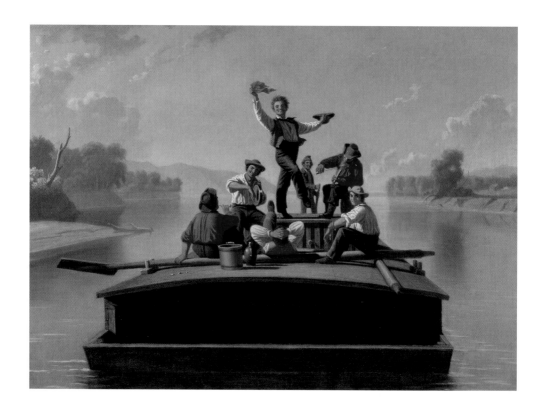

George Caleb Bingham (1811–1879)
The Jolly Flatboatmen, 1877–78

Oil on canvas, 26 ¹⁄₁₆ × 36 ³⁄₈ in. (66.2 × 92.4 cm),
Terra Foundation for American Art, Daniel J.
Terra Collection, 1992.15

Raised in Missouri, George Caleb Bingham
was one of the first American artists to hail
from the Western frontier and the first to
elevate the region's colorful character types to
the status of high-art subjects. Near the end of
his life he returned to one of his best-known
themes—river boatmen at leisure, the subject

of an 1846 painting that catapulted him to fame
(*The Jolly Flatboatmen*, National Gallery of Art,
Washington, DC). The Terra Foundation's picture
follows the earlier work in subject and compo-
sition, but here the artist suppressed several
details and dramatically altered the pose of the
dancer, who dominates the group. By 1877, such
a scene of river life could only be viewed nostal-
gically. Steamboats had long supplanted barges
and flatboats, the railroad had begun rendering
water transport obsolete, and the river hand was
a figure of the past. In this painting, Bingham
revisited the bygone times of his native region.

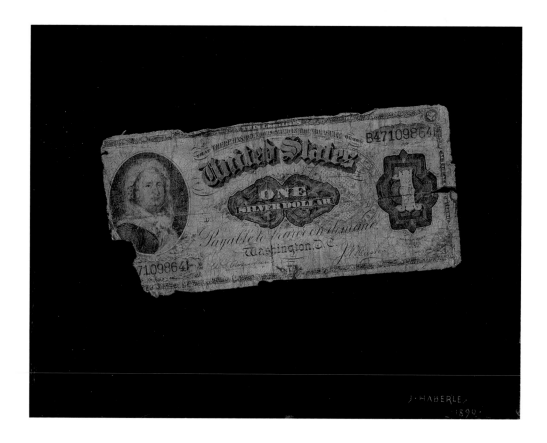

John Haberle (1853–1933)
One Dollar Bill, 1890

> Oil on canvas, 8 × 10 in. (20.3 × 25.4 cm),
> Terra Foundation for American Art, Daniel J.
> Terra Art Acquisition Endowment Fund, 2015.4

John Haberle, master of trompe l'oeil painting, was particularly well known for his still-life paintings of currency. His *One Dollar Bill* features a single silver-dollar certificate, first circulated in the 1870s as part of a shift away from the gold standard in American currency. Although banks initially were not required to honor these certificates—a compromise with those who supported gold—the bill featured in Haberle's detailed painting appears worn, suggesting frequent use. The first US Treasury–issued currency to display the image of a woman, the silver-dollar certificate featured an engraving after a 1796 portrait of Martha Washington. *One Dollar Bill* is a multifaceted visual pun that shifts from still life to celebrity portrait to reproduction of a famous painting, inviting viewers to consider the roles of wealth and artistic reproduction in nineteenth-century American visual culture.

Many art history books argue that Winslow Homer's rural genre scenes of young boys, painted in the years following the American Civil War (1861–65), are celebrations of youth and high spirits. During this period, 1865–76, images of boyhood symbolized the will to rebuild a stronger and more united nation, as well as the country's attempt to forget the recent conflict and forge a new future. One such painting, *Snap the Whip* (1872, Butler Institute of American Art, Youngstown, Ohio), depicts a group of children playing a game in a field in front of an old red schoolhouse, and has been perhaps Homer's most beloved image among the general public (although viewers outside the United States sometimes wonder why). It represents a view of a rural, racially homogeneous America that has become part of the nation's shared self-image. The boys at play in the painting embody an ideal of childhood innocence; their freedom, vigorousness, happiness, and sense of solidarity can be seen as the qualities of a young nation looking to the future.

Homer's renderings of boys do not always suggest such pure optimism, however. In *The Whittling Boy* (1873), he painted a quieter scene featuring a solitary boy absorbed in whittling with a knife in a wooded clearing. This painting reflects the nation's backward glance in the postwar decade. During this turbulent and confusing period, Americans felt anxious and disoriented, and developed a prevailing, antimodernist sentiment toward the increasingly complex, urbanized way of life that, especially in the North, was animated by technological innovation and rapid industrialization. Homer's carefree images of boys immersed in pleasurable pursuits indicated a longing for lost innocence and offered his viewers an escape from the harsh realities of contemporary life. Unlike the prospective and optimistic world he created in *Snap the Whip*, the calm, isolated realm of *The Whittling Boy* conveys nostalgia for the simpler, less worldly era before the war. It also denotes the nation's somber mood of reflection in its aftermath.

During the period of post–Civil War Reconstruction, these optimistic and nostalgic scenes of white boys also had implications in terms of race and gender. From 1874 to 1876, Homer painted a group of images of African Americans in the southern state of Virginia. While his earlier Civil War paintings utilized the racial stereotypes of the period without any political critique, his renderings of the 1870s turn such stereotypes into images of tacit social protest. *The Watermelon Boys* (1876, Cooper Hewitt, Smithsonian Design Museum, New York) presents a peaceful, rural scene of three boys—one white and two black—eating together in a field, an idyllic world in which the two races could coexist, if only as children. *The Cotton Pickers* (1876, Los Angeles County Museum of Art) hints at a darker side of rural America, depicting two African American girls gathering cotton bolls in a boundless field, much as they would have done before the end of slavery. The girl on the right gazes defiantly into the distance, perhaps an indication of high-minded aspirations that lie beyond the cotton field. Today's viewers might wonder whether she is looking at the same future as the white boys in those earlier paintings. In this context, *The Whittling Boy* may be seen as Homer's attempt to articulate his contemporaries' ambivalent feelings about America's future.

Go Kobayashi, *Professor*, Department of American and
British Cultural Studies, Kansai University, Osaka

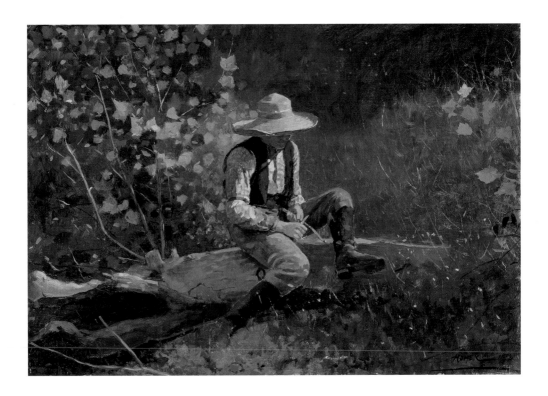

Winslow Homer (1836–1910)
The Whittling Boy, 1873

> Oil on canvas, 15 ¾ × 22 ¹¹/₁₆ in. (40 × 57.7 cm),
> Terra Foundation for American Art, Daniel J.
> Terra Collection, 1994.12

One of the most admired nineteenth- and early twentieth-century American artists, Winslow Homer captured scenes of contemporary outdoor life. After working as a commercial illustrator of battle scenes and camp life during the American Civil War (1861–65), he traveled extensively in the Northeast, depicting subjects ranging from coastal resorts to bucolic childhood pursuits. His paintings broke new ground in their naturalism and rejection of obvious narrative, and they revealed his exceptional command of natural light. *The Whittling Boy* presents an idyllic view of a lad seated on a log in a sun-dappled wooded clearing, absorbed in paring wood with a knife. The close-up image of a boy apparently unaware of the onlooker's presence suggests guileless self-absorption. Childhood innocence, a subject Homer addressed throughout the 1870s, was popular among his contemporaries, as Americans regarded rural life and provincial youth as nostalgic representations of a country that was less fraught before the war.

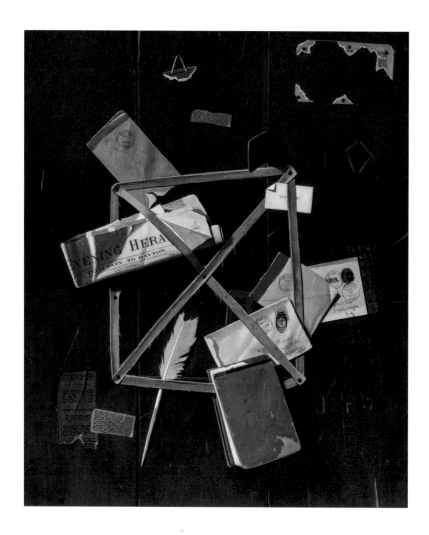

John Frederick Peto (1854–1907)
Old Time Letter Rack, 1894

Oil on canvas, 30 ⅛ × 25 ¼ in. (76.5 × 64.1 cm),
Terra Foundation for American Art, Daniel J. Terra
Art Acquisition Endowment Fund, 2015.5

A master of American trompe l'oeil painting
during the late nineteenth and early twentieth
centuries, John Frederick Peto is particularly
known for his letter-rack pictures—displays not
only of letters but also of newspaper clippings,
photographs, and other ephemera. The Terra
Foundation's work shows used objects strewn
across a simple rack made of taut, frayed strips
of fabric pinned to a wooden surface. Trompe
l'oeil paintings are often layered with wordplay,
visual puns, and narrative meaning, and Peto was
known for the subtle personal hints he inserted
into his works. The newspaper and letters, which
bear Ohio addresses and postage, reinforce an
autobiographical reading of the image. Peto
painted *Old Time Letter Rack* in 1894, the same
year he and his wife briefly relocated to her home
state of Ohio. He thus imbued this assemblage
with tantalizing bits of family history and the
significance of place.

Cosmopolitanism and the Gilded Age

Frances Fowle
Reader in History of Art, University of Edinburgh and
Senior Curator, Scottish National Gallery

Introduction

American painting of the late nineteenth century is well represented in the Terra Foundation holdings, a reflection of the popularity and availability of these artists when Daniel J. Terra began collecting in the 1970s. From precursors such as the landscape artist George Inness (1825–1894) to Frederick Carl Frieseke (1874–1939), leader of the last wave of American impressionism, these painters were united by their engagement with Europe, especially France. This was the era of impressionism, but unlike their French contemporaries, the American artists who practiced the "new art" were not initially part of a cohesive, identifiable group.[1] They rose to prominence in the late 1880s and 1890s, the period on which this essay will focus, but they did not join forces until 1898 when the Ten American Painters exhibited at Paul Durand-Ruel's New York gallery. This collective, organized by the painters J. Alden Weir (1852–1919), John Henry Twachtman (1853–1902), and Childe Hassam (1859–1935), had defected from the Society of American Artists, which itself had been formed in protest against the conservatism of the National Academy of Design. The canvases they exhibited illustrated the varied nature of American painting of the so-called Gilded Age: while Frank W. Benson (1862–1951), Thomas Wilmer Dewing (1851–1938), and Edmund C. Tarbell (1862–1938) leaned toward Whistlerian aestheticism, others such as Robert Reid (1862–1929), Hassam, and Twachtman embraced the brighter palette of impressionism and post-impressionism.[2]

Taken from an 1873 social satire by Mark Twain (1835–1910) and Charles Dudley Warner (1829–1900), the term "Gilded Age" has come to denote the period from the end of the American Civil War (1861–65) to the outbreak of the First World War (1914–1918).[3] It was a time of rapid economic growth, technological expansion, and industrialization in America, especially in areas such as mining, iron and steel, shipping and railroads. There were dramatic social changes as well, with large numbers of people moving from the country to the city, increased immigration, a rising middle class, a new awareness of women's rights, and the creation of superrich industrialists such as Cornelius Vanderbilt (1794–1877) and Andrew Carnegie (1835–1919).[4] America was prosperous and confident, sophisticated and outward looking.

Bubbling beneath this prosperous veneer, however, was an undercurrent of corruption and social unrest—this period witnessed the assassination of three presidents: Abraham Lincoln, James Garfield, and William McKinley. In this materialistic, post-Darwinian world, economic exchange became the primary focus. In the artistic sphere, aesthetic worth might be viewed as less important than commercial value.[5] Indeed, the second half of the nineteenth century saw the development of the modern art market in the United States, as well as in France, and the emergence not only of a new generation of collectors and middlemen—often artists—in cities such as Boston and New York, but of dealers such as Durand-Ruel, who brought impressionism to America in the 1880s.[6]

Gilded Age artists were united in their commitment to contemporary subjects, but to what extent did their work reflect the politics of their time, and its social and economic changes? Did they retreat to their summer havens and paint an idealized vision of America, far removed from contemporary reality—or did they succeed in creating a style of painting that reflected an evolving, modern nation? There is a tendency to dismiss American art of this period as picturesque and superficial, and its artists as derivative or second rank in relation to the French impressionists.[7] My aim here is to dispel this myth through close analysis of six works from the Terra Foundation collection in relation to three broad themes: the relationship of style and influence

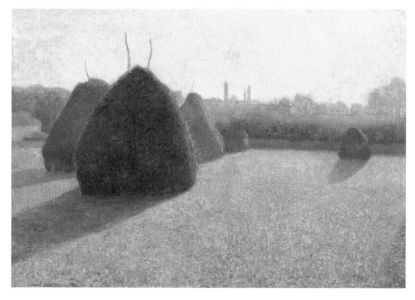

1 **John Leslie Breck (1860–1899),** *Morning Fog and Sun,* **1892**. Oil on canvas, 32 × 46 3/16 in. (81.3 × 117.3 cm), Terra Foundation for American Art, Daniel J. Terra Collection, 1999.19

between Claude Monet (1840–1926) and John Leslie Breck (1860–1899); the observation of social and technological change in paintings by Childe Hassam and William Merritt Chase (1849–1916); and modern women in the work of Edmund Tarbell and Mary Cassatt (1844–1926). As we shall see, American painting of this period was concerned not simply with, as one critic put it, "figures of gracious women and lovely children drenched in sweet sunlight,"[8] but only if one is prepared to look beneath the surface.

In 1892 the Bostonian artist John Leslie Breck completed one of his most mysterious and evocative canvases, *Morning Fog and Sun* (Fig. 1). The scene is a meadow in Giverny in Normandy, where several grainstacks are viewed through a hazy morning light. The sun casts long, colored shadows across the golden fields, while a soft mist rises in the distance. Like primitive monoliths, the mounds of grain draw us toward the light; they are placed off-center, leaving a vast area of foreground and creating a dreamlike, meditative atmosphere. This is enhanced by short strokes of complementary colors, which blend at a distance—a technique close to the neoimpressionism of artists such as Georges Seurat (1859–1891) and Paul Signac (1863–1935).

The picture's particular light effects and flattened, abstracted forms derive from one of the fifteen *Studies of an Autumn Day* (1891, Terra Foundation for American Art) that Breck completed the previous year.[9] This small panel, painted entirely out of doors, evokes the blanching, almost blinding sensation of morning sunlight. But whereas the small studies were painted in the Giverny fields over the course of three days, the larger painting was completed over a much longer period, and most likely from memory after Breck had left France. Both the studies and the larger painting pay homage to Monet's own series of grain stack paintings, which had enjoyed enormous commercial success at Durand-Ruel's Paris gallery in 1891. The extent to which Monet influenced the direction of Breck's work, however, deserves further exploration.

Since settling in Giverny in 1883, Monet had been exploring, and often struggling with, this motif, working on several canvases simultaneously and producing repeated images of one or two grain stacks viewed under different conditions of light and weather. Shortly after Breck paid his first visit to Giverny in 1887, Monet invited him to set up his easel in his garden, where the American began to experiment with broken brushwork and a brighter palette, producing a series of smallish canvases such as *Garden at Giverny (In Monet's Garden)* (c. 1887–91, see page 146).

It is worth comparing *Morning Fog and Sun* with Monet's *Haystack: Snow Effect* (Fig. 2) in order to assess their intentions. In both works,

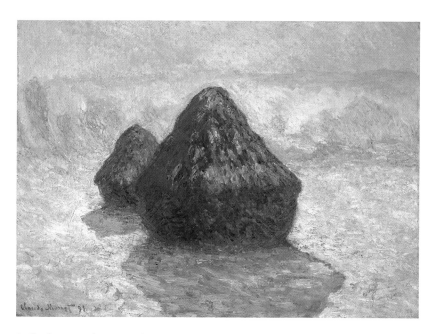

2 **Claude Monet (1840–1926),** *Haystacks: Snow Effect,* **1891**. Oil on canvas, 25 ½ × 36 in. (65 × 92 cm). Scottish National Gallery, bequest of Sir Alexander Maitland, 1965, NG 2283

background detail is suppressed, creating an otherworldly, suggestive quality, close to symbolist art.[10] Yet Breck's landscape is carefully painted and appears almost frozen in time, while Monet's brushstrokes are expressive and gestural, and his application of paint more varied, contrasting warm, sunlit areas with cooler blues and violets. Despite its apparent modernism, Breck's picture reflects his academic training, which had taught him to work toward carefully finished, large-scale works such as his *Autumn, Giverny (The New Moon)* (1889, Terra Foundation for American Art). This canvas has a similarly suggestive, neosymbolist undertone, which finds its source in the romanticism of Jean-François Millet (1814–1875), rather than Monet.

Breck's studies also differ from Monet's 1891 paintings in tone and technique. Monet painted quickly in order to express instantaneity—the transience of the moment—and, as he wrote, "above all the *enveloppe,* the same light diffused over everything,"[11] Breck was interested in carefully and prosaically recording the passage of the sun across the sky over the course of a day; he was responding, in his own way, to an aspect of the Giverny landscape that was painted by numerous members of the art colony there, among them Willard Metcalf (1858–1925), Theodore Wendel (1859–1932), Theodore Robinson (1852–1896), and Lilla Cabot Perry (1848–1933). Breck may have observed Monet closely and absorbed certain aspects of impressionist theory, but with

Morning Fog and Sun he was working toward an altogether more aesthetic and atmospheric end, intended for an American, rather than a French, audience.

In 1899 the picture was exhibited at the artist's memorial exhibition at the St. Botolph Club in Boston as *Haystacks at Giverny*, thus drawing attention to Monet and the village associated with his famous grain stacks series.[12] Breck's close relationship with the leader of impressionism was further underlined in the foreword to the exhibition catalogue, which noted that Monet had "distinguished Breck by appreciation and encouragement and afforded him unusual opportunities to paint with him in the fields."[13] More recently, art historians such as Derrick Cartwright have exaggerated this relationship, writing that "painters like Breck did not simply live in the village, they imitated Monet's technique and took on his favorite subjects."[14] In reality, neither Breck nor any of the other artists at Giverny were attempting to "imitate" the French master; on the contrary, they forged their own independent paths, while practicing a hybrid style of painting that combined differing tendencies, from naturalism to neoimpressionism.

Like Breck, fellow Bostonian Childe Hassam practiced an eclectic style that drew progressively on naturalism, impressionism, and postimpressionism. He always maintained that his most important influence was the Dutch artist Johan Barthold Jongkind (1819–1891), from whom he learned to lighten his palette, even before moving to France in 1886. While Breck was working near Monet at Giverny, Hassam was in Paris, preoccupied with his submission to the Paris salon of 1887, *Une Averse—rue Bonaparte* (Fig. 3). Painting in a naturalist style suitable for an official exhibition, Hassam nevertheless

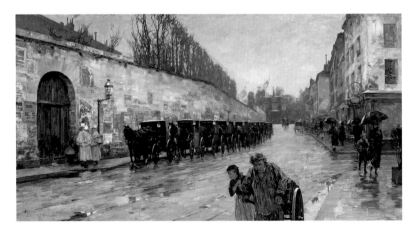

3 **Childe Hassam (1859–1935),** *Une Averse—rue Bonaparte,* **1887**. Oil on canvas, 40 ⅜ × 77 ⁷⁄₁₆ in. (102.6 × 196.7 cm), 1993.20

chose a contemporary urban subject—a corner of the city not far from the Luxembourg Garden, the periphery of which is just visible in the distance. The archetypal *flâneur*, he turned his back on the obvious tourist view—the magnificent façade of the church of St. Sulpice—and surveyed instead the full extent of the rain-soaked rue Bonaparte, with hansom cabs lined up along the wall of the seminary to the left, and hurrying pedestrians sheltering under black umbrellas on the right. The view recalls the artist's first essay as the "painter of streets," *Rainy Day, Boston* (1885, Toledo Museum of Art, Ohio).

As curator David Park Curry has noted, Hassam was interested in urban change, which he encountered all around him both in Boston and Paris.[15] In his view of the rue Bonaparte he further observes the disparity between rich and poor. The critic Theodore Child (1846–1892) compared Hassam to Giuseppe de Nittis (1846–1884), who painted the Parisian bourgeoisie,[16] but the addition of the peddler and his daughter brings him more in line with the social realism of French artist Jean-François Raffaëlli (1850–1924). Hassam uses these figures as a contrast to what he described as the "more fortunate wayfarers with umbrellas" and the cabdrivers, who are "better dressed."[17]

The Boston critic Susan Hale (1833–1910) made special note of "the high blank wall covered in posters of all tints."[18] Close observation reveals that at the top of the cab rank, to the right of the seminary door, is Jules Chéret's color lithograph for Alexandre Dumas's popular 1844 novel *Les Trois Mousquetaires* (*The Three Musketeers*), cleverly juxtaposed with three cab drivers standing underneath. To the left of the door, another poster announces an event in aid of "Les Inondés du Midi" (the flood victims of the Midi), perhaps a discreet reference to the rain-filled scene before us, but also a reminder of the severe flooding across the Var region of France in December 1886. Among the state-funded events organized in aid of the victims was an exhibition at the École des Beaux-Arts, 14 rue Bonaparte—that is, the other end of the same street.[19]

While *Une Averse—rue Bonaparte* is set in a historic part of Paris and is painted in a conventional naturalist style, it is nevertheless full of contemporary social detail. Hassam's *Commonwealth Avenue, Boston* (Fig. 4) is almost the opposite: situated in one of Boston's newest streets, it is painted with the light palette and fragmented brushstrokes of impressionism, yet was executed in New York, largely from memory, and is full of subtle historic references.

The view looks northeast toward the public garden adjacent to Boston Common, where a memorial to the American Civil War is just visible, while on the right the solid neo-Romanesque tower of the First Baptist Church, designed by Henry Hobson Richardson (1838–1886),

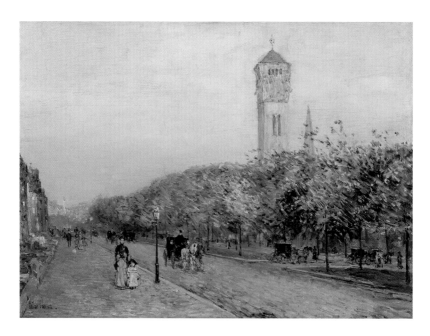

4 **Childe Hassam (1859–1935),** *Commonwealth Avenue, Boston,* **c. 1892.** Oil on canvas, 22 ¼ × 30 ¼ in. (56.5 × 76.8 cm), Terra Foundation for American Art, Daniel J. Terra Collection, 1992.39

has a position of prominence. This congregation had an important history in American race relations: it had welcomed nonwhite members from as early as 1772, ordained the first African-American pastor in Boston, and in 1889 began a Chinese Sunday school. Its new building, completed in 1871, was famous for its distinctive friezes, designed by the French sculptor Frédéric Auguste Bartholdi (1834–1904), best known for creating the Statue of Liberty. These included the likenesses of both President Abraham Lincoln (1809–1865) and Charles Sumner (1811–1874), leader of the antislavery movement in Massachusetts. These heroes look down on what was, in 1892, one of the most fashionable streets in Boston, indicated by the elegant town houses, carriages, and the promenading figures, there simply to be seen.

Hassam's painting also celebrates modern urban design, since Commonwealth Avenue was the first residential area of its kind to be built in America. The district, known as Back Bay, was developed on landfill in what had once been a marshy wasteland, and the street was constructed between 1861 and 1899, designed by the Boston architect Arthur Delevan Gilman (1821–1882).[20] The elegant townhouses, soon to be inhabited by the wealthy mercantile classes, were laid out on either side of a broad avenue, 240 feet wide, which was equipped with shady, tree-lined walkways, designed to promote health and well-being,

Fowle

and inspired by Baron Haussmann's transformation of Paris in the 1860s.[21] On the left of the composition the figures of a promenading woman and child signal to the viewer that this is now a safe, sanitized, and genteel area.

We find the same juxtaposition of bourgeois leisure and modern design in William Merritt Chase's *Morning at Breakwater, Shinnecock* (Fig. 5).[22] Shinnecock is an area on the South Fork of Long Island where in 1891 Chase was appointed by the art patron Janet Hoyt (1847–1925) to direct a new art school dedicated to plein-air painting. After the extension of the railroad from New York City to Sag Harbor in 1872, tourist resorts had begun to spring up all along the South Fork's southern shore. The painting shows a group of women and children—possibly including Chase's own family—playing on the beach at Shinnecock Bay, close to Chase's summer house, designed by his friend Stanford White (1853–1906) in 1892.[23]

Chase draws attention to the large man-made structures on the left: the breakwaters.[24] These not only guide us into the composition but offer a strong, masculine counterpoint to the soft, hastily sketched forms of the women and children on the right. Two breakwaters are visible, constructed from large pieces of granite, kept

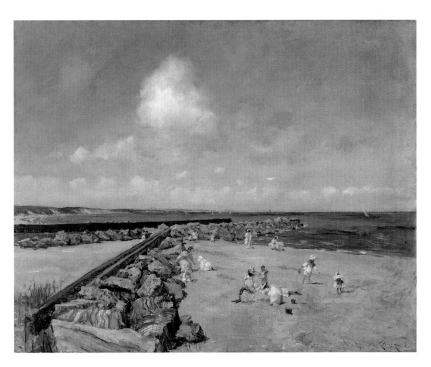

5 **William Merritt Chase (1849–1916),** *Morning at Breakwater, Shinnecock,* **c. 1897.** Oil on canvas, 40 × 50 in. (101.6 × 127 cm), 1999.30

in place by long wooden buffers. The bay's original channel to the Atlantic Ocean had silted up, and its water had become brackish and unsanitary; the breakwaters were part of an engineering project to reconnect Shinnecock to the ocean through a canal, completed in 1892.[25] Designed to prevent further movement of sand and to control the force of the waves, the breakwaters also created a sheltered area suitable for bathing. Chase shows no sign of anyone entering the water, suggesting that the water was still unsuitable for swimming.

The father of six daughters, Chase was supportive of his female students, declaring, "Genius has no sex."[26] The Massachusetts painter Edmund Tarbell, too, was surrounded by powerful women, as exemplified by his masterpiece, *In the Orchard* (Fig. 6), which shows family and friends relaxing in the French countryside. The self-assured woman on the left, with hand on hip, is the artist's sister-in-law, Lydia Souther Hatch. Seated opposite her is Lemira Eastman, a family friend, looking equally modern in her fashionable yet practical "rational" dress. On the far right, Tarbell's wife, Emeline, herself a trained artist, confronts the viewer with a direct gaze.

When the painting was exhibited at the New York Academy in 1892, a critic for the *New York Times* noted that the women were "of

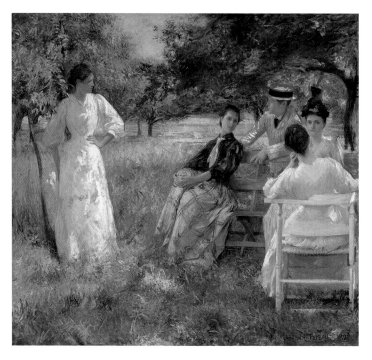

6 **Edmund C. Tarbell (1862–1938),** *In the Orchard,* **1891**. Oil on canvas, 60 ¾ × 65 ½ in. (154.3 × 166.4 cm), 1999.141

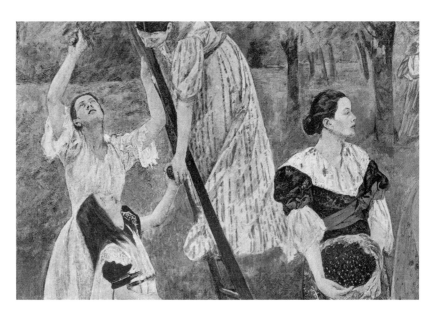

7 **Mary Cassatt (1845–1926),** *Modern Woman* **(detail), 1893**. Published in color in
William Walton, *World's Columbian Exposition 1893: Art and Architecture*, Vol. 1 (Philadelphia:
George Barrie, 1893). Ryerson and Burnham Libraries, Art Institute of Chicago

that sturdy type of girlhood often seen in Massachusetts; their ruddy
cheeks, the coarse paint on the bench, the colors of the sky and grass …
all very positive in hue."[27] One can detect a note of disapproval in the writ-
ing; to this critic, the painting's bright palette and lack of finish and finesse
were a reflection of its somewhat brazen subjects. The *Times* preferred
the Whistlerian elegance of Frank Benson's *By the Firelight* (1889, private
collection), which portrayed a slender young woman in black evening
dress, bathed in the soft, reflected glow of a fire. Tarbell's painting, by con-
trast, was decidedly contemporary and executed in the new, broadly
impressionist style, even making tacit reference to Renoir's *Luncheon of
the Boating Party* (1880–81, Phillips Collection, Washington, DC).

Though the painting's style and location was French, its subject was,
as another critic of the time noted, "purely American," reflecting a nation
that was, like these New England women, self-assured and outward look-
ing.[28] The same confidence and optimism infuses images such as Benson's
Summer (1909, Museum of Art, Rhode Island School of Design, Providence).
Here, a group of young women, hatless and bathed in sunshine, occupy
themselves in the open air, while the artist's daughter Eleanor stands
proudly erect, hand on hip, surveying the vast world that lies before her.

In 1892, the year after Tarbell produced *In the Orchard*, Mary Cassatt
began working on her mural decoration for the central court of the
Woman's Building of the 1893 World's Columbian Exposition in Chicago.

She had been commissioned to paint an allegory of "Modern Woman" (Fig. 7) as a foil to Mary MacMonnies's panel devoted to "Primitive Woman."[29] Cassatt, like Tarbell, chose to place her modern women in an orchard, but instead of conversing they are, according to Cassatt, "plucking the fruits of knowledge or science."[30] Tarbell gives us women of leisure, while Cassatt offers active, working women, eager to improve their minds. On the other hand, while Tarbell's models are dressed in the latest rational wear, Cassatt's are dressed in decorative but impractical gowns fashioned from delicate fabrics such as silk and taffeta.

The following year Cassatt acquired her first property, the Château de Beaufresne, in the Oise region not far from Paris. Here, seated on the edge of a pond, she painted *Summertime* (Fig. 8), arranging her models to give the impression of a young girl and her older companion enjoying a boat ride. The woman is dressed in a cool pink long-sleeved dress and, unlike the women in Tarbell's and Benson's paintings, she wears a wide-brimmed hat and white fabric gloves—clothes designed to maintain a pale complexion. By contrast, the girl has only her hat to shield her from the sun. She is bare-shouldered and the strap of her skimpy white sun-dress has fallen down. There is no hint of eroticism, but the juxtaposition is deliberate and the inference drawn depends on the viewpoint of the spectator. A mother might criticize the woman for neglecting to protect her young charge from sunburn; while a nineteenth-century feminist might envy the younger girl's freedom: she is enjoying the summertime of life and is not yet obliged to follow the restrictive dress code imposed by adult society.

Like the women in Cassatt's mural, the models in *Summertime* seem also to be thirsting for knowledge, looking down into the water with empirical curiosity.[31] The cropping of the boat on the right hand side suggests the presence—or rather absence—of a male rower or punter: the women are free to float across the water, contemplating nature. Curator Judith Barter has compared the meditative quality of Cassatt's images of women and children in boats with the Asian concept of life as a voyage down an "ever-changing river."[32] Cassatt collected Japanese prints and had been inspired by the 1890 exhibition of Japanese art at the École des Beaux-Arts, encouraging her to experiment with the unu-su-al viewpoint and flattened space evident in *Summertime*.[33] Cassatt may also have been aware of Monet's paintings of his stepdaughters boating at Giverny, which adopt a similarly high viewpoint. On the whole, however, Cassatt, like Breck and the other American artists of their generation, distanced herself from Monet's impressionism, preferring, like Degas, to define herself as an independent artist.

Like their French contemporaries, Cassatt and her peers were aware of the social and economic changes around them, both in France

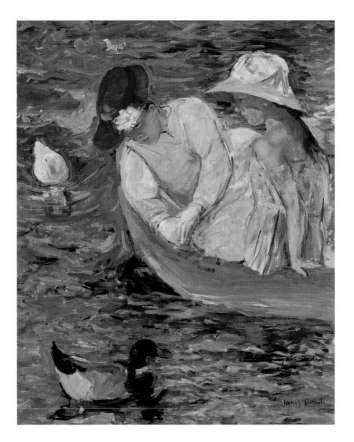

8 **Mary Cassatt (1845–1926),** *Summertime,* **1894**. Oil on canvas,
39 ⅝ × 32 in. (100.6 × 81.3 cm), 1988.25

and America, and this awareness is reflected in the figurative paintings
of Tarbell and Cassatt as much as in the landscapes of Hassam and Chase.
As these examples from the Terra Foundation reveal, American painting
of this period was not restricted to elegant women in white dresses bathed
in sunlight; beneath its charming surfaces lay a complex world of social,
historical, and technological change. In order to reflect this evolving
modern landscape, artists adopted and adapted a variety of new approaches
and techniques: the immediacy of realism, the broken brushwork of
impressionism, the decorative qualities of tonalism and *japonisme* and
even the prismatic palette of neoimpressionism. In the end, they devel-
oped a fusion of styles that epitomized the richness and diversity of
America's Gilded Age.

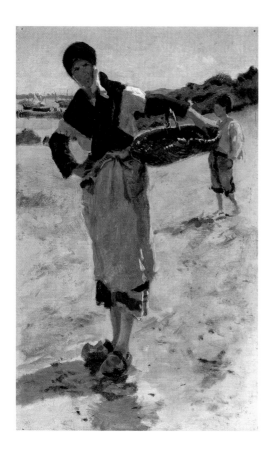 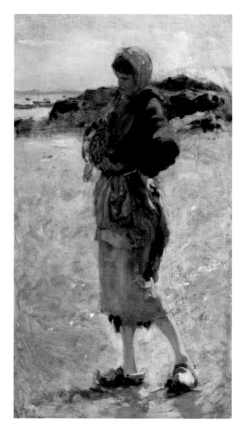

John Singer Sargent (1856–1925)
Breton Woman with a Basket, Study for
En route pour la pêche and ***Fishing for***
Oysters at Cancale, 1877

> Oil on canvas, 18 ½ × 11 ¾ in. (47 × 29.8 cm),
> Terra Foundation for American Art, Daniel J.
> Terra Collection, 1996.53

Girl on the Beach, Study for ***En route***
pour la pêche and ***Fishing for Oysters at***
Cancale, 1877

> Oil on canvas, 19 × 11 ½ in. (48.3 × 29.2 cm),
> Terra Foundation for American Art, Daniel J.
> Terra Collection, 1999.131

Young Boy on the Beach, Study for
En route pour la pêche and ***Fishing for***
Oysters at Cancale, 1877

> Oil on canvas, 17 ¼ × 10 ¼ in. (43.8 × 26 cm),
> Terra Foundation for American Art, Daniel J.
> Terra Collection, 1999.132

Breton Girl with a Basket, Study for
En route pour la pêche and ***Fishing for***
Oysters at Cancale, 1877

> Oil on canvas, 19 × 11 ½ in. (48.3 × 29.2 cm),
> Terra Foundation for American Art, Daniel J.
> Terra Collection, 1999.129

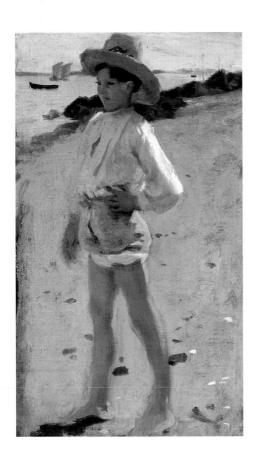

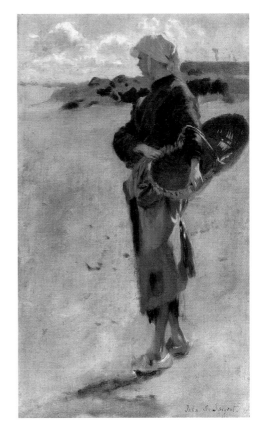

In 1877, early in his career, the American expatriate artist John Singer Sargent spent the summer painting in the picturesque Breton fishing town of Cancale. His intention was to make sketches for his first major outdoor subject, which would command attention in important exhibitions in France and the United States. To suit the different audiences, Sargent painted two slightly varied versions of the scene, one for Paris titled *En route pour la pêche* (*Setting Out to Fish*) (1878, National Gallery of Art, Washington, DC) and a smaller version called *Fishing for Oysters at Cancale* (1878, Museum of Fine Arts, Boston), which may have begun as a preparatory sketch for the larger work. Using fluid, animated brushwork, he painted these sketches of individual figures on-site and worked from them to create the two finished compositions in his studio. A contemporary interest in themes of peasant life, especially fisherfolk, determined his choice of subject.

While organizing the Corcoran Gallery of Art traveling exhibition *Sargent and the Sea* (2009–10), I had frequent opportunities to study these four small oil studies depicting Breton peasants along the shore of their village, Cancale. In particular I analyzed the paintings' relationship to two other oil studies and five pencil sketches as well as to Sargent's 1878 exhibition pictures, *En route pour la pêche* (*Setting Out to Fish*), then in the Corcoran Collection (Washington, DC) and now at the National Gallery of Art (Washington, DC), and the closely related *Fishing for Oysters at Cancale* (Museum of Fine Arts, Boston); both depict peasants preparing to fish on foot in the Bay of Mont St. Michel's tide pools.

Eight years on I set out to consider these same four oils, and, inescapably, the two completed works, from a different perspective. Why and how might these speak to viewers well over 100 years after they were painted? Does their impact on audiences today differ from that on observers in the 1870s? As the canny Sargent knew when he selected his subject for the painting now in Washington (which was intended for and accepted to the annual Paris Salon exhibition), the French welcomed nostalgic views. Weary from the dizzying changes—industrialization, urbanization, and economic growth—wrought during the Second Empire (1852–1870), exhibition-goers, critics, and collectors alike embraced romantic views of everyday life by artists such as Jules Breton (1827–1906) and the brothers Eugène Feyen (1815–1908) and Auguste Feyen-Perrin (1826–1888).

Nearly a century later, in his 1970 book, *Future Shock*, Alvin Toffler contended that the "Super-industrial Revolution" of technological change that swept through much of the world beginning in the late twentieth century had no parallel in human history. Albeit unrivaled, that revolution's societal repercussions echo those of its nineteenth-century antecedent. *Future Shock*'s opening words could describe either era: Toffler explained that his purpose was to explore "what happens to people when they are overwhelmed by . . . the roaring current of change, a current so powerful today that it overturns institutions, shifts our values and shrivels our roots."[1]

Toffler's aquatic metaphor in mind, I invite the reader to consider whether the contemporary appeal of these four figure studies may be, at least in part, a reaction to the present-day ubiquity of technology and the resulting "information overload" (a phrase popularized by Toffler). Like Sargent's contemporaries, many in today's frenetic society long for sensual escape and simplicity to counter the "roaring current of change." We have only to consider the wildly popular DIY, maker, buy local, and locavore movements; Etsy; or the revival and exponential growth since the 1980s of plein-air painting. Sargent's four paintings, handmade on site in the light and salt air of the seaside—the light made all the more extraordinary by the artist—conjure somatic reactions as well as daydreams and memories. Displaying Sargent's unerring gesture in their facture, the canvases offer visual comfort in the form of serenely posed peasants about to perform the marine equivalent of farm-to-table activity: gathering fish with their hands to cook for their dinner. Plus ça change.

Sarah Cash, *Associate Curator of American and British Paintings*,
National Gallery of Art, Washington, DC

James Abbott McNeill Whistler (1834–1903)
The Zattere: Harmony in Blue and Brown,
c. 1879

> Pastel, with traces of black chalk, on brown
> wove paper, 11 × 7⅝ in. (27.9 × 19.4 cm),
> Terra Foundation for American Art, Daniel J.
> Terra Collection, 1992.162

The American expatriate James Abbott McNeill Whistler was one of the nineteenth century's most influential, controversial, and experimental artists. He executed this work, considered one of his finest pastels, during a yearlong stay in Venice. It captures a view of the Fondamenta della Zattere, on the city's busy waterfront.

Positioned high above the passersby, Whistler worked on the image over time, but the economical rendering of the scene in sketchy black outlines, spare touches of color, and patches of negative space all give the impression of a fleeting moment. The high horizon and perspective testify to his passion for Japanese woodblock prints, from which he also absorbed an aesthetic of linear detail balanced with flat, open areas. The drawing's apparently unfinished state and seemingly random arrangement of colors demonstrate Whistler's iconoclastic ideal of art as the harmonious organization of color, line, shape, and texture—independent of imposed subject matter.

James Abbott McNeill Whistler (1834–1903)
Note in Red: The Siesta, by 1884

> Oil on panel, 8 ⁵⁄₁₆ × 12 in. (21.1 × 30.5 cm),
> Terra Foundation for American Art, Daniel J. Terra
> Collection, 1999.149

One of Whistler's distinctive innovations was his use of musical terms such as *harmony*, *nocturne*, and *note* in titles of his works. Its purpose was to evoke the "purity" of music, an art form then considered to be independent of narrative content. *Note in Red: The Siesta* portrays Maud (Mary) Franklin, the artist's model and mistress, lying on a red divan. Quickly and sketchily executed, her form, enveloped within a voluptuous dress that trails along the floor, suggests an unposed moment, a nap for the weary model. Whistler repeatedly returned to the theme of recumbent women and treated the subject in a thoroughly modern way. The apparent immediacy with which he painted Maud emphasizes his presence and their personal relationship. In its candid depiction of a private moment and its assertion of his persona and process, this work attests to Whistler's status as an early proponent of modernism.

Joseph H. Boston (1860–1954)
From Shore to Shore, 1885

Oil on canvas, 27⅝ × 35⅝ in. (70.2 × 90.5 cm),
Terra Foundation for American Art, Daniel J.
Terra Collection, 1999.13

Joseph H. Boston painted landscapes, genre scenes, and portraits. *From Shore to Shore* places the viewer in the saloon of a ferry whose passengers come from several social and economic backgrounds. This was one of many ferries that shuttled between Manhattan and Brooklyn, which was a separate municipality until its 1898 incorporation into New York City. As a resident of Brooklyn who participated in such Manhattan institutions as the National Academy of Design, the artist was quite familiar with the short trip across the East River. His focus on the cross section of passengers randomly gathered here evinces artists' growing interest in urban subjects during this period, when unprecedented population density and modern technologies gave rise to new spaces for social encounter, such as public-transit boats and parks.

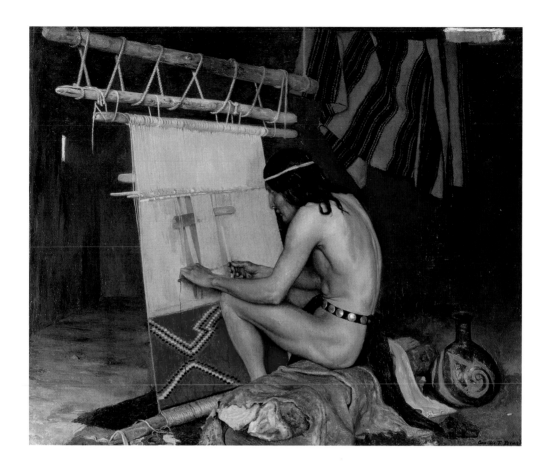

George de Forest Brush (1855–1941)
The Weaver, 1889

> Oil on canvas, 12 × 15 in. (30.5 × 38.1 cm),
> Terra Foundation for American Art, Daniel J.
> Terra Collection, 1988.23

George de Forest Brush studied in Paris with
the French academic painter Jean-Léon Gérôme
(1824–1904), who impressed upon the young
American the importance of an exacting tech-
nique, careful anatomical modeling, and the
pursuit of exotic subject matter. After returning
to the United States in 1880, Brush studied the
Arapahoe and Shoshone in Wyoming, the Crow

in Montana, the Sioux in the Dakotas, and the
Apache in Florida, sketching the tribe members
and collecting artifacts. Unconcerned with
ethnographical accuracy, Brush created roman-
ticized pastiches of Native American life. In *The
Weaver*, an indigenous man weaves a Navajo rug
on an upright loom in an earthen-walled setting
suggestive of Pueblo culture. Brush likely painted
this work in his New York studio, using as props
various objects from his collection. Brush's weaver
represents two purportedly "vanishing races":
the Native American and the craftsman, a rapidly
disappearing figure in late-nineteenth-century
America's increasingly industrialized workplace.

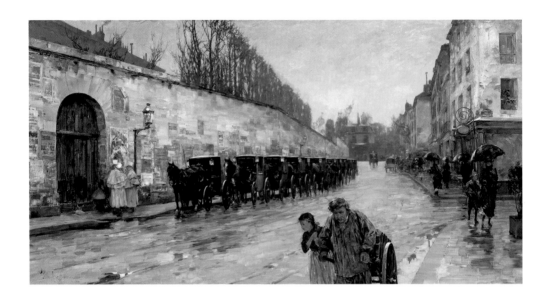

Childe Hassam (1859–1935)
Une Averse—rue Bonaparte, 1887

Oil on canvas, 40 ⅜ × 77 ⁷⁄₁₆ in. (102.6 × 196.7 cm),
Terra Foundation for American Art, Daniel J.
Terra Collection, 1993.20

Childe Hassam formulated a genteel, sensuous,
distinctly American interpretation of impression-
ism. In *Une Averse—rue Bonaparte*, he pictures
a rainy Parisian street as a byway for a complex
mix of urban dwellers: fashionable bourgeois
pedestrians under umbrellas, a toiling laborer
and his daughter, and liveried drivers chatting
as they await passengers for their black cabs
along the curb. The setting, with its bright but
overcast sky, pools of water on the pavement,
and sheen on black umbrellas and cab roofs,
contributes to the impression of a quotidian
Paris as experienced not by the foreign tourist
but by an ordinary resident. Hassam's first major
painting of Paris, created during his formative
1886–89 stay there and exhibited in the Paris
Salon in 1887, *Une Averse—rue Bonaparte* marks
an important advance in his portrayal of the
modern city as he came under the influence of
French impressionism.

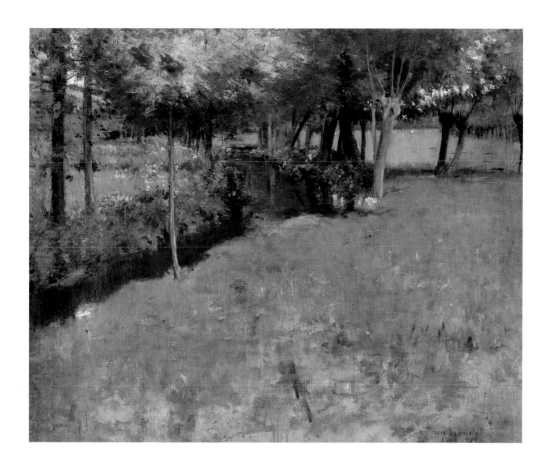

Theodore Wendel (1859–1932)
Brook, Giverny, 1887

Oil on canvas, 28 ½ × 35 ⅝ in. (72.4 × 90.5 cm),
Terra Foundation for American Art, Daniel J.
Terra Collection, 1987.13

Theodore Wendel studied with the influential teacher Frank Duveneck (1848–1919) in Cincinnati, Ohio, and traveled with fellow students throughout Europe in the early 1880s. Later, he was among the first group of visiting artists to spend time in the French village of Giverny, home of the master impressionist Claude Monet (1840–1926). The landscape paintings Wendel made during his two summers there are considered some of the earliest by an American artist to incorporate the hallmarks of impressionism. Here he depicts one of the many small streams feeding the lush meadows that surround the village. An expanse of green dominates the foreground, and the brook is an angular ribbon of darker green curving into the background, overshadowed by trees lining its banks. *Brook, Giverny* demonstrates a transition in Wendel's work away from the realism of his academic training and toward the gradual assimilation of a more spontaneous and immediate painting mode associated with impressionism.

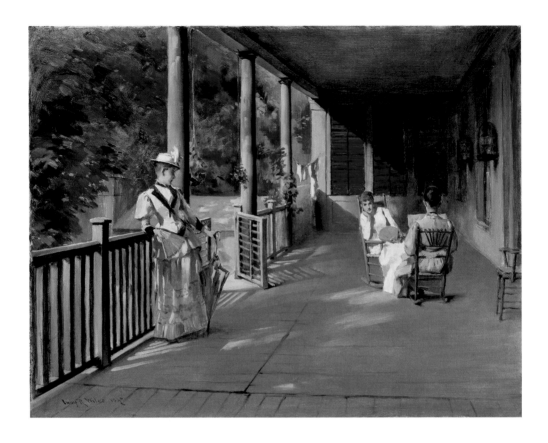

Irving Ramsey Wiles (1861–1948)
On the Veranda, 1887

> Oil on canvas, 20 ¼ × 26 ¼ in. (51.4 × 66.7 cm),
> Terra Foundation for American Art, Daniel J.
> Terra Collection, 1999.152

Best remembered for his fashionable portraits of women, Irving Ramsey Wiles produced works that captured the informal elegance character-istic of cosmopolitan American art at the turn of the twentieth century. In *On the Veranda*, three young women enjoy a summer afternoon on the wide, columned porch of a country home.

Two sit in a pool of afternoon sunlight; one of them seems lost in a pensive reverie. Hanging laundry in the background, mismatched chairs, and the open porch gate add touches of informality to the scene. A celebration of the pleasures and ease of everyday life, *On the Veranda* exemplifies an artistic interest in middle-class leisure during the decades following the American Civil War (1861–65). Picturing women in domestic settings as symbols of the peace and growing prosperity of America's Gilded Age, Wiles advances an idyllic vision of his country.

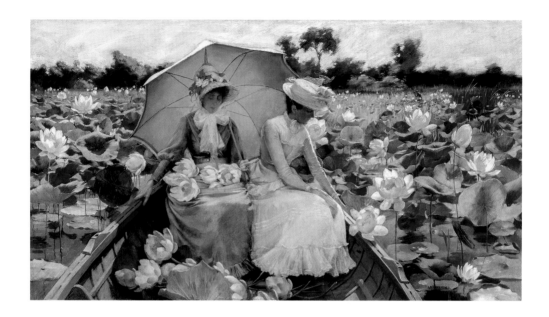

Charles Courtney Curran (1861–1942)
Lotus Lilies, 1888

Oil on canvas, 18 × 32 in. (45.7 × 81.3 cm),
Terra Foundation for American Art, Daniel J.
Terra Collection, 1999.35

Trained in both New York and Paris, Charles Courtney Curran was a prolific artist known for his idyllic paintings of young women. In *Lotus Lilies*, two women—Curran's new bride, Grace Winthrop Wickham, on the left, and her cousin Charlotte "Lottie" Adams Taylor, on the right—sit in a rowboat surrounded by lilies carpeting the surface of a lake. The women are protected from the glare of the summer sun by hats, diaphanous veils, and a large green parasol. The painting's foreshortened perspective positions the viewer in the boat. Although *Lotus Lilies* predates Curran's first trip to France in 1889, it demonstrates his awareness of the emerging aesthetic of impressionism. Like many Americans experimenting in the new mode, he tempered bold color and free brushwork with refined academic drawing. Shortly after Curran created this fond portrayal of his wife, the couple moved to Paris, where the painting won a medal in the Salon of 1890.

Dennis Miller Bunker (1861–1890)
Brittany Town Morning, Larmor, 1884

Oil on canvas, 14 × 22 in. (35.6 × 55.9 cm),
Terra Foundation for American Art, Daniel J.
Terra Collection, 1991.1

A promising painter who died young, Dennis Miller Bunker is known for his bucolic scenes bathed in the diffused light of northern France. He imbues the work here with an almost palpable sense of a Breton morning. The medieval church at the center of the composition rises from the compact architecture of the village. Monochromatic bands of sky accentuate the surrounding green fields, while the steep slate roofs of dark stone houses reflect the region's distinctive light. This interplay of contrasts demonstrates Bunker's interest in studying the effects of light as it strikes various surfaces. Despite the presence of a laundress in the foreground and of two minuscule figures beside the stone wall, the painting is less a narrative interpretation of the setting than a demonstration of the artist's attention to its singular atmosphere.

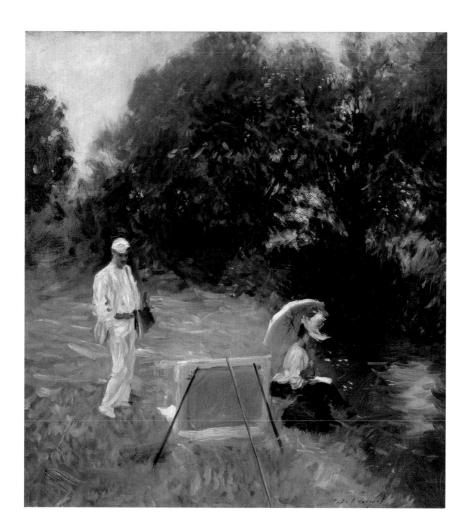

John Singer Sargent (1856–1925)
Dennis Miller Bunker Painting at Calcot, 1888

Oil on canvas mounted on Masonite, 27 × 25 ¼ in.
(68.6 × 64.1 cm), Terra Foundation for American
Art, Daniel J. Terra Collection, 1999.130

A widely traveled and cosmopolitan American
expatriate artist, John Singer Sargent lived and
worked in Paris for twelve years before moving
permanently to London in 1886. He made nota-
ble and extended visits to the United States, and
was one of the country's most popular painters
during the late nineteenth and early twentieth
centuries. *Dennis Miller Bunker Painting at Calcot*
depicts Sargent's close friend and fellow artist at
work in the countryside. Bunker's portable canvas
is positioned low, on the bank of a stream, where
Sargent's younger sister Violet is absorbed in
reading. Like other progressive American artists
influenced by the French impressionist Claude
Monet (1840–1926), Sargent and Bunker experi-
mented with painting outdoors, working directly
on the canvas to capture transient effects of natural
light and color. The dense vegetation of the river-
bank proved to be an ideal vehicle for the broken
brushwork and dappled light evident here.

William Merritt Chase's exquisite pastel *Spring Flowers (Peonies)*, created around 1889, is commanding in its size, its bold jewel-toned coloring, and its subject: an alluring female in a Japanese gown. Featured in the artist's 2016–17 retrospective, the four-by-four-foot pastel dazzled many visitors who mistook it for an oil painting.[1] The exhibition's curatorial team (myself, Katherine Bourguignon, Erica Hirshler, and Giovanna Ginex) was eager to shed light on Chase's daring experiments in pastel and to study their global context, exploring other novel approaches to the medium across the Atlantic.

One innovative practitioner who offered an inspiring example to Chase was the Italian painter Giuseppe de Nittis (1846–1884). Widely celebrated for his large-scale, luminous pastels, de Nittis was known for his profound interest in, and collection of, Japanese art. Chase too was swept up in the mania for Japan (*Japonisme*), which peaked in the 1880s after displays of Japanese art in the 1876 Philadelphia Centennial Exhibition and the 1878 Paris Universal Exposition. A cosmopolitan artist with a voracious appetite for diverse cultural traditions, Chase amassed an extraordinary collection of non-Western objects, including many Japanese prints and items of decorative art and clothing. Like de Nittis (see for example *Orange Kimono*, 1883–84, private collection) and other contemporaries such as James Abbott McNeill Whistler (1834–1903), Chase enjoyed dressing his models in Japanese costume. *Spring Flowers (Peonies)* is one of over 25 works he made between 1882 and 1908 featuring women in kimonos or Japanese-inspired gowns. The art of the esteemed Belgian painter and fellow collector Alfred Stevens (1823–1906) offered Chase other variations on the theme, including *The Japanese Robe* (c. 1872), a work that in 1887 entered the collection of the Metropolitan Museum of Art.

Less obvious but equally compelling sources for *Spring Flowers (Peonies)* are tied not to the figure but the flowers—the subject for which the picture is named. Chase has orchestrated a virtuosic performance of glistening strokes of white and pink in a shimmering brass pot—a veritable masterpiece. Among the compositional precedents are peony still lifes by the Japanese *ukiyo-e* print artists Hiroshige (1797–1858) and Hokusai (1760–1849) as well as those by their French admirers Édouard Manet (1832–1883) and Henri Fantin Latour (1836–1904).

Though Chase himself never traveled to Japan, many of his American friends enjoyed firsthand contact with Japanese culture that influenced the American view of Japan through widely circulated articles in illustrated art journals: in 1885, his former student Theodore Wores (1859–1939) was one of the first American artists to travel there; John La Farge (1835–1910) went the following year; and Robert Frederick Blum (1857–1903) made the journey in 1890.

By threading together the wide network that shaped Chase's interest in *Japonisme* we can gain a deeper understanding of its significance to his art. According to his biographer Katherine Roof, Chase's dying wish was to show his friend Irving Ramsey Wiles (1861–1948) a Japanese hanging recently received from his wife. The words of La Farge ring true: "a man's likings are his important self."[2]

Elsa Smithgall, *Curator,*
The Phillips Collection, Washington, DC

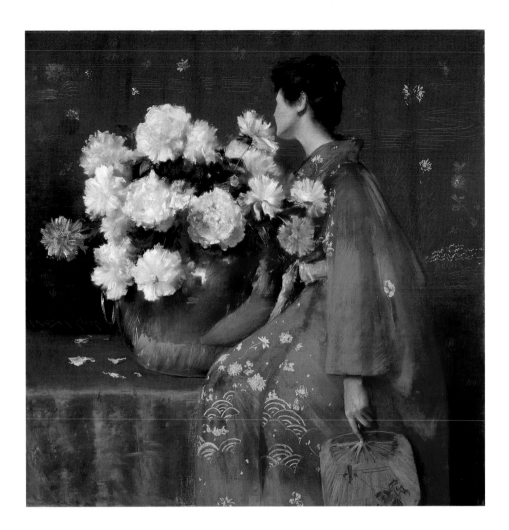

William Merritt Chase (1849–1916)
***Spring Flowers (Peonies)**, by 1889

> Pastel on paper, prepared with a tan ground, and
> wrapped with canvas around a wooden strainer,
> 48 × 48 in. (121.9 × 121.9 cm), Terra Foundation for
> American Art, Daniel J. Terra Collection, 1999.32

One of America's most influential artists and
teachers in the late nineteenth and early twenti-
eth centuries, William Merritt Chase embraced
new approaches to art-making, breaking ground
not only in oil painting but also in the use of
pastels. In this pastel, a woman holding an Asian
fan and wearing an orange dressing gown made

of Japanese fabric leans gracefully on a table
that supports a large pot of peonies in full
bloom. Highlighting the composition's formal
qualities, the light shade of the flowers con-
trasts with the flaming color of the dress, while
the tapestry hanging in the background offsets
the pot's glossy surface. The woman's face is
gracefully turned away from the viewer. *Spring
Flowers (Peonies)* conveys an ideal of purely
visual beauty that illustrates the influence of
Japanese aesthetics on Chase's work. An unusu-
ally large work for the delicate technique of
pastel, it demonstrates the artist's mastery of
the medium.

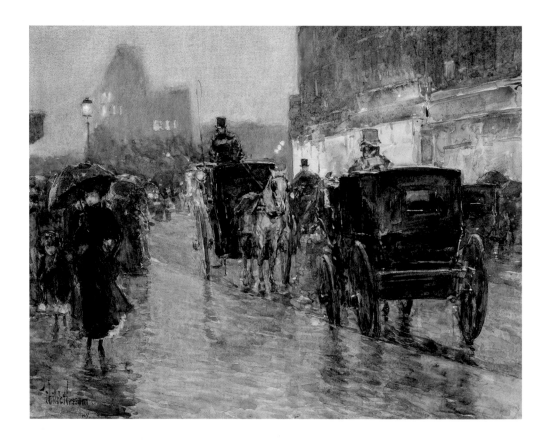

Childe Hassam (1859–1935)
Horse Drawn Cabs at Evening,
New York, c. 1890

Watercolor on paper, 14 × 17¾ in. (35.6 × 45.1 cm),
Terra Foundation for American Art, Daniel J. Terra
Collection, 1999.66

Childe Hassam, a preeminent American impressionist, pioneered the artistic portrayal of the modern American city and was one of the most critically and financially successful artists of his generation. *Horse Drawn Cabs at Evening, New York* is a view looking toward Madison Square in Manhattan. Hassam skillfully employed the fluid medium of watercolor to obscure recognizable landmarks, as if viewed through rain, and to explore the effects of light shimmering on wet pavement, the blurred movement of passersby under umbrellas, and cabs in the street. Urban street scenes became Hassam's specialty when he moved to New York in 1889 after a three-year sojourn in Paris. He was particularly drawn to the theme of cabs, and is said to have painted from the perch of a hansom, using the front seat as his easel. His broken, expressive brushwork and keen interest in the incessant flux of modern urban life signify his embrace of impressionism.

The experience of turn-of-the-century New York City was a subject as important to painters as it was to novelists, but where writers such as Theodore Dreiser (1871–1945) dug into the grittiness of urban lives, Childe Hassam absorbed its visual spectacle. Illustrations by Hassam and Hughson Hawley (1850–1936) for articles in *Scribner's* and *Harper's Weekly* documented the popular joy of promenading. As in Paris, this was an important social activity for New York's upper classes, who made themselves visible to others in spaces of leisure and amusement. Hassam, like a latter-day descendent of midcentury French *flâneurs*, used a hansom cab as a moving studio, inserting himself into the multitude while remaining invisible from the crowd. "There is nothing so interesting to me as people," Hassam remarked in an 1892 interview. "I am never tired of observing them in every-day life, as they hurry through the streets on business or saunter down the promenade on pleasure. Humanity in motion is a continual study to me."[1]

The watercolor *Horse Drawn Cabs at Evening, New York* (c. 1890) demonstrates Hassam's persistent interest in rainy scenes, which can also be seen in the paintings *Rainy Day, Boston* (1885, Toledo Museum of Art, Ohio) and *Cab Stand at Night, Madison Square, New York* (1891, Smith College Museum of Art, Northampton, Massachusetts). The faint light of the street lamp reflecting off the display window creates a shimmering reflection on the wet surface of the street. Hassam preferred specific weather conditions and settings that offered a view of the city unaffected by the class conflict and ethnic tensions prevalent in America's urban centers. To capture this moment, Hassam would have waited for the most picturesque groups of passersby to appear. Confined to a brief sketch rather than an overwhelming panoramic view, this work provided a visual parallel to critic and writer Mariana G. Van Rensselaer's (1851–1934) representation of the metropolis in her essay "Picturesque New York," published in *Century Magazine* in 1892.

During his long career, Hassam worked in both oils and watercolor, but the latter dominated his early output. Comparing the Terra Foundation watercolor with the oil sketches *April Showers, Champs Elysees, Paris* (1888, Joslyn Art Museum, Omaha, Nebraska) and *Cab Stand at Night, Madison Square, New York*, it is not difficult to see a subtle transition in Hassam's technique. In the watercolor it appears he was on the threshold of achieving an eclectic conglomerate of staccato dabs of impressionism, as well as the tonal harmony and flat patterning of James Abbott McNeill Whistler (1834–1903). Realist execution in Hassam's work gradually gave way to a more flattened and decorated way of painting through the dissolution of figure and form. As skyscrapers supplanted the genteel avenues of the nineteenth-century city, the horse-drawn cabs he depicted would soon be replaced by automobiles and the upward thrust of the skyline would soon forever alter New York's urban view.

Chen Yao, *Assistant Professor*,
Hefei University of Technology, China

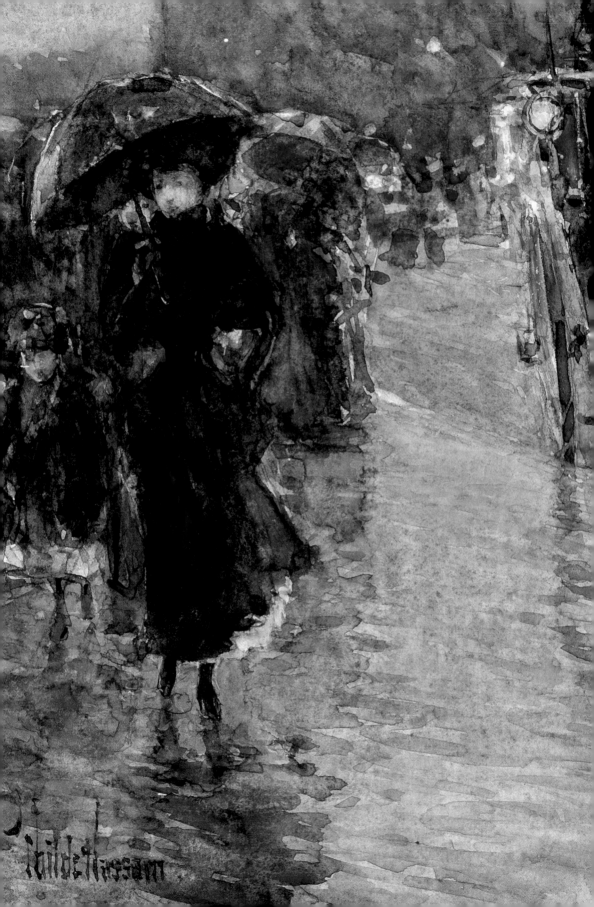
Childe Hassam

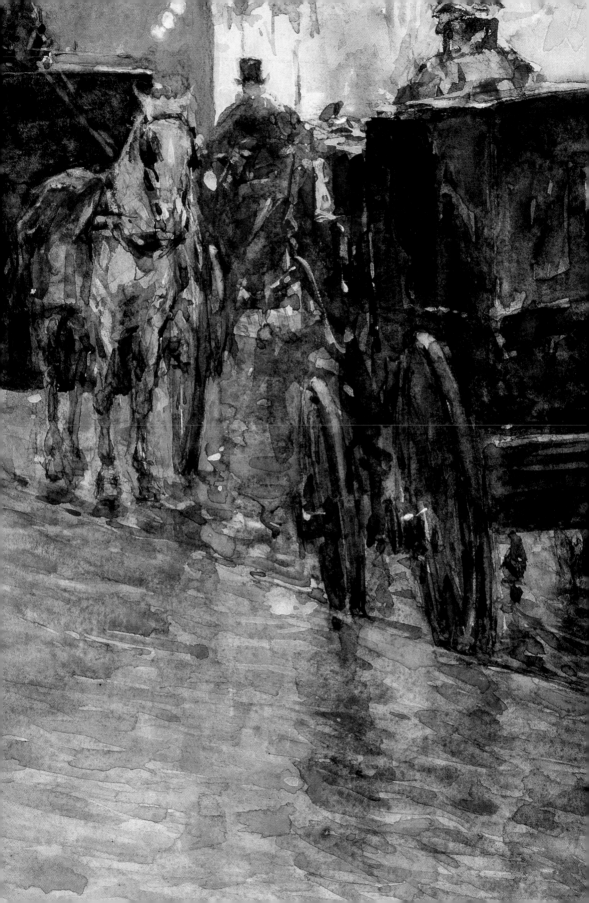

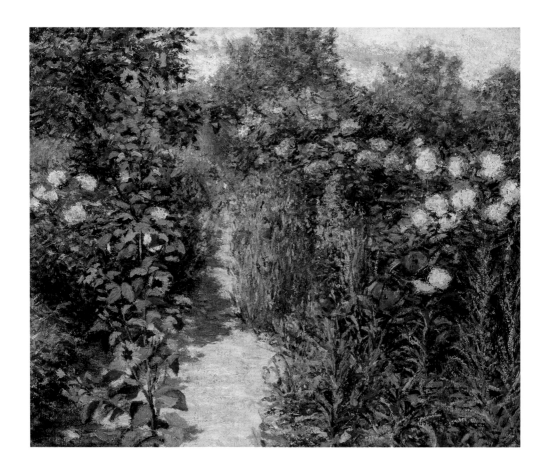

John Leslie Breck (1860–1899)
Garden at Giverny (In Monet's Garden),
c. 1887–91

> Oil on canvas, 18 ⅛ × 21 ⅞ in. (46 × 55.6 cm),
> Terra Foundation for American Art, Daniel J.
> Terra Collection, 1988.22

John Leslie Breck was one of the first American artists to work in the French village of Giverny, home to the French master Claude Monet (1840–1926). Initially, he experimented with Monet's aesthetic principles and later was a leading proponent of American impressionism, before his untimely death at age forty. This painting introduces viewers to a luxuriant garden, probably Monet's own. Various colorful flowers and feathery foliage crowd the picture frame, engulfing the path that meanders from the foreground. Contrasts between strong shadows and bright colors demonstrate the artist's interest in recording the transient effects of light. During his years in Giverny (from 1887 to 1891), Breck was privileged to be among the select few admitted to Monet's inner circle. Confirming the young artist's position as one of America's foremost impressionists, this painting is also a tribute to his famous mentor's swirling brushwork and strong hues.

Guy Rose (1867–1925)
Giverny Hillside, c. 1890–91

Oil on panel, 12 7/16 × 16 1/8 in. (31.6 × 41 cm),
Terra Foundation for American Art, Daniel J.
Terra Collection, 1992.2

Guy Rose was not only instrumental in introducing California to impressionism, but he was also considered the state's premier artist in this style. Throughout his career, he worked periodically in Giverny—one of many American and international artists who gravitated to the French village, about fifty miles northwest of Paris, that was

home to Claude Monet (1840–1926). In Rose's quiet landscape, the expanse of hillside, painted with delicate lines and individual brushstrokes to represent the grassy surface, rises to a bright but overcast sky, truncating the view of another hill in the distance. The painting represents the hills behind the village where residents maintained vegetable fields, which the artist indicated by variegated patches. *Giverny Hillside* is experimental in its dramatic simplicity, casual composition, and lack of narrative. Asymmetrical and starkly two-dimensional, the composition suggests the influence of Japanese aesthetics.

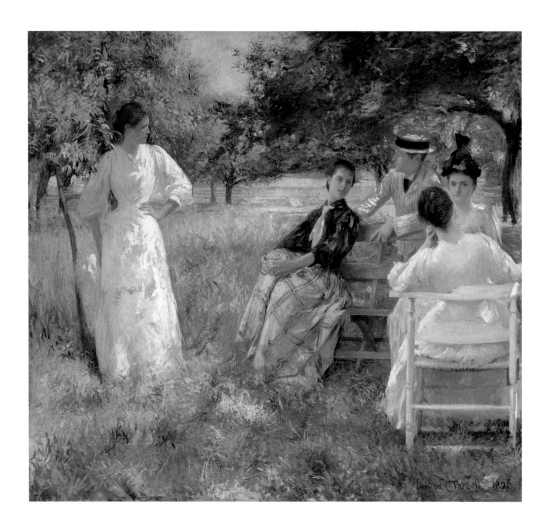

Edmund C. Tarbell (1862–1938)
In the Orchard, 1891

> Oil on canvas, 60¾ × 65½ in. (154.3 × 166.4 cm),
> Terra Foundation for American Art, Daniel J.
> Terra Collection, 1999.141

Edmund C. Tarbell represented the so-called
Boston school of impressionism and was a mem-
ber of the group known as the Ten American
Painters. When he showed *In the Orchard* at the
1893 World's Columbian Exposition in Chicago,
Tarbell became the acknowledged leader of a
national impressionist movement. The painting
depicts Tarbell's wife, Emeline, on the right

and wearing a black hat; his sister-in-law, Lydia,
standing in a white dress at left and again seated
with her back to the viewer; his brother-in-law,
Richmond, leaning on the bench; and Lemira
Eastman, a family friend, in blue at center,
conversing in a bucolic setting on a summer
afternoon. Poses and glances tie the five together
in an intimate circle under dappled sunlight.
The ambitious composition attracted consider-
able praise at a time when Americans typically
saw French impressionism as crude and garish.
In the Orchard demonstrated that heightened
color and loose brushwork could be used by
American artists to create pleasing subjects.

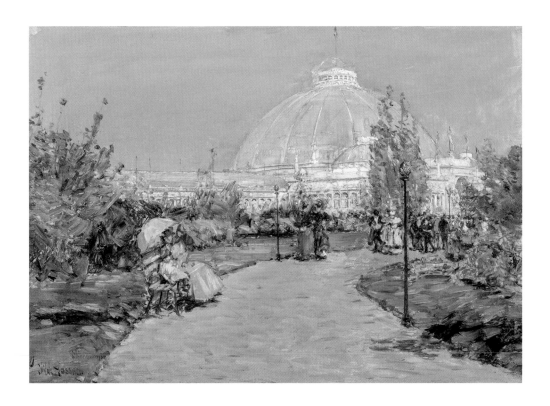

Childe Hassam (1859–1935)
***Horticulture Building, World's Columbian
Exposition, Chicago***, 1893

> Oil on canvas, 18½ × 26¼ in. (47 × 66.7 cm),
> Terra Foundation for American Art, Daniel J.
> Terra Collection, 1999.67

While in Paris from 1886 to 1889, Hassam was
inspired by the French impressionists, and he
began to paint with short, emphatic strokes in
bright, light-saturated colors. Back in New York,
he became a leading proponent of that move-
ment and was a founder of the group known as
the Ten American Painters. *Horticulture Building,*

World's Columbian Exposition, Chicago shows
the large, glass-domed edifice as seen from the
parklike Wooded Island set in the lagoon at
the heart of the fairgrounds. Vigorous brush-
work and brilliant color suggest the glare of
midday sun and the blur of moving bodies,
garments, and faces. Hassam visited Chicago
in 1892, but his images of the exposition,
which did not open until the following year,
were made from architects' drawings of the
projected buildings. As an imagined view of
the artificial "White City," it underscores the
fairy-tale-like perfection of the extraordinary
event, with its uniformly classical architecture.

A painting with the title *From a Chamber Window* was exhibited in 1895 at Theodore Robinson's first solo show. We do not know with certainty what work that title referred to, but from the description of the painting it was likely either *Blossoms at Giverny* or *In the Orchard* (1891, Princeton University Art Museum, New Jersey), which are similar in format, scenery, and subject matter. The original title suggests that the scene was captured from the artist's second-floor room in Giverny, France, where he would have taken the photographs used as sources for his paintings. Though the photographs themselves are now lost, the graphite grid used to transfer the photographic image onto the canvas is still visible in *Blossoms at Giverny*. Furthermore, the moments depicted in the two paintings appear to be based on photographs taken a few seconds apart. The sequence gives rise to a sort of narration that affords Robinson's scene a cinematic character.

In the first "still," *Blossoms at Giverny*, we see two figures walking toward the right, a few steps away from one another, enveloped by the branches of an apple tree in bloom. The viewer senses that the figures will soon leave the field of vision, following the descending diagonal line that marks the path. In the second still, *In the Orchard*, the viewpoint of the painter has shifted to the right and turned slightly to the left. He has also zoomed in a bit on the figures, who have now stopped, face to face. Robinson emphasizes the inconsequential nature of the scene by leaving the action in the background, almost out of focus. The possibility of reading this work in cinematic fashion is in keeping with the idea that early cinema appropriated the subject matter and techniques of the impressionists, a thesis explored in the 2005 exhibition *Impressionnisme et naissance du cinématographe* (Musée des Beaux Arts, Lyon). The bird's-eye view in *Blossoms at Giverny* results in a daring composition, exceptional in Robinson's oeuvre. The painter combined the daily act of observing what was happening beneath his window with new ways of seeing, fueled by novelties such as the Japanese prints, stereoscopic views, and aerial photography that were popular in France and the United States during the 1880s.

Robinson, like the impressionists, sought to capture modern life with the greatest realism possible. Scenes of passersby are common in the work of the French impressionist painters whom Robinson would have known. *Blossoms at Giverny* was included in the traveling 2014–2015 exhibition *American Impressionism*, organized by the Musée des Impressionnismes, Giverny, and the Terra Foundation for American Art, in collaboration with the National Galleries of Scotland and the Museo Thyssen-Bornemisza. In the accompanying catalogue, curator and art historian Frances Fowle points out that a striking compositional similarity casts this work as a rural version of *The Boulevard Seen from Above* (1880, private collection), painted by Gustave Caillebotte (1848–1894) eleven years earlier. Caillebotte captured what he saw from the window of his apartment in Paris at an even sharper angle than the one used by Robinson. In both works the ground becomes a backdrop against which the branches of a tree and the figures of the passersby stand out, a space hard to understand at first, but nevertheless faithful to what the painter had seen.

Clara Marcellán, *Assistant Curator*,
Museo Thyssen-Bornemisza, Madrid

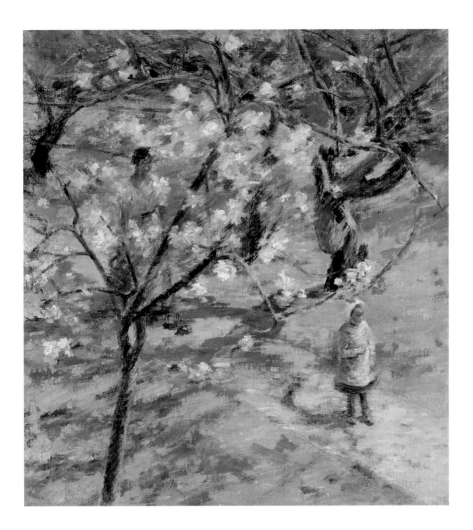

Theodore Robinson (1852–1896)
Blossoms at Giverny, 1891–92

> Oil on canvas, 21 ⅝ × 20 ⅛ in. (54.9 × 51.1 cm),
> Terra Foundation for American Art, Daniel J.
> Terra Collection, 1992.130

Theodore Robinson, one of the foremost American impressionists, was a friend of Claude Monet (1840–1926) and lived in the same French village as the master from 1888 to 1892. *Blossoms at Giverny* is one of two closely related works Robinson painted there that depict a little girl followed by a woman beneath blossom-laden trees. The soft pink that dominates the image is reminiscent of the subtle hues of apple trees during spring and creates a sense that the whole picture is in bloom. Captured from an elevated point of view, the scene displays a tipped-up perspective that reflects the influence of Japanese prints. The faint traces of penciled grid lines under the paint suggest that Robinson copied the composition from a photograph. If so, the painting shows how he combined modern technology—to capture a moment in time—with the immediate and spontaneous brushwork characteristic of impressionism.

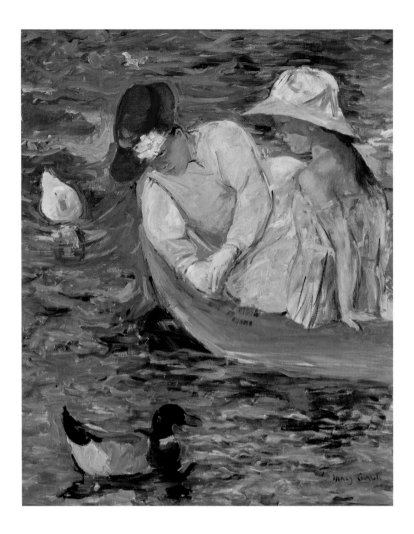

Mary Cassatt (1844–1926)
Summertime, 1894

> Oil on canvas, 39 ⅝ × 32 in. (100.6 × 81.3 cm),
> Terra Foundation for American Art, Daniel J.
> Terra Collection, 1988.25

Mary Cassatt achieved recognition in both
Europe and the United States during her
career, and was the only American to exhibit
with the French impressionists. In 1894 the
artist purchased the Château de Beaufresne in
the countryside fifty miles northwest of Paris.
There she created a series of paintings, includ-
ing *Summertime*, and prints of people in boats
feeding or observing the ducks on her new
property's reflecting pool. This work marks her
return to easel painting after four years, during
which time she focused on printmaking and
created her mural, *Modern Woman*, for the
1893 World's Columbian Exposition in Chicago.
Cassatt's vigorous technique and use of bright
colors assert her identification with impression-
ism. The work's compressed perspective, equal
emphasis of figures and ground, and theme
of feminine leisure owe a debt to Japanese art,
which influenced Cassatt's production, particu-
larly after she viewed an exhibition of Japanese
prints in 1890.

Leisure boating among the bourgeois class was a frequent subject of impressionist painters such as Claude Monet (1840–1926) and Berthe Morisot (1841–1895). It is also well known that these artists were considerably influenced by Japanese *ukiyo-e* prints, including in their expression of boating themes. During the Edo period (1603–1868) the general public in Japan enjoyed leisure boating, boarding various types of vessels to view the scenery of seasonal attractions—spring cherry blossoms, summer fireworks, colorful autumn leaves, and winter snow. These subjects became popular *ukiyo-e* themes, and Japanese woodblock artists often depicted beautiful women enjoying boating excursions in seasonal settings. The themes also appealed to impressionist painters, who sought to capture the daily life of the bourgeoisie in scenery filled with light. The impressionists adopted *ukiyo-e* compositional elements, such as cropping in a way that would allow a boat image to move off into space beyond the picture plane.

Cassatt had been introduced to *ukiyo-e* through Edgar Degas (1834–1917), and was exceptionally impressed by the exhibition of Japanese prints held in 1890 at the École des Beaux-Arts in Paris. She made several visits to the exhibition and urged Morisot also to see it. Cassatt immediately set about making a series of ten etchings inspired by the prints that had so moved her. The linear delicacy and flat color configurations of these etchings, which depicted women rearing children and in daily routines of grooming, reflect *ukiyo-e* influence.

In 1894, Cassatt moved to Château de Beaufresne, her country home located in Le Mesnil-Théribus, where she produced oil paintings and prints of boating in the garden pond. *Summertime* is one of these. Its high-angle, close-up perspective and vertical orientation distinguish it from her other depictions of this subject, which are characterized by horizontal orientations and a more distant viewpoint that includes the pond environs. It is very likely that Cassatt's reference for *Summertime* was the center panel of the *ukiyo-e* print triptych *Sumida River Ferry* (c. 1757) by Torii Kiyonaga (1752–1815), which appeared in the catalogue of the *Exposition de la gravure Japonaise* (Japanese Print Exhibition) in 1890. Both are vertical in format and the cropping of the boat is similar. Unlike the print, however, Cassatt's composition precluded any indication of scenery beyond the water's surface. She brilliantly represented the reflections of a dazzling summer sun by juxtaposing rough strokes of complementary blue and orange pigment to depict the ripples of water. The carefully crafted gaze of the women contemplating the surface of the water allows us to imagine their emotions in a narrative of a summer day. The painting is considered a masterpiece and prime example of Cassatt's distinctive technique for portraying the atmosphere of summer.

Hideko Numata, *Chief Curator*,
Yokohama Museum of Art, Japan

Portraits (self- and otherwise) are inevitably, to borrow a phrase from the writer Henry James (1843–1916), "partial portraits": representations that are incomplete, biased, or appreciative. Lilla Cabot Perry's self-portrait is inevitably partial though it seems straightforward, conventional, and simple in composition: she depicts herself as a serious artist in the act of painting, using a style that reflects her formal training in Boston and Paris, as well as the influence of her impressionist mentor, Claude Monet (1840–1926). The image engages the viewer because we are invited to read what is visible and also what is not.

An unseen mirror enabled Perry to paint this image. Unlike self-portraits in which the subject looks out at the viewer directly, in this one the artist's gaze is on her reflection in a mirror to her left. The mirror also reflects an image on the back wall that may be a window or a painting; either way, it serves as a counterpoint to the artist working indoors. She is undeterred by the waving figure—perhaps her husband—so close to her line of sight, but depicted outside. One might interpret the juxtaposition of the two figures to be a comment on how, despite the unexpected blurring of gender roles in her life, she thrived and prevailed.

The artist's marriage to Thomas Sergeant Perry (1845–1928) was a happy one, but his lack of a steady income compelled her, an accomplished poet and translator, to take up painting and become the breadwinner of the family, a role for which her upbringing in a prominent Boston Brahmin family had not prepared her. In an era in which men occupied the public sphere and women the private, she straddled both, earning acclaim through her paintings, introducing impressionist art to the United States and Japan, intellectually engaging her husband (a literary critic and translator) and members of their various circles, and instilling in her three daughters a keen sense of the world.

The couple's spousal responsibilities were often realigned or shared. For example, when Thomas Perry taught English literature for three years at Keio University in Japan (1898–1901), his family joined him in Tokyo, and it was he who mostly stayed in town to look after their daughters, then in their teens and early twenties, while Lilla pursued her profession by traveling to scenic locations in Japan to sketch and paint.

This self-portrait thus reminds us how conventional views of privilege, gender, and space in the late nineteenth century can be upended. A privileged female upbringing does not preclude having to work out of financial necessity. Painting oneself in a setting that suggests the familial does not necessarily represent being confined to the domestic sphere, unable to engage with a predominantly male artistic world; Perry was a successful transatlantic artist who later painted Japanese landscapes that male artists such as Monet could only dream of. Finally, compartmentalizing one's family life (here, possibly reducing her husband to a small indistinct figure framed by a window) to concentrate on one's art does not have to be disastrous.

The cautiously confident, contemplative expression on Perry's face in this painting seems tempered by the knowledge that her accomplishments were hard-won. Read in this light, her "partial self-portrait" provides a tantalizing glimpse of a complex and courageous life.

Yuko Matsukawa, *Professor of English*, Seijo University, Tokyo

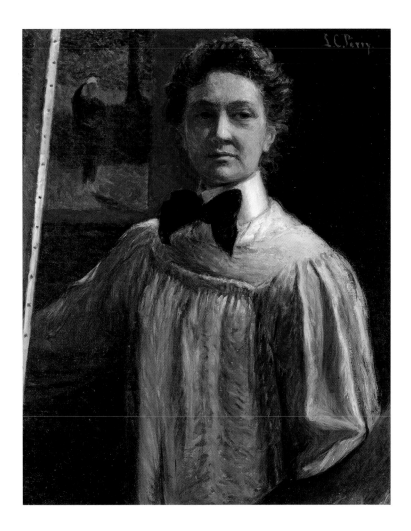

Lilla Cabot Perry (1848–1933)
Self-Portrait, c. 1889–96

> Oil on canvas, 31⅞ × 25⅝ in. (81 × 65.1 cm),
> Terra Foundation for American Art, Daniel J.
> Terra Collection, 1999.107

Lilla Cabot Perry was instrumental in introducing American audiences to impressionism through her figure paintings, portraits, and landscapes. In the only self-portrait in which she presents herself as a working artist, she is a commanding figure. Wearing a lavender smock and a black bowtie over her high-necked blouse, she holds the palette in her left hand and extends her right arm toward the canvas on her easel. She is turned away from her work and looks outward, as if toward a mirror she likely used in painting herself. Perry was profoundly influenced by the French painter Claude Monet (1840–1926), whose open brushwork, rapid and direct techniques, and bright colors she adopted. This work attests to her abilities as a portraitist as well as to her status as a successful professional woman.

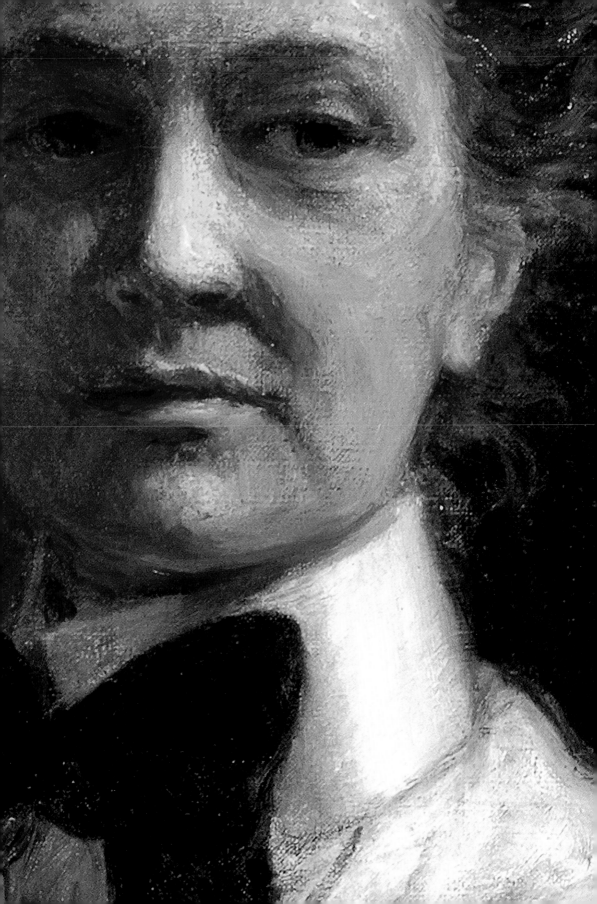

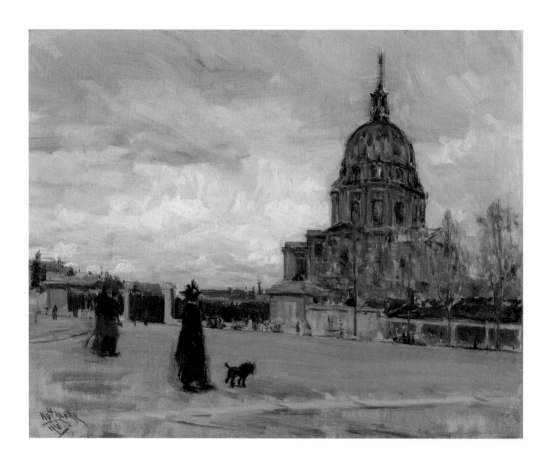

Henry Ossawa Tanner (1859–1937)
Les Invalides, Paris, 1896

Oil on canvas, 13⅛ × 16⅛ in. (33.3 × 41 cm),
Terra Foundation for American Art, Daniel J.
Terra Collection, 1999.140

Henry Ossawa Tanner was one of the foremost
African American artists of the late nineteenth
and early twentieth century. In 1894 he moved
permanently to Paris, where he forged collegial
relationships with white artists that would have
been unimaginable in his homeland. He won
numerous awards both in the United States
and Europe and was an inspiration for younger
African American artists. Although best known
for his religious paintings, Tanner depicted an
urban scene in this work, which demonstrates his
interest in impressionist subjects and techniques.
The painting shows Les Invalides, a complex
including Napoleon's tomb and the Hôtel des
Invalides, which was founded as a home for
disabled military veterans—the first institution
of its kind. Tanner's choice of this landmark may
reflect the artist's interest in social injustice.

Crossing the Atlantic in 1891, Henry Ossawa Tanner may have been the first African American artist to set out on the European Grand Tour that familiarized young artists with the canon of European culture. He was following the example of his role model, the great Philadelphia painter Thomas Eakins (1844–1916), and he intended to study in France and Italy before returning home. Paris changed his plans.

The sparkling dome in *Les Invalides* (1896), which Tanner painted in this impressionistic view of the "city of light," is a symbol of the artistic experience he had anticipated, and also of the refuge from American racism and the violence of the world, which Paris came to embody for him. An asylum in the literal sense, the institution of Les Invalides had been established by Louis XIV (1638–1715) at the end of the seventeenth century as a nursing and retirement home for wounded soldiers; in 1840 under King Louis-Philippe (1773–1850) it was transformed into a grandiose tomb for Napoleon (1769–1821), whose thirst for conquest plunged Europe into fire and blood. Tanner mobilized these echoes of war in a painting that can also be seen, metaphorically, as acknowledging victims of the American Civil War and the brutal institution of slavery that preceded it. The artist's mother, Sarah, had been a slave in Virginia but had escaped to the North, eventually settling in Philadelphia when Henry was a small child.

What Philadelphia represented for his parents, Paris became for Tanner. This small canvas was painted as a personal side note to two great public successes: his *Daniel in the Lions' Den* (1895; later version, 1907–1918, Los Angeles County Museum of Art) and *The Banjo Lesson* (1893, Hampton University Museum, Virginia), painted during a brief return trip to Pennsylvania. This last painting pictures filial love, paternal transmission, and the intimacy of the family home—things the young painter had abandoned for a foreign artistic "family" and place of shelter. In *Les Invalides* the woman in black and the clergymen may allude to the artist's parents (his father was a bishop in the African Methodist Episcopalian Church), but they cede pride of place to the great national refuge.

Is Paris still the city of exile and art that Tanner saw? In this pioneering, programmatic painting, he invites us to write a history of this mythic metropolis—the Paris of arts—as a place both politically hospitable and experimentally creative. Has it ever really been that place? It is useful to recall that at the time of Tanner's painting this perceived utopia was also the Paris of the Dreyfus affair (1894–1906), which exposed the breadth and depth of French anti-Semitism.[1]

Regardless, through much of the twentieth century the city continued to attract African American artists, and we should follow Tanner's invitation and study seriously the contribution of artists like himself to the art of Paris—a contribution focused on the city's predisposition for welcoming and sheltering the conflicted and paradoxical aspects of art and politics.

Anne Lafont, *Professor (Directrice d'études),*
Early Modern Art and Visual Culture History, École des
Hautes Études en Sciences Sociales, Paris

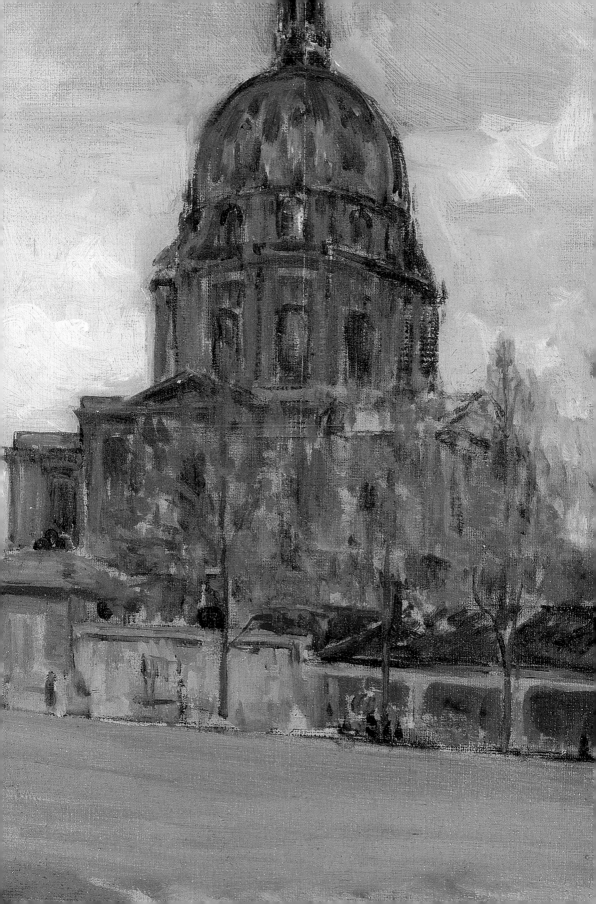

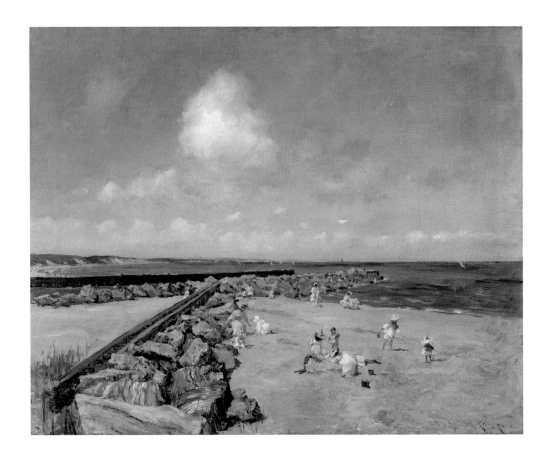

William Merritt Chase (1849–1916)
Morning at Breakwater, Shinnecock, c. 1897

Oil on canvas, 40 × 50 in. (101.6 × 127 cm),
Terra Foundation for American Art, Daniel J.
Terra Collection, 1999.30

An accomplished oil and pastel painter, William
Merritt Chase was the principal instructor at
the popular, seasonal Shinnecock Hills Summer
School of Art, founded in 1891 on Long Island.
During his months there, Chase devoted himself
to plein-air painting and produced numerous
serene evocations of Peconic Bay's sandy shore,
including *Morning at Breakwater, Shinnecock*.
In this expansive view, a group of women and
playful children populate the beach, shielded
from rough waters by the stone breakwater.
While the loose brushwork demonstrates the
artist's knowledge of impressionist principles,
the composition is carefully orchestrated with
a steep diagonal formed by the breakwater's
boardwalk. Suggesting the triumph of man-
made order over the unpredictable forces of
nature, this rigid line delineates a safe area
devoted to family leisure and thus epitomizes
Chase's domestic ideal.

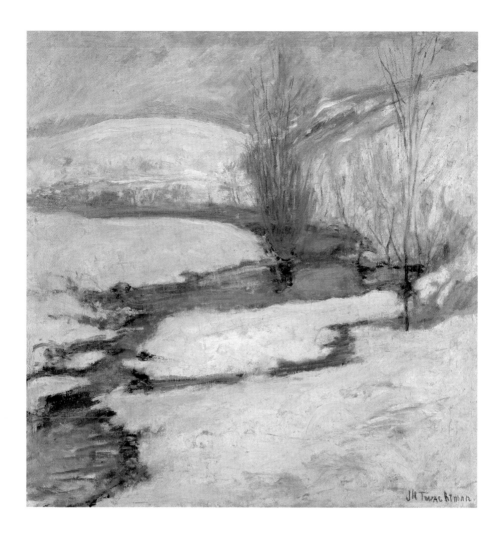

John H. Twachtman (1853–1902)
Winter Landscape, c. 1890–1900

Oil on canvas, 30 ⅛ × 30 ⅛ in. (76.5 × 76.5 cm),
Terra Foundation for American Art, Daniel J.
Terra Collection, 1992.136

Best known for his winter landscape paint-
ings, John Henry Twachtman developed a
highly personal approach to impressionism.
Characteristic of his mature output, this work
is one of numerous portrayals of a brook that
meandered through the artist's property in
rural Connecticut. The water zigzags into the
distance, where low snow-covered hills appear
almost indistinguishable from the opaque sky.
Tranquil and inanimate, the frozen landscape is
rendered in a reduced palette of whites and frosty
blues. During his eleven years in Connecticut,
Twachtman obsessively painted scenes around
his property. The serial nature of his practice and
his blurred, rough brushwork demonstrate his
adaptation of impressionist techniques, while the
high horizon and flattened forms echo the aes-
thetics of Japanese prints. Twachtman developed
a mode of painting rooted in his attachment to
his home and immediate surroundings.

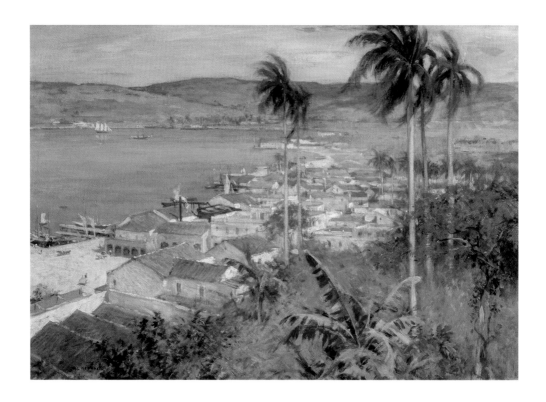

Willard Metcalf (1858–1925)
Havana Harbor, 1902

Oil on canvas, 18 5/16 × 26 1/8 in. (46.5 × 66.4 cm),
Terra Foundation for American Art, Daniel J.
Terra Collection, 1992.49

Willard Metcalf was a member of the Ten
American Painters, a group that withdrew
from the Society of American Artists in 1897
and exhibited their work together for the next
twenty years. He is known for his depictions
of American coastlines and domestic interiors.
In *Havana Harbor*, he turned to the theme of
tropical exoticism, painting the Cuban port
and its lush environment from a hillside. The
rapidly applied touches of color exemplify
Metcalf's embrace of an impressionistic tech-
nique. The work was originally part of a series
of paintings Metcalf created to complete the
interior decor of a new luxury store opened
by the Havana Tobacco Company in New
York City. The artist traveled to Cuba in 1902
for this project, which sought to contrast the
elegance and sophistication of Cuban cigars
with the domestic products sold by the rival
American Cigar Company.

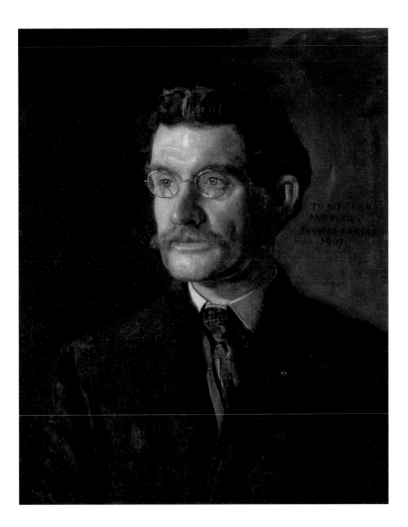

Thomas Eakins (1844–1916)
Portrait of Thomas J. Eagan, 1907

> Oil on canvas, 24 × 20 in. (61 × 50.8 cm),
> Terra Foundation for American Art, Daniel J.
> Terra Art Acquisition Endowment Fund, 1998.1

A master of American realism, Thomas Eakins painted many penetrating portraits and scenes of everyday life in Philadelphia in the late nineteenth and early twentieth century. He was especially drawn to subjects that showcased well-honed skills and intellectual pursuits. *Portrait of Thomas J. Eagan* is typical of Eakins's late portraits in its compositional simplicity and sympathetic scrutiny of a sitter drawn from the artist's immediate circle. Often setting his subject against a dark, nondescript background, Eakins dramatized the face with strong, harsh lighting. Originally Eakins's student at the Pennsylvania Academy of the Fine Arts, Eagan left the academy in protest when Eakins was dismissed in 1886 for using a nude male model in a mixed-gender class. Eagan helped found the Art Students League of Philadelphia and participated in Eakins's photography sessions. The portrait, which Eakins inscribed "to his friend and pupil," reflects the artist's professional and personal regard for his subject.

Thomas Dewing's *Portrait of a Lady Holding a Rose* exhibits direct references to Asian art. The seated figure is wearing a wide-sleeved gown in the style of a kimono and posing before a Japanese hanging scroll and ceramic vase, also likely Japanese. She does not interact with the viewer. Like the porcelain and the flower, her profile becomes a decorative object of the viewer's gaze. This painting is similar to numerous other portrayals of American women by Boston and New York artists of the time, including William Merritt Chase, Childe Hassam, Edmund Tarbell, Frank Benson (1862–1951), Robert Reid (1862–1929), and Joseph DeCamp (1858–1923).

Notwithstanding individual stylistic differences, these artists painted women with generalized features and artful accessories, picturing a new ideal of femininity. They represented recognizably "modern" American women at leisure in interior settings amid Asian art and artifacts, lost in reverie and often dressed in kimonos, features that to an affluent audience suggested both sophisticated taste and female sexuality. Drawing on art historical sources including paintings of women in Dutch interiors by Johannes Vermeer (1632–1675), and amid Asian motifs by James McNeill Whistler (1834–1903), artists such as Dewing found a ready market for their images of decorative femininity. The models' languid poses and the paintings' highly orchestrated and nearly claustrophobic interior settings might be seen as a foil to the so-called New Woman's demands for greater social freedoms and political agency in the public arena.

The inclusion of Japanese elements in these works underscores this vision of passive femininity. Though Japan had begun to emerge as a global economic and military power after the Meiji Restoration of 1868, Japanese art and aesthetics were regarded in the West as highly feminized, embodying elegance, refinement, and serenity. White, wealthy Americans used Japanese objects to exhibit their refined taste and signify their economic status, and artists responded by producing aestheticized portrayals of American women that evoked this stylistic milieu. Dewing was a friend of, and buying agent for, the collector Charles Lang Freer (1854–1919), who shared his admiration for Asian art and Japanese aesthetics, and held in high esteem the *ukiyo-e* woodblock print master Kitagawa Utamaro (1753–1806), especially known for his depictions of women.

The aestheticized women created by Dewing and his peers emulated the Western perception of Japanese women as delicate, quiet, and passive. Through countless artistic and cultural sources, including fiction and nonfiction, operas and musicals, paintings, prints, photographs, and advertisements, Americans became infatuated with this illusionary image of the Japanese, which remains in the national imagination to this day. American women imitated these fictive Japanese maidens in their fashions, poses, and lifestyles, while searching for their own new feminine ideals. The theatricality of Dewing's picture reflects both the aspirations of his model, Gertrude McNeill, who later worked in silent films, and the artist's own status as an amateur actor who enjoyed costumed entertainments. His painting exemplifies the cultural politics of representation during a time of shifting American gender roles and new American encounters with Asia.

Eunyoung Cho, *Professor of Art History,* Wonkwang University, South Korea

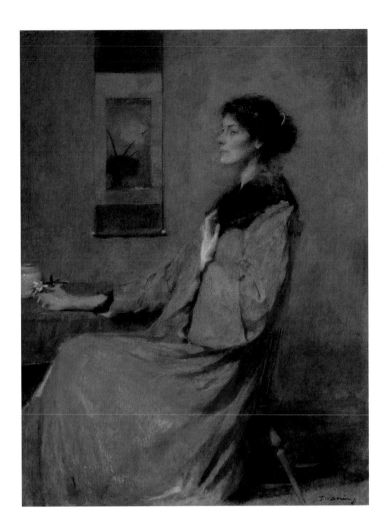

Thomas Wilmer Dewing (1851–1938)
Portrait of a Lady Holding a Rose, 1912

Oil on canvas, 21 ¼ × 16 ¼ in. (54 × 41.3 cm),
Terra Foundation for American Art, Daniel J.
Terra Collection, 1999.46

Inspired by the Dutch seventeenth-century painter Johannes Vermeer (1632–1675) and the English Pre-Raphaelites of the mid-nineteenth century, Thomas Wilmer Dewing produced ethereal depictions of women. By elevating formal values over narrative content, he embraced the "art for art's sake" doctrine promoted by the expatriate artist James Abbott McNeill Whistler (1834–1903). *Portrait of a Lady Holding a Rose* shows a seated woman, in profile, absorbed in a contemplative reverie. The painting also reveals the influence of Japanese art on Dewing, who portrayed his model in a wide-sleeved green garment resembling a kimono and included a Japanese scroll on the back wall. Less a portrait than a celebration of purely formal beauty, the painting blends the abstraction of Asian aesthetics with the realism of the Western tradition to appeal to both the intellect and the senses.

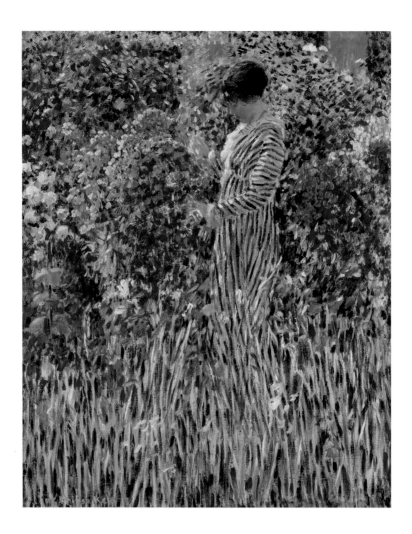

Frederick Carl Frieseke (1874–1939)
Lady in a Garden, c. 1912

Oil on canvas, 31 ⅞ × 25 ¾ in. (81 x 65.4 cm),
Terra Foundation for American Art, Daniel J.
Terra Collection, 1999.52

Frederick Carl Frieseke was a prominent member of the group of American artists who settled in Giverny in the late nineteenth and early twentieth century. Spending every summer between 1906 and 1919 in the small village northwest of Paris, he produced colorful portrayals of women in tasteful interiors and flower-filled gardens. In

Lady in a Garden, a woman—standing in what was probably the artist's garden in Giverny—is barely distinguishable from the luxuriant vegetation surrounding her. Flowers and foliage fill the composition, nearly overwhelming the image. Frieseke's brushstrokes mimic the shimmering effect of the sun's bright light on verdant textures and eliminate any sense of depth. Taking impressionist ideas to the limit, he produced an all-over composition that may indicate an embrace of aesthetic principles developed in the 1890s by a group of French artists known as Les Nabis who emphasized pure pattern, expressive color, and decorative design.

David Peters Corbett
Professor, Courtauld Institute, University of London

Introduction

This essay addresses a number of paintings made by American artists between the last years of the nineteenth century and the middle years of the twentieth. All are concerned with the experience of modern life— bustling, often bemusing, frequently harsh. In depicting this world, these artists chose to deal with something other than the traditional subjects of European painting—landscapes, portraits, local scenes, still lifes, or narrative scenes inspired by gods or history. Although they drew on this rich tradition, American artists of these years sought a new visual language that could do justice to new realities.

Here are two paintings, both made during the 1890s, both small in their dimensions, loosely or rapidly painted, and focused on urban everyday scenes: *Street Corner in Paris* (Fig. 1) by Robert Henri (1865–1929) and *Evening on a Pleasure Boat* (Fig. 2) by Maurice Prendergast (1858–1924). Henri's picture, which measures only 3 ⅞ by 6 ⅛ inches (9.8 × 15.6 cm), uses fluid but substantial paint to describe the rush and bustle of a city street. A figure in the foreground leans rightward as she strides toward a group of people, barely articulated, that occupy the middle ground. Behind

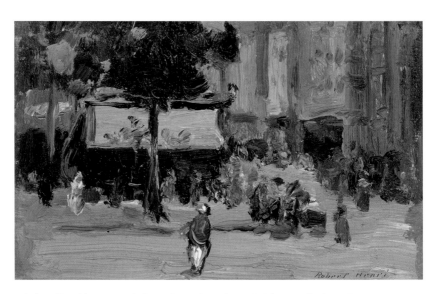

1 **Robert Henri (1865–1929),** *Street Corner in Paris*, **1896**. Oil on panel, 3 ⅞ × 6 ⅛ in. (9.8 × 15.6 cm), Terra Foundation for American Art, Daniel J. Terra Collection, 1999.70

176

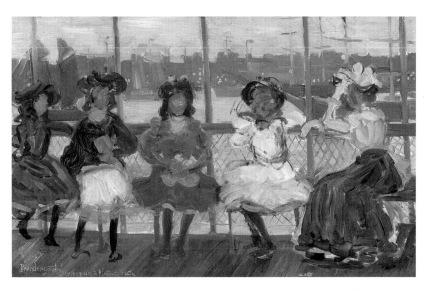

2 **Maurice Brazil Prendergast (1858–1924)**, *Evening on a Pleasure Boat*, **1895–97**.
Oil on canvas, 14 ⅜ × 22 ⅛ in. (36.5 × 56.2 cm), Terra Foundation for American Art, Daniel J. Terra
Collection, 1999.110

this scatter of human presence, a canvas awning and solidly planted tree
anchor the eye and buildings rear up, marking this as a city scene. The
dominant impression, however, owes as much to the lushness and vitality
of the brushwork as to the subject matter. The evident rapidity of the
artist's application of paint conveys the woman's rolling gait, the ambula-
tory, vivid presence of the city's inhabitants, and also their distance and
anonymity. Henri's figures possess the vagueness and indeterminacy
of the stock figures art historians call *staffage*—groups or individuals that
could be classified, recognized, or ignored in terms of "type," rather than
as discrete personalities. Henri's small panel painting is a *pochade*—a swift,
telling sketch—and derived from the example of the leading painter of
nineteenth-century Parisian life, Édouard Manet (1832–1883). Its vision
of the city is both pictorially seductive and indifferent to its human actors,
a visual experience rather than a social one.

Prendergast's picture is slightly larger, at 14 ⅜ by 22 ⅛ inches
(36.5 × 56.2 cm), and shows four well-dressed girls and one adult woman
in a line, sitting against the railing of a boat as it steams through Boston
Harbor. In an echoing frieze behind them, the cityscape of Boston passes
in a regular rhythm, interrupted by the upright supports of the deck and by
ships' masts to the right and left. Prendergast's rapid, generalized execu-
tion and summary description of the figures, along with the grid imposed
by the rails, draw the fluency of the paintwork to our attention and reduce
any sense of individuality. The girls appear as variations on a theme of

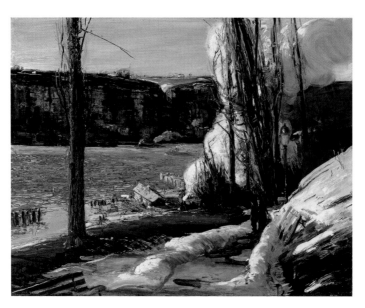

3 **George Bellows (1882–1925),** *The Palisades*, **1909**. Oil on canvas, 30 × 38 ⅛ in. (76.2 × 96.8 cm), 1999.10

decorous excitement set by their postures. The emphasis is on the scene's typicality rather than on either the woman's pleasure at the spectacle or the girls' various negotiations of demureness. Though the city is visible behind them, they are distanced from it by the orientation of their seats and their prim attitudes. *Evening on a Pleasure Boat* is one of Prendergast's earliest oils, painted at a time when he was mainly working in watercolor. The thin, expressive paint owes something to watercolor technique, and reinforces the sense of a consciously painterly work.

The emphasis in these paintings on the physicality and expressive immediacy of paint and its ability to seize urban experience evokes the work of the American expatriate James Abbott McNeill Whistler (1834– 1903), whose canny balancing of representation and painterliness was powerfully influential in both the US and Europe during the final years of the nineteenth century.[1] Henri's Parisian *pochade*, with its assertive central awning, recalls the prints and small painted sketches of shop fronts such as *Carlyle's Sweetstuff Shop* (c. 1887, Terra Foundation for American Art) that Whistler began making in the 1880s.[2] Several of these employ horizontals and verticals in a grid effect similar to Prendergast's lattice organization in *Evening on a Pleasure Boat*, while their rapid execution can be seen as a complement to the influence of Édouard Manet (1832–83) in Henri's painting. Prendergast may also have been referencing Whistler's images from the 1860s of the East London waterfront, a forest of masts and busy boats at the heart of a world city.

The painted sketches of Henri and Prendergast embody the tension, present throughout this period of American art, between aesthetic concerns—the designed, decorative, or explicitly painterly—and social ones, specifically the urban scene. The counterpoint between social description, with its rhetorical claims for authenticity, even grittiness, and aesthetic intent animates these images. Both artists offer views of human interaction in the modern city—Henri's busy Parisians as much as Prendergast's decorous observers—while foregrounding the artists' expressive responses. In addition to this persistent dualism, these works raise the issue of how American painters represented modernity and responded to questions about the human experience of cities.

Painted about a dozen years later, *The Palisades* (Fig. 3) by George Bellows (1882–1925) and *Brooklyn Bridge* (Fig. 4) by Ernest Lawson (1873–1939) confirm a sense of the modern city as intense and demanding. Bellows's *Palisades* depicts the view from Riverside Park in uptown Manhattan looking across the Hudson River to New Jersey. Between piles of snow in the foreground, a cleared path provides an opportunity for two walkers. Below the rolling snowbank on their right bare earth fades down to the river, marked on the near side by pylons, a pier, and a shed, and on the other by a cliff face of the Palisades. Between these two edges tugboats head downriver, while along the shoreline a train heading downtown belches a cloud of steam that fills the top right-hand corner of the canvas.

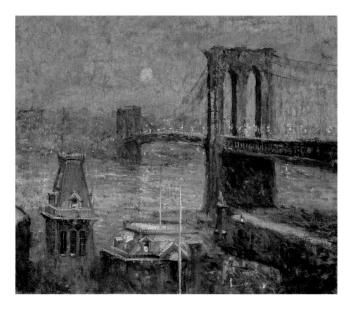

4 **Ernest Lawson (1873–1939),** *Brooklyn Bridge,* **1917–20.** Oil on canvas, 20 ⅜ × 24 in. (51.8 × 61 cm), Terra Foundation for American Art, Daniel J. Terra Collection, 1992.43

Bellows was a prominent member of the Ashcan school, the group of painters (including John Sloan [1871–1951], Everett Shinn [1876–1953], and George Luks [1867–1933]) who followed Henri's urging to paint the American scene, and his example in choosing to depict the New York of their daily lives. *The Palisades* is one of several paintings Bellows made around this time depicting the Hudson along Manhattan (then called the North River) and its adjacent cityscapes. Here he represents the strange modernity of a place where the city and the landscape meet and are transmuted. The river—a marker of the natural world—is brought within the urban sphere by the tugs, the strolling watchers, and the industrial structures at the water's edge. At the same time, the park can be seen as the city's attempt to reimagine itself as rural (though it achieves only an urban version of the natural world). The steam from the train merges almost indistinguishably with the white clouds and snow. The meshing of natural and artificial realms is asserted in this vaporous, condensed substance, which occupies so much of the canvas.

A further transformation occurs toward the top, where sharp splinters of trees and roiling billows of steam, immense in relation to the tiny train beneath them, abandon mimesis almost entirely and turn explicitly into paint. Bellows sets up a mobile series of substitutions, from steam to clouds to paint, which destabilizes the relationship between representation and the world it seeks to describe. Into this strange and unresolved environment Bellows inserts two strolling, top-hatted figures: positioned on a ridge, looking across at the yet untamed Palisades, these figures allow us to consider a different view—one that skips over the train and boats with their implications of a busy commercial world, taking in just the icy blue of the river and the black rock face above it. They see an aesthetic, rather than the dingy world of modernity.[3]

Instead of the urban-natural transition zone of Bellows, Lawson's painting concentrates on the striking presence of the Brooklyn Bridge, a symbol of American progress completed in 1883. By the turn of the century, artistic expressions of the sublime—images evoking awe and mystery—had moved away from the wildernesses that had inspired nineteenth-century American painters and had begun to seek out the soaring buildings and complex infrastructure of the twentieth-century city. As this technological sublime became a prime mode of representing American modernity, the marvel that was the Brooklyn Bridge emerged as one of its principle subjects. It was ceaselessly represented and written about in popular and official culture in the decades after it opened.[4] But Lawson's painting contains another, perhaps surprising, element: painted from the Brooklyn side, looking toward Manhattan, it depicts in the foreground a cluster of buildings from the 1860s, including the Fulton Ferry Terminal—an instance of the supersession of one defining technology by another.[5] The Fulton Ferry had been the first public steamboat service between Brooklyn and Manhattan

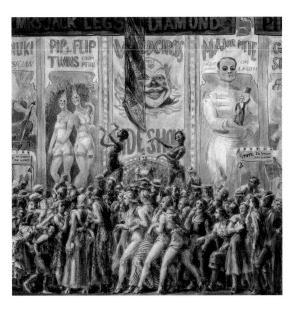

5 **Reginald Marsh (1898–1954),** *Pip and Flip*, **1932**. Tempera on canvas mounted on canvas, 48 ¼ × 48 ¼ in. (122.6 × 122.6 cm), 1999.96

in the early nineteenth century, and had been critical to the development of Brooklyn Heights as a commuting community.[6] Hard hit by the opening of the bridge, the ferry and its old-fashioned terminal suggested the rapidity of change when Lawson painted his scene.

In this sense, the picture seems less a vision of technological sublimity than of the melancholy traces of a vanishing past. Lawson and Bellows both seem somewhat disenchanted with the industrialized American city of their time. The sulfurous atmosphere and lowering sun of the Lawson, like the dark blues and disintegrating wooden structures of the Bellows, seem to re-flect a world of rapid change and decay. Human beings are peripheral to these urban spaces. The protagonists of these paintings are the rivers, and the mechanical systems that gather around them. Manhattan's rivers are part of the story of its growth and development, but they are also separate from it.

A quite different vision of New York can be found in two paintings of the 1930s: *Pip and Flip* (Fig. 5) by Reginald Marsh (1898–1954) and *Coney Island* (Fig. 6) by Harry Roseland (1867–1950). Both expand on the theme of waterfront pleasures that had been explored in earlier Ashcan painting, including Bellows's *Beach at Coney Island* (1908, private collection) and Sloan's *South Beach Bathers* (1907–08, Walker Art Center, Minneapolis, Minnesota). The somberness of Lawson's *Brooklyn Bridge* and Bellows's *Palisades* is absent here; people move to center stage, explored as masses and as objectified subjects. Roseland's *Coney Island* bears comparison with the Coney Island pictures taken in the 1940s by the documentary photographer

Weegee (Arthur Fellig, 1899–1968), such as *Coney Island Beach* (Fig. 7). Weegee, like Roseland, emphasized people *en masse*, fluctuating, fractal, and infinitely mobile. He captured individuals within the crowd who looked up as the photographer, famously, mugged and danced to attract their attention. The people in Roseland's crowd, however, turn away from the painter (and viewer), pursuing their own activities and blending into an anonymous, immeasurable mass.

Marsh focused on the culture of popular entertainment, leisure, and exploitation. In *Pip and Flip*, a river of humanity passes from right to left across the composition, a flow of social, racial, and gender types that ebbs toward the picture's edges and crests before the entrance to World Circus, a famous Coney Island "freak show."[7] Above them, brash signs for the acts inside dominate the canvas through egregious scale and color. In the center, where two burlesque performers and one of the headliners stand above the crowd, a huge clown face is capped by a word play where a hanging flag transforms "World Circus" into "Wild Circus."

"Pip" and "Flip" were the stage names of the microcephalic sisters Elvira and Jenny Snow, who also appeared in the movie *Freaks*, directed by Tod Browning and released the same year. Robin Jaffee Frank has written about Marsh's painting and the realities of Coney Island and its entertainers, stressing Marsh's emphasis on sexuality and the coarser human emotions.[8] The sodality of linked girls who stride across the midpoint of the painting,

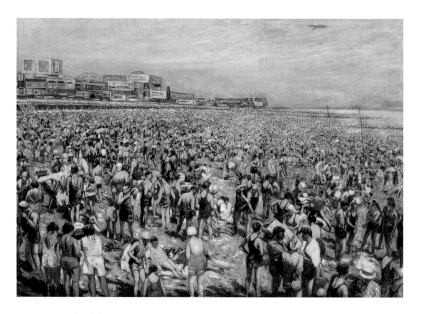

6 **Harry Roseland (1866–1950), *Coney Island*, 1933.** Oil on canvas, 28 ¼ × 40 ⅛ in. (71.8 × 101.9 cm), Terra Foundation for American Art, Daniel J. Terra Collection, 1993.12

the burlesque dancers who pose to attract the crowd, the interplay of types and glances—all contribute to a vision of the city quite distinct from the empty built spaces of Lawson's Brooklyn Bridge or the emotional distance of Bellows's Riverside Park. Coney Island represented a different American modernity.

Up to now, all the pictures I have discussed have been of urban locations—Paris and Boston, and New York City from Riverside Park to Coney Island. The last two paintings I will discuss, however, use modernist stylistic devices to represent rural environments: in *Bucks County Barn* (Fig. 8) by the precisionist painter Charles Sheeler (1883–1965), the material structures of human endeavor stand without their makers, while *After Church* (Fig. 9) by Romare Bearden (1911–1988) is jammed with human presence, as palpable and obdurate as buildings. In the early years of the twentieth century, Sheeler had depicted New York City in paintings, works on paper, and photographs, but at the same time he repeatedly portrayed the landscape and architecture of Bucks County, Pennsylvania, where he shared a colonial house in Doylestown with his friend the painter Morton Schamberg (1881–1918) until the latter's death from influenza in 1918. Sheeler's *Bucks County Barn* exhibits the tension between realism and self-conscious aestheticism we saw in Henri and Prendergast. Sheeler's first sustained artistic encounter with vernacular architecture occurred in the late 1910s, when he produced a large number of photographs and works

7 **Weegee (Arthur Fellig) (1899–1968),** *Coney Island Beach***, 1940**. Gelatin silver print, 8 ⅛ × 10 in. (20.6 × 25.4 cm), The Metropolitan Museum of Art, Ford Motor Company Collection, gift of Ford Motor Company and John C. Waddell, 1987.1100.252

on paper depicting the interior of his Doylestown house and nearby buildings.[9] By the 1930s, rural and historic subject matter of this sort, which had been seen as eccentric and innovative when he began, had become a more common modernist interest, and Sheeler's impersonal, precisionist technique had become identified with the depiction of industrial and urban sites. His formal geometries and evocation of historical America through vernacular structures suggested to critics and contemporaries a specifically American modernism.[10]

Bucks County Barn, like Lawson's *Brooklyn Bridge*, is unpeopled. The only living things are two cows behind a split-rail fence and a dog passing by a kennel, which divides his body. Human presence is implicit in the architecture and tools—means of structuring the world. Mortality and the dissolution of the body are evoked by the collapsed fence and a damaged board on the porch roof.

Bearden, a generation younger than Sheeler, adapted the formal simplifications and spatial contradictions of modernism to a subject it had rarely been tasked with: African American life in the twentieth century. Born in the southern state of North Carolina, Bearden moved with his family to New York as a young child. *After Church* is one of several works that emerged from a return visit to the South he made in the early 1940s. On the face of things, the subject is a brief and unremarkable moment as men leave a country church after a service, but the mood is silent and ominous. The composition is dominated by the heads and shoulders of large figures who push up against the picture plane, while in the distance rolling hills and leafless trees frame two smaller figures and the gray clapboard church.

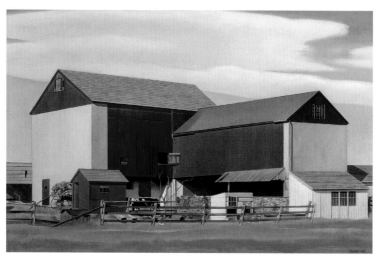

8 **Charles Sheeler (1883–1965)**, *Bucks County Barn*, **1940**. Oil on canvas, 18 3/8 × 28 3/8 in. (46.7 × 72.1 cm), 1999.135

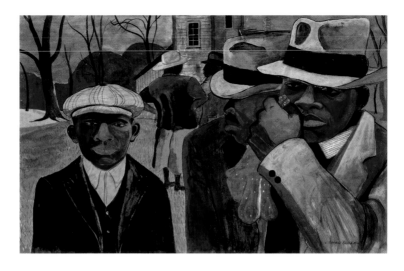

9 **Romare Bearden (1911–1988),** *After Church,* **1941**. Gouache on brown paper, 22 × 34 ½ in. (55.9 × 87.6cm), 2015.2. Art © Romare Bearden Foundation / Licensed by VAGA, New York, NY

Bearden's subtle understanding of historical and contemporary painting is evident in the Matisse-like flattening of form and brilliant colors. The men appear near to us and therefore implicitly require a response, but this immediacy is subordinated by the formal choices Bearden makes and by the closure of feeling in the figures' faces, deportment, and address to the spectator. One is seen in profile, his eyes hidden by the brim of his hat; the frontmost raises a handkerchief to his face and glances off to the side; a third, wearing a cloth cap and smaller than the others, stands apart and faces us squarely, but his eyes are lowered and do not meet the viewer's. The faces of the figures behind cannot be seen at all. Everyone and everything appears simultaneously direct and evasive. This depiction of the Jim Crow South, seen from the perspective of a New York painter, is a further example of an American artist consciously maneuvering between pictorial strategies, personal vision, and social subjects.

Bearden's painting returns us to the concerns with which this essay opened: the decorative and aesthetic, the socially meaningful, the desire to characterize the present moment, and the questioning of American identity and its symbols. If much of this activity concentrated on the nation's greatest metropolis—its most dizzying exemplar of mankind's technological interventions in the natural world—it also looked further afield, to the "old world" of Paris and to the deep American time of Boston Harbor, Pennsylvania farm country, and the former Confederacy.

This very early work by William Glackens, *Bal Bullier,* radiates youth and ambition. In his choice of topic—a Parisian night scene—and in his use of flattened figures, muted tones, and gestural brushwork, Glackens clearly aims to emulate the French impressionists, especially Édouard Manet (1832–1883). The largely dark outfits of the crowd, crammed into a vague black mass against the top edge of the canvas, recall, for instance, Manet's *Bal masqué à l'Opéra* of 1873 (National Gallery of Art, Washington, DC). The central two dancers strongly resemble characters portrayed by Henri de Toulouse-Lautrec (1864–1901)—the contrasting petticoats of the woman and the top hat of the man are signature features popularized by the can-can dancer La Goulue (Louise Weber, 1866–1929) and her long-time partner Valentin Le Désossé (Jacques Renaudin, 1843–1907). And the blurry faces emerging from the indistinct crowd are reminiscent of the mottled light illuminating dancers and café customers in the *Bal du Moulin de la Galette* (1876, Musée d'Orsay, Paris) by Auguste Renoir (1841–1919). Glackens's inclusion of artificial lighting might also discreetly refer to Manet's insistence on the artificiality of the electric globes in his *Bar aux Folies Bergère* (1882, The Courtauld Gallery, London).

As art historian S. Hollis Clayson has demonstrated in her work on artificial lighting in late nineteenth-century art, this attention to electricity is perceptible in many works by American artists in Paris, yet they often merely allude to the modernity that the impressionists, by contrast, depicted in its full glare. Glackens, like many of his compatriots in the French capital, remains, as Clayson puts it, an "outsider," eager to show he understands and participates in Parisian artistic life, while at the same time keeping at a safe distance from it. This fleeting reference to electricity is far from the only symptom of this distancing. In the mid-1890s, the Bal Bullier, a dance hall on the edge of Montparnasse and the Quartier Latin, was losing ground to the Montmartre cafés on the other bank of the Seine. And like most such "*café-concerts,*" its originally subversive identity was fading. *Nuits à Paris,* a nightlife guide written for tourists visiting the 1889 Exposition Universelle, notes that while the Bal Bullier had been the "last refuge of French gaiety" in the 1870s, its original population of rebellious students and the working-class girls dubbed *grisettes* had now been replaced by "commercialism and English coolness, bankers, politicians, and *filles de brasserie*"—café waitresses dabbling in casual prostitution.[1] The golden age of dance halls in the 1860s and 1870s had coincided with the artistic careers of the genre's most important performers and impressionist painters, but by the 1890s this once-provocative avant-garde had shifted toward standardized show business, with more generic shows and images shaped for the consumption of a larger, less adventurous audience. One could compare, for instance, Glackens's picture to the 1894 poster advertising Bal Bullier by Georges Meunier (1869–1942), itself a tamed version of Jules Chéret's (1836–1932) daring precedent. On the threshold of a career devoted to the depiction of American street life, young Glackens started paradoxically with a look back, paying nostalgic homage to a Parisian nightlife and art scene already on the verge of extinction.

Hélène Valance, *Assistant Professor*, American Studies, Université Bourgogne Franche-Comté, France

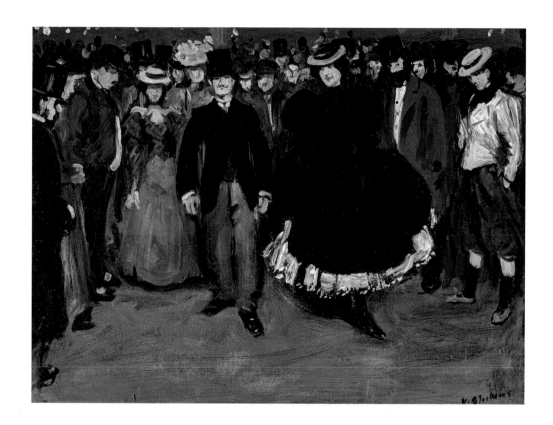

William Glackens (1870–1938)
Bal Bullier, c. 1895

> Oil on canvas, 23 ¹³⁄₁₆ × 32 in. (60.5 × 81.3 cm),
> Terra Foundation for American Art, Daniel J.
> Terra Collection, 1999.59

William Glackens, a Philadelphia native, was inspired by the dark colors, expressive brushwork, and ideals of artistic freedom promoted by the artist and teacher Robert Henri (1865–1929). In addition, he was drawn to the urban subject matter and flattened forms that characterized paintings of the French artist Édouard Manet

(1832–1883). *Bal Bullier*, one of Glackens's earliest oil paintings, prefigures his affiliation with the progressive New York artists known (at first derisively) as the Ashcan school; they depicted a wide range of big-city scenes in a deliberately crude, painterly style. Here, a woman lifts her skirt flirtatiously to reveal her white petticoat as she glances at her partner, stiff in his formal suit and top hat. The mismatched couple in *Bal Bullier* demonstrates Glackens's ability to capture not only an urban setting but also intriguing nuances of interaction among people of different social classes.

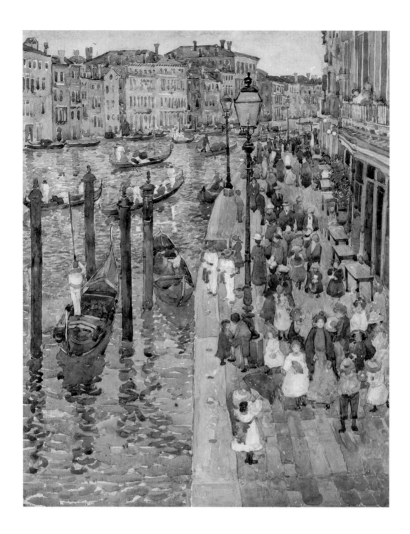

Maurice Brazil Prendergast (1858–1924)
The Grand Canal, Venice, c. 1898–99

> Watercolor and graphite on paper, 18 ⅛ × 14 ¼ in.
> (46 × 36.2 cm), Terra Foundation for American Art,
> Daniel J. Terra Collection, 1999.123

Watercolorist and oil painter Maurice Brazil Prendergast produced vivid, modernist compositions that capture the sparkling effects of light and movement in public places. Painted during his eighteen-month stay in Italy, in 1898 and 1899, this work provides a bird's-eye view of a bustling area along the central Venetian canal. Façades of splendid palaces border the waterway, while formal and color contrasts emphasize a surprisingly vertical division between land and water. A crowd of pedestrians on the street offers a strong counterpoint to the brightly shining water on the left, where a handful of gondolas punctuate the surface. Carefully inserted are white-clad figures that balance the rich colors of the busy scene and demonstrate Prendergast's polished compositional skills. His mastery of watercolor technique allows the colors to merge with one another while retaining their individuality. The picture confirms the artist's status as an innovative interpreter of modern life.

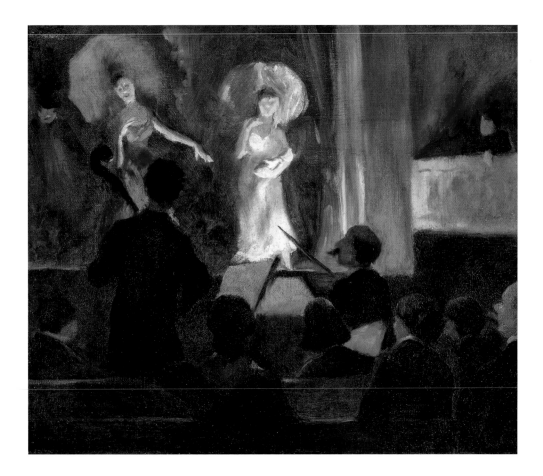

Everett Shinn (1876–1953)
Theater Scene, 1903

> Oil on canvas, 12 ¾ × 15 ½ in. (32.4 × 39.4 cm),
> Terra Foundation for American Art, Daniel J.
> Terra Collection, 1999.136

Everett Shinn ranks among the most versatile
and talented members of the derisively named
Ashcan school, artists best known for their
portrayal of gritty urban subjects. In 1900 he
traveled to Paris and London, where visits to
music halls and vaudeville theaters fueled
his passion for the stage and inspired some of

his primary subjects. In the intimate yet vivid
Theater Scene, two actresses, lit from below by
unseen footlights, pose near the edge of a stage,
with a spectral male figure in the shadows
behind them. The immediacy and realism of
this painting—effected through rough, sketchy
brushwork and casual, off-center framing—
suggest that Shinn painted it in the theater
itself. For him and his fellow artists Robert
Henri, George Bellows, and William Glackens,
such popular-entertainment venues embodied
the ebullience and pathos that characterized
the modern urban experience.

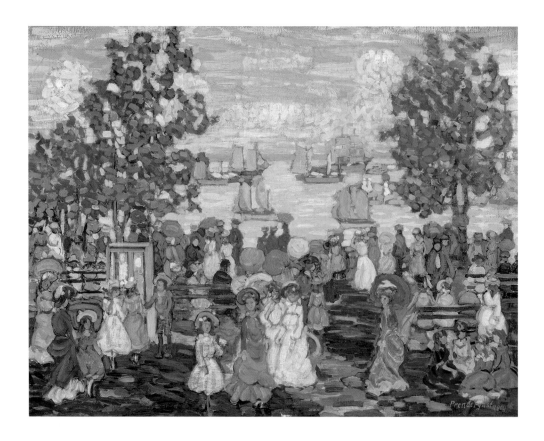

Maurice Brazil Prendergast (1858–1924)
Salem Willows, 1904

Oil on canvas, 26 ¼ × 34 ¼ in. (66.7× 87 cm),
Terra Foundation for American Art, Daniel J.
Terra Collection, 1999.120

An early modernist, Maurice Brazil Prendergast
was known for his vibrant depictions of busy
cities, urban parks, and beaches. In the first
decade of the century, he captured scenes of
contemporary life by dissolving his images in

dense tapestries of color. *Salem Willows* is one of
several works he devoted to the seaside munic-
ipal park of the same name on Massachusetts'
northern coast that opened in 1858. A crowd
of brightly dressed women and children stroll
or rest against a backdrop of open water dotted
with ships and boats; two tall trees frame the
view. Prendergast used layered pigment to
achieve a complex textural effect. The careful
arrangement of dark and light colors animates
and energizes the picture.

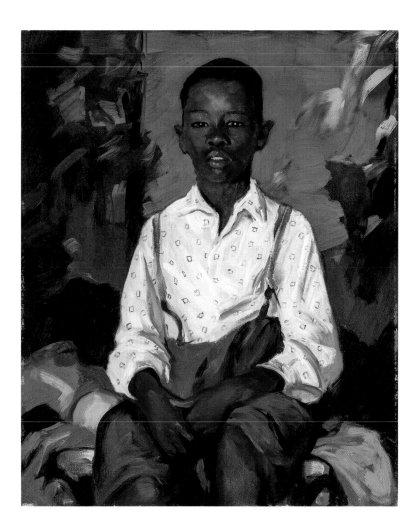

Robert Henri (1865–1929)
Sylvester, 1914

> Oil on canvas, 32 × 26 in. (81.2 × 66 cm),
> Terra Foundation for American Art, Daniel J.
> Terra Art Acquisition Endowment Fund, 2017.2

Sylvester belongs to a group of portraits Robert Henri made in La Jolla, California, during the summer of 1914, following his participation in the groundbreaking 1913 Armory Show in New York. In California, he painted portraits of Native Americans, Mexican and Chinese immigrant children, and a local African American newsboy named Sylvester Cunningham Smith, whom the artist considered an "irresistible" subject. Here, the boy—dressed in a white patterned shirt and knickerbockers held up by suspenders—sits erect, gazing directly at the viewer. As in his most daring La Jolla portraits, Henri depicted Sylvester before a brightly colored, abstract background that focuses attention on the sitter's nuanced expression. He painted few portraits of African Americans during his long career, but in 1914 he produced three of Sylvester. The Terra Foundation's version is representative of Henri's best work in child portraiture, a major part of his oeuvre from about 1900 until his death in 1929.

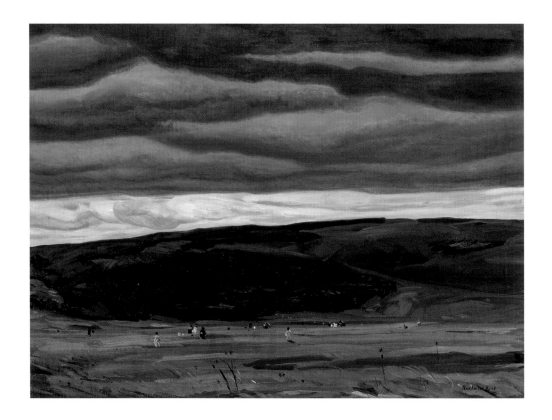

Rockwell Kent (1882–1971)
Cranberrying, Monhegan, c. 1907

Oil on canvas, 28 1/16 × 38 1/4 in. (71.3 × 97.2 cm),
Terra Foundation for American Art, Gift of
Mr. Dan Burne Jones, C1983.4

The multitalented Rockwell Kent was a skilled
painter, printmaker, illustrator, photographer,
and filmmaker as well as an intrepid traveler,
writer, and political activist. A contentious ideal-
ist who rejected modernism's focus on the artist's
inner life, he favored a style he described as
"romantic realism" to make his work accessible to
a wide audience. In *Cranberrying, Monhegan*,
tiny figures are scattered across a cranberry
bog below a grassy ridge and a veil of thick
blue-gray clouds. The artist's application of
paint in broad, sweeping strokes comple-
ments the boundless horizontal landscape, in
which the harvesters appear vulnerable to this
island's mutable weather. In his paintings of
Monhegan, a popular summertime destina-
tion in Maine where he lived and worked from
1905 to 1910, Kent depicted an isolated locale
whose inhabitants come face-to-face with
elemental nature.

In Rockwell Kent's *Cranberrying, Monhegan*, people pick fruit in an open landscape: between land and sky they labor in a bog on this remote, wild, and wind-blown island off the coast of Maine. Humankind dissolves under a menacing blue and gray sky. The scene is calm, but the painting hints at an oncoming storm. Kent first came to Monhegan—an island of less than one square mile that was home to a fishing village and a small artists' colony—from New York City in 1905 at the age of 22. The works he made there, this one among them, were early revelations of his gift for capturing the tenor of isolated places.

In subsequent decades, Kent established himself as the premier painter of coastlines and oceans throughout the Americas, working in rarely visited areas and depicting landscapes largely devoid of people. From the cliffs and coastal rocks, houses and boats of Monhegan, he moved west to Resurrection Bay in the Gulf of Alaska in 1918, then south to the Strait of Magellan at the tip of South America in 1922, before going north to Greenland in the summer of 1930, where he weathered the brutal winter of 1931. He made paintings of these desolate places, as well as numerous drawings and wood engravings of persons, objects, and detailed scenes of those in transit to the uttermost ends of the earth.

Throughout his career, Kent considered himself a "romantic realist." Across two-and-a-half decades and thousands of miles of travel north and south, he combined elements of naturalism with a modernist tendency to critique both objective and subjective experience. His peripatetic travels, his voluminous writings on a range of topics, together with his paintings, drawings, wood engravings, and photographs are representative of the possibilities available to artists in the early twentieth century for experience, media, and technologies, as well as political and social understandings of the world and the role of art within it. There are resemblances between Kent's aims and those of other artists and writers: in his 1920 book *Wilderness: A Journal of Quiet Adventure in Alaska*, Kent quoted the British poet and printmaker William Blake (1757–1827) and enthused over Blake's "intense and illuminating fervor,"[1] a quality echoed in the vivid prose of Kent's travelogues, including *Wilderness* and *Voyaging Southward of the Strait of Magellan* (1924).

Cranberrying may be an autobiographical painting, as many of Kent's works were—a portrait of quiet and solitude wrapped around a small convulsion of human life. "The only things that are far away are those that we do not know how to see," sang Argentine folk guitarist Atahualpa Yupanqui (1908–1992) in "Distancia." Continually shifting his focus from the macro to the micro, Kent collapsed the distance between his viewers and the far-flung landscapes he traversed and depicted.

Alberto Harambour, *Associate Professor*,
Universidad Austral de Chile, Valdivia

First laid out in 1872, Riverside Park on the Upper West Side of Manhattan was meant to bring the splendor of the Hudson River Valley into the heart of New York City. Much of it is hillside descending precipitously to the mighty Hudson, while even steeper cliffs, the Palisades of New Jersey, rise on the far bank. In the early twentieth century the park was still a work-in-progress. In the early months of 1909, when George Bellows painted this raw and chill-inducing view, foliage remained sparse, visitors rare, pathways muddy, and the New York Central Railroad cut like a knife along the shoreline. This was one of those liminal areas—of the city but with its back turned to it, no longer natural, not quite urban—which had attracted the artist's eye almost from the moment he arrived in New York in 1904. His early paintings of the city constitute a rough survey of its ragged edges, from the Brooklyn Bridge sheltering a lone tenement to the docks of Brooklyn, from the teeming Lower East Side to the Battery. Not long before he turned to Riverside Park, Bellows had focused his attention on the hell-mouth whose gaping maw had opened in the middle of Manhattan—the excavation for Pennsylvania Station.

It was Bellows's genius to perceive the aesthetic interest in such unlovely urban motifs. He captured the dynamism of the explosively growing city in an art that exemplified the epic forces at play at the beginning of what would come to be called "the American century." And yet in important aspects he was adopting strategies of French avant-garde painting of the previous forty years. The impressionists of Paris were among the first to identify the incursion of the railway as a quintessential contemporary theme. Claude Monet (1840–1926) painted the Parisian Gare Saint-Lazare over and again, locomotives filling the metal train shed with swirling steam. Georges Seurat (1859–1891), in his *Bathers at Asnières* of 1884 (The National Gallery, London), depicts working-class lads enjoying their day off along the Seine; in the background a train roars across a steel bridge and factory chimneys belch sulphurous fumes; the boys' respite will be brief. When he arrived in Paris in 1886, Vincent van Gogh (1853–1890) sought out vantage points high in Montmartre whence to depict countryside giving way to city, charming windmills to charmless apartment blocks, rows of street lamps where the streets had not yet been laid in. That fascination with transition—not quite one thing, not yet another—is what Bellows brought to New York.

So too his persistent exploration of the city under snow; Riverside Park without it interested him little. More than thirty years earlier, during the French winter of 1874–75, famous for its heavy snowfall, Monet obsessively painted some eighteen views of the town of Argenteuil, every street buried in white. For both artists, perhaps, the challenge was technical. Snow, with its infinite responses to the play of light, is the painter's ideal vehicle for finding the equivalence between what is depicted and how it is painted, so that paint itself takes on the quality, consistency, and obdurate physicality of snow. That, for both painters, constituted the deep formal challenge of modern painting.

Christopher Riopelle, *Curator of Post-1800 Paintings*,
The National Gallery, London

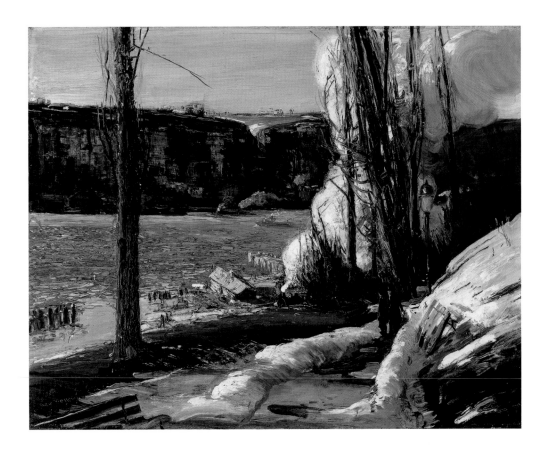

George Bellows (1882–1925)
The Palisades, 1909

Oil on canvas, 30 × 38 ⅛ in. (76.2 × 96.8 cm),
Terra Foundation for American Art, Daniel J.
Terra Collection, 1999.10

A prominent realist painter of modern urban life active in the early twentieth century, George Bellows captured New York City and its inhabitants in numerous paintings, drawings, and prints. *The Palisades* is part of a series of Hudson River paintings in which the artist demonstrated his mastery of painting snow. Framed by tall trees, this plunging view of the riverbanks conveys the crystalline light and dry chill of a winter day. In the background, the darkened New Jersey Palisades provide a strong counterpoint to the brilliant sky, water, and snow. By juxtaposing complementary colors such as orange and blue, Bellows revealed his adherence to the color theory promoted by the Chicago paint manufacturer Hardesty Maratta (1864–1924), who likened color combinations to chords in music and encouraged the use of strong contrasting colors. *The Palisades* signals a major shift in Bellows's approach to both color and composition.

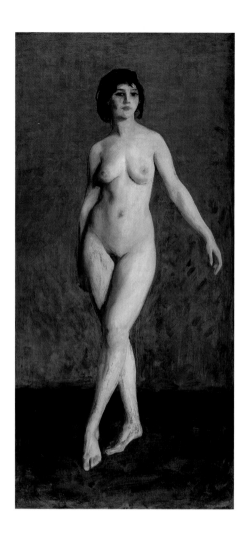

Robert Henri (1865–1929)
Figure in Motion, 1913

Oil on canvas, 77 ¼ × 37 ¼ in. (196.2 × 94.6 cm),
Terra Foundation for American Art, Daniel J.
Terra Collection, 1999.69

A founder of the so-called Ashcan school and respected teacher of several major modernists, Robert Henri rejected conservative art education and instead encouraged subjective artistic expression. Created for the famed Armory Show of 1913, *Figure in Motion* presents a nude woman in a dancelike pose; it evokes a single moment in a movement that presumably will continue. Henri's expressive brushwork complements the figure's sense of motion and emphasizes the active nature of painting itself. He portrays the female nude as a modern individual. Her fluid gesture, as she raises herself on her toes, recalls the emerging art of modern dance as pioneered by the acclaimed performer and choreographer Isadora Duncan (1877–1927), whose work Henri avidly followed. In this work, he suggests that the relentless motion and change characterizing modernity are synonymous with the dynamism of life itself.

With chin aloft, lips taut, and dark eyes meeting our gaze, she steps toward us on tiptoes, one arm swung wide. Poised, unabashedly naked, seductive, and self-possessed, Robert Henri's *Figure in Motion* commands attention.

That air of confrontation accords with the way the painting—made quickly in the weeks prior to the 1913 Armory Show—has been understood by scholars: an American realist's preemptive strike against European modernism generally and Marcel Duchamp's (1887–1968) *Nude Descending a Staircase* (1912) specifically. But while *Figure in Motion* can be seen as an attempt to meet the Europeans on their own terms, it is also an expression of Henri's sustained artistic and intellectual investment in the naked body.

In his 1912 etching *Anshutz on Anatomy*, John Sloan (1871–1951) pictures himself, Henri, and members of their circle at the New York School of Art absorbed by a 1905 lecture in which the painter Thomas Anshutz (1851–1912) uses clay to model musculature on a skeleton. This was a nod to the anatomy-centered teaching that Anshutz and Thomas Eakins (1844–1916) had pioneered at the Pennsylvania Academy of Fine Arts in the 1880s, and that Henri pursued before coming to his own "unscienced but alive" approach, in which painting from a naked model became a sensual, even mystical, encounter.[1] Guy Pène du Bois (1884–1958) re-called Henri questioning the manhood of students who "could draw or paint this woman in all her glorious nudity as though she were a plaster cast, a thing less alive than a cabbage."[2] Alice Klauber (1871–1951) transcribed a 1912 class in which Henri observed, "a nude young girl in the light is a mystery. I wish to know and could understand the reason for my great pleasure—the thing that causes an activity in my mind, to understand what I see and feel, and to be able to paint the sensation."[3]

While these pronouncements are made in the macho idiom often associated with Henri, they mark a wider interest among both men and women in his milieu in the positive nakedness celebrated by Walt Whitman (1819–1892), America's great "poet of the Body," who understood nakedness as a removal of barriers, as fig-ure and expression for honest encounter with the self and others. Sloan complained in a 1908 diary entry, "How few painters can show in their work, 'I had a manly love or desire.'"[4] Isadora Duncan (1877–1927), whose Whitman-inspired dances often revealed her naked form, was described by Henri as "one of the prophets."[5] The anarchist writer and activist Emma Goldman (1869–1940), another strong, modern woman friend of Henri's, urged artists to embrace the human form as "the nearest thing to us in all the world, with its vigor and its beauty and its grace."[6] In a 1912 article on fashion, he celebrated the "gradual, if more or less unconscious, tendency in modern dress toward less concealment of the form.... We have got to get over thinking that the entire body is something to be ashamed of."[7] From studio to stage to street, these figures pursued a frank, materialist embrace of the body.

In *Figure in Motion* Henri seeks to make the encounter between model and artist palpable, confrontational, and sexual, to paint the sensation of two modern bodies meeting.

John Fagg, *Lecturer in American Literature*, School of English, Drama and American & Canadian Studies, University of Birmingham, UK

George Luks (1867–1933)
Knitting for the Soldiers:
High Bridge Park, c. 1918

Oil on canvas, 30 3/16 × 36 1/8 in. (76.7 × 91.8 cm),
Terra Foundation for American Art, Daniel J.
Terra Collection, 1999.87

George Luks was part of a group of artists known as The Eight, who showed their work in 1908 in reaction to the National Academy of Design's conservative exhibition policies. Although his painting style evolved throughout his career, expressive depictions of everyday life in New York City remained Luks's primary subject matter.

The refined middle-class figures and vibrant palette seen in *Knitting for the Soldiers: High Bridge Park* contrast sharply with the more somber subject matter and style of his earlier work. Here, the artist captured the brisk atmosphere and cold light of a winter's day; companionable women of various ages are knitting outdoors for a mutual cause. The bright colors and unsentimental appreciation of this mundane activity recall French impressionist scenes of modern life. When exhibited in 1918, Luks's painting was titled simply *Knitting*, but contemporary critics assumed that the garments were intended for men serving in World War I (1914–18).

Thomas Hart Benton (1889–1975)
Slaves, 1925

Oil on cotton duck mounted on board,
66 7/16 × 72 3/8 in. (168.8 × 183.8 cm), Terra Foundation
for American Art, Daniel J. Terra Art Acquisition
Endowment Fund, 2003.4. Art © Romare Bearden
Foundation / Licensed by VAGA, New York, NY

Thomas Hart Benton was a pioneering painter
and muralist known for his dynamic large-scale
depictions of Midwestern agriculture, industry,
and landscapes as well as of challenging episodes
in American history. _Slaves_ is one panel in his
extensive multi-painting series _The American_
Historical Epic (1919–28), which presents a revi-
sionist view of the country's early history through
themes of racial conflict and economic exploitation.
This work is an indictment of the abuse enslaved
Africans suffered in America from the seventeenth
century until the practice was abolished in 1865.
A white overseer brutalizes a man and his family
on the deck of a slave ship as it approaches the
American shore. Although in Benton's time slavery
was a topic considered largely in historical terms,
Slaves appears unabashedly contemporary in style
and execution and unequivocally conveys the
artist's abhorrence of both slavery and the ongoing
mistreatment of African Americans.

Walter Ufer's 1923 painting *Builders of the Desert* exemplifies the Taos Society of Artists' potent blend of academic proficiency and identifiably American subject matter. Though Ufer, like many of the group's members and patrons (including the well-known manufacturer Oscar Mayer [1859–1955]), was of German ancestry, he supported the United States' involvement in World War I, lending his skills as an illustrator to the government's Fourth Liberty Loan war bond poster campaign. His "Guard Your Interests," "For Freedom of the Seas," and "Bomb The Hun!" designs encouraged anti-German wartime sentiment.

Prior to 1917, American artists still favored studies abroad. Ufer, aspiring to move beyond commercial art, returned to his native Germany in 1911 to study painting and to visit European collections. Following the example of his Munich teacher, Walter Thor (1870–1929), whose technique encouraged painterly immediacy in rendering color through light and shadow, Ufer produced remarkable portraits of rural types such as *Tyrolean Woman—Plein Air* (1912, collection of Mike Abraham).

Ufer returned to Chicago ready to transfer his skills to an American context, and the city's mayor, Carter Harrison Jr., garnered support among the city's sizable German-American business community to send the artist to New Mexico in 1914. The former territory had become the nation's forty-seventh state two years prior, just over 60 years after Mexico ceded its holdings in the American Southwest following the Mexican-American War (1846–48). Taos and Santa Fe quickly emerged as destinations for artists, writers, and collectors inspired by the Santa Fe Railway's promotion of New Mexico's clear skies, Pueblo architecture, and the topographic splendor of plains, mountains, basins, mesas, and desert. The Taos Society of Artists was subsequently founded in 1915 and its members earned national acclaim for their distinctive American landscapes. Travel postcards promoted art as "A Taos industry": one iconic image shows a painting palette inset with regional landscape; another shows an artist (looking remarkably like Ufer in his signature Stetson cowboy hat) outdoors at his easel.

In 1918 Ufer was already being described as "the strongest painter" of the Taos group.[1] *Builders of the Desert*, labeled a "fine landscape" in 1924,[2] ambitiously combines multiple images of Taos Puebloans—all of whom resemble Ufer's friend and model Jim Mirabal—engaged in various stages of traditional adobe-building practice. Pueblo Peak, seen in the distance, and the ruins of the original San Geronimo church rising in the middle ground identify the geographic location under a bright midday sun.

Ufer's painting attests to the hard-won survival of Pueblo culture in the twentieth century. In 1921 the federal Office of Indian Affairs issued Circular No. 1665 classifying certain dances and rituals as "Indian Offences"; in 1923—the year Ufer's picture was painted—a supplement to the circular further refined this condemnation.[3] The 1922 Bursum Bill aimed to reduce native land ownership through federal regulation.[4] These efforts failed and today the Tiwa-speaking community of Taos remains a "living Native American community," a UNESCO-designated World Heritage Site, and a National Historic Landmark.[5]

Anna Hudson, *Professor*, Canadian Art History
and Curatorial Studies, York University, Toronto

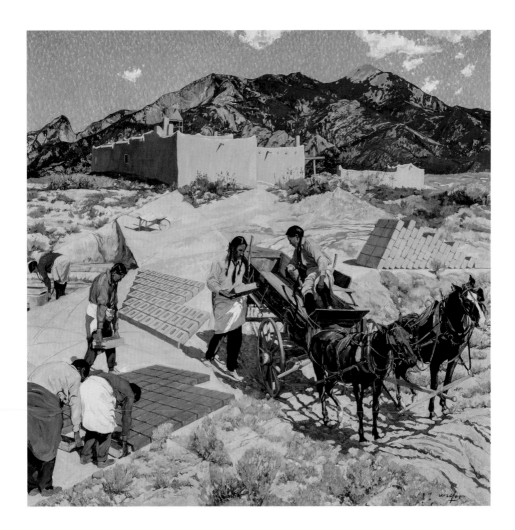

Walter Ufer (1876–1936)
Builders of the Desert, 1923

> Oil on canvas laid down on aluminum,
> 50 ⅛ × 50 ⅛ in. (127.3 × 127.3 cm),
> Terra Foundation for American Art, Daniel J.
> Terra Collection, 1992.174

In the early twentieth century, Walter Ufer, a leading member of the Taos art colony, became well known for his naturalistic depictions of New Mexico and its indigenous inhabitants. *Builders of the Desert* shows several stages of adobe brick construction while rendering the unique effects of the glaring sun on the region's parched landscape. It demonstrates Ufer's adherence to plein-air painting and his remarkable ability to transcribe New Mexico's unique colors. It also delivers a strong social message. The rugged mountains and vertical lines of the adobe church contrast sharply with the hunched postures of the Taos Puebloans. By highlighting the backbreaking labor necessary to produce such buildings, Ufer vividly portrays contemporary Pueblo life in ways that refute the romantic stereotype of the so-called vanishing race.

Reginald Marsh (1898–1954)
Chicago, 1930

> Watercolor, over graphite, on cream wove watercolor paper, 13 ⅞ × 20 in. (35.2 × 50.8 cm),
> Terra Foundation for American Art, Daniel J.
> Terra Art Acquisition Endowment Fund, 1998.4

The urban-realist painter Reginald Marsh is known for his scenes of New York City, which he showed as vulgar, chaotic, and teeming with life. A departure from his dynamic representations of social types, *Chicago* displays his sensitivity to urban built environments. This watercolor presents a row of decaying Victorian-era storefronts along a nearly deserted street, with a factory building, water towers, and an exhaust stack looming in the background. Marsh's 1930 visit to Chicago yielded several images of the city in watercolor, which he applied in rapid lines and washes. Ignoring the recently erected architectural showplaces in the city's bustling commercial districts, he focused on scenes that captured the anxiety and despair following the stock market crash of October 1929. In *Chicago*, the woeful condition of these modest structures suggests the glaring contrast between the optimism of the 1920s and the encroaching realities of what became known as the Great Depression.

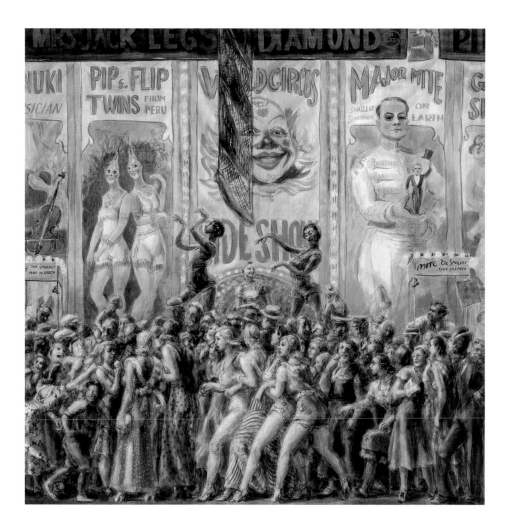

Reginald Marsh (1898–1954)
Pip and Flip, 1932

> Tempera on canvas mounted on canvas,
> 48 ¼ × 48 ¼ in. (122.6 × 122.6 cm), Terra
> Foundation for American Art, Daniel J. Terra
> Collection, 1999.96

Reginald Marsh was an important urban-realist painter of Depression-era New York who made vibrant images of the seedier sides of big-city life. Coney Island, New York's beach refuge for the masses, appealed to Marsh for its energy and eccentricities and for the opportunities it gave him to study the human body in all its variations. Like many of his compositions, *Pip and Flip* presents a frieze-like throng of people in a compressed space and highlights the voluptuous female form that came to be known as the "Marsh girl." An excellent draftsman, the artist appreciated the way translucent layers of egg tempera could reveal the linear drawing beneath the color. His attraction to gaudy entertainment is clearly evident here: banners represent the circus sideshow and painted backdrops depict the stars of the midway.

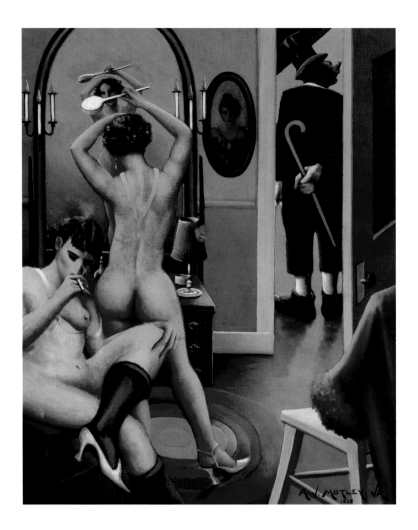

Archibald J. Motley Jr. (1891–1981)
Between Acts, 1935

Oil on canvas, 39 ½ × 32 in. (100.3 × 81.3 cm),
Terra Foundation for American Art, Daniel J.
Terra Art Acquisition Endowment Fund, 2009.1

Archibald J. Motley Jr., one of the best-known
African American artists of the twentieth century,
broke new ground by depicting contemporary
black urban subjects in portraits and images of
everyday life. Working mainly in Chicago, he
painted lively South Side street scenes with bril-
liant colors, dramatic light effects, and stylized
forms evocative of jazz and the blues. *Between
Acts* makes the observer a backstage voyeur,
peering into a dressing room where two nearly
naked female performers relax. A top-hatted
figure stands just outside the door, holding a
cane behind his back and smoking a cigar. His
clownishly oversized hands and exaggerated red
lips refer unmistakably to the racist caricatures
of blackface minstrel shows, which drew audi-
ences well into the twentieth century. Motley's
use of streamlined, stylized forms and eccentric
color schemes endow such images with a fantas-
tical quality.

When philosopher and critic Alain Locke wrote in 1936 that, in contrast to the artistic sobriety of many African American painters and sculptors, "[Archibald] Motley's Rabelaisian turn is a promising departure,"[1] he probably had in mind a painting like *Between Acts* (1935). Part of Motley's (1891–1981) exploration of Chicago's predominately African American, culturally vibrant, status-conscious Bronzeville neighborhood, *Between Acts* portrays one of that community's more sordid aspects: the scantily clad showgirls and ludicrous blackface comedians who performed in local theaters and nightclubs. Instead of depicting these entertainers dancing and clowning, *Between Acts* shows them offstage, and, in essence, out of their respective, invented characters—smoking, idling, and primping before a mirror.

In typical Motley fashion, *Between Acts* used an intimate, boudoir-like setting as a rationale for painting naked and virtually nude women in seductive poses, a strategy he also employed in *Brown Girl After the Bath* (1931, Columbus Museum of Art, Ohio) and *Black Belt* (1934, Hampton University Museum, Virginia). Like the paintings of George Grosz (1893–1959), with their depictions of the moral decay of Weimar Berlin, *Between Acts* suggests a narrative with moral overtones about denizens of the African American *demimonde* forming their own confraternity (or in this instance, a consorority) of social outsiders. As targets of spectatorship and derision, these two "loose women," and the stereotypical black jokester standing in the doorway, performed their desultory roles against the social backdrop of moral probity and racial uplift. And yet by painting them as a trio of sorts—in a casual, nontheatrical way—and within a composition of arches, rectangles, and interior patterns, Motley challenged Bronzeville's more somber and neurotic side via an audacious, transgressive scene of explicit female sexuality and hyperbolic blackness.

Three iconographic flashpoints in *Between Acts*—the blackface minstrel's cane, the painted portrait of a woman on the dressing room wall, and the seated woman's crossed leg sporting black hosiery and a white "Spanish heel" shoe—insert subliminal content that, given their somewhat Freudian, psycho-sexual connotations, may explain the painting's forty-odd year confinement to Motley's studio. The painted oval portrait aligns with the depicted room's wall and creates a link between the two women on the left and the man on the right; it contributes to the enigmatic nature of *Between Acts* a shadowy, intractable cameo of a sitter whose vague identity echoes the elusive and problematic personae of the flanking minstrel and showgirls. Motley's fearless probing of the psychological symbolism of figural subjects and compositional elements set him apart from other Depression-era artists (and likewise from a conservative American art market) and, in matters pertaining to racial identity and sexual mores, singularized his work.

"Motley seems more and more fascinated by the grotesqueries and oddities of Negro life," Locke astutely noted, "which he sometimes sarcastically, sometimes sympathetically, depicts."[2] In the case of *Between Acts*, one might add to Locke's assessment Motley's at times problematical, insurrectionary depictions: pictorial passages that introduced impolitic issues the majority of Americans preferred to sweep under society's metaphorical carpet.

Richard J. Powell, *John Spencer Bassett Professor of Art & Art History*,
Duke University, Durham, North Carolina

During the early 1930s, New York City art dealer Edith Halpert (1900–1970) convinced Charles Sheeler to distance himself from photography for fear that the much admired clarity of his painting would be attributed solely to its photographic origins. Sheeler duly obliged, meaning, ironically, that the artist often considered the preeminent artist of the Machine Age willingly suppressed his use of a machine. As early as 1920, critic Henry McBride (1867–1962) noted in his review of Sheeler's "Bucks County Barns" exhibition at the De Zayas Gallery in New York that what ignited his interest most were the artist's photographs. McBride argues against the "ascetism" of the drawings titled *Barn Abstraction* but for the photographs of the barns. Sheeler's "relentless eye" and the fact he "never forgets for a moment that the camera is a machine" are counted as major achievements.[1] Perhaps Halpert's concern had grounds.

Against Halpert, I would like to argue that Sheeler's photography is not a problem but rather a means to understand the artist's nonphotographic work better. Throughout his life, Sheeler was very clear that every medium he chose possessed distinct and unique attributes, despite their shared subject matter. This is especially true of his continued exploration of Bucks County barns. As a guide, I offer a modern interpretation of photography that postdates Sheeler's work, Museum of Modern Art curator John Szarkowski's (1925–2007) take on the American photographer William Eggleston (b. 1939): "Form is perhaps the point of art," argues Szarkowski. "The goal is not to make something factually impeccable, but seamlessly persuasive."[2] Sheeler's *Bucks County Barn* (1940) appears seamlessly persuasive, but the formal continuity of the image is a visual trick—it is Sheeler's photographic vision remade through the medium of painting.

Remaking and revision are central to Sheeler's method. Few of his works are simply themselves. Singular. Unique. Each of his images has a past (and a future). And its past, present, and future will always be different. *Bucks County Barn* was followed by *Thunder Shower* (1948, Carnegie Museum of Art, Pittsburgh) and preceded by several conté crayon drawings—including *Barn* (1917, Museum of Modern Art, New York) and *Barn Abstraction* (1918, Philadelphia Museum of Art)—and these had in turn succeeded a series of photographs, including *Bucks County Barn* (*with Chickens*), (*with Wall*), and (*with Gable*) (all 1916–17, Museum of Fine Arts, Boston).

Bucks County Barn is a sleight of hand—a contiguous whole, a fully formed and coherent image. But look beyond the dominance of volumetric form, note the opacity of the windows, the suggested thresholds and blocked entry points to the barn. The building is both pristine and weather worn, with some areas of high detail and other areas blank. Seriousness is set against playfulness, reality is skewed. A broken fence, next to the low coop or shed, leads the eye to a predatory silhouette advancing on two headless cows. A perimeter breached, a quiet invasion in plain sight of the sightless. A symbolic gesture toward American insularity and indifference to world events in 1940? Perhaps. A skewering of photographic realism, itself a myth: definitely.

Mark Rawlinson, *Associate Professor of History of Art*, University of Nottingham, UK

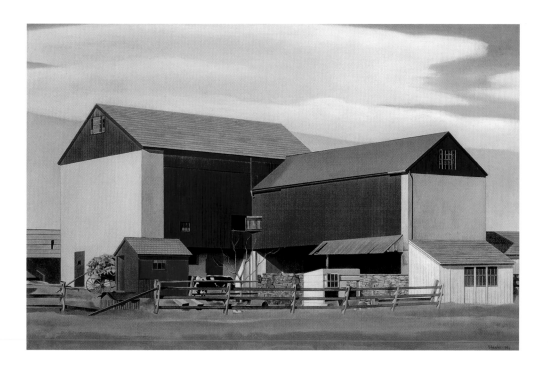

Charles Sheeler (1883–1965)
Bucks County Barn, 1940

> Oil on canvas, 18⅜ × 28⅜ in. (46.7 × 72.1 cm),
> Terra Foundation for American Art, Daniel J.
> Terra Collection, 1999.135

Charles Sheeler pioneered the distinctly American style known as precisionism. Characterized by a stark aesthetic, it drew inspiration from the stripped-down utilitarian look of the industrial environment. Recognized for his work both as a photographer and a painter, Sheeler relied on the uncluttered functionality of vernacular design to produce coolly analytical art.

Bucks County Barn emphasizes the building's geometric structure to celebrate the clean clarity and spare design of Pennsylvania's traditional architecture. Countering the aura of stillness and impersonality that the painting projects, two cows, pale-green grass, and the downed rails of a fence lend the image authenticity and immediacy. This crisp portrait of the red-and-white barn, based on a Sheeler photograph, recalls the intent of the so-called American Scene movement, which exalted the heartland and advocated an artistic style both modern and emphatically American.

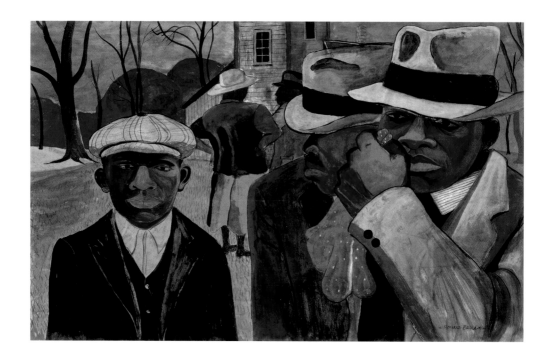

Romare Bearden (1911–1988)
After Church, 1941

Gouache on brown paper, 22 × 34 ½ in. (55.9 × 87.6
cm), Terra Foundation for American Art, Daniel J.
Terra Art Acquisition Endowment Fund, 2015.2. Art
© Romare Bearden Foundation / Licensed by VAGA,
New York, NY

A renowned African American collage artist and
painter, Romare Bearden was born in the South
but lived most of his life in New York City. His
gouache painting *After Church*, completed after
a lengthy visit to Georgia and his home state

of North Carolina, marks the beginning of his
engagement with Southern African Americans—
particularly their families, faith, and livelihoods
as farmers. The work depicts a small group of
male congregants socializing outside a church.
A man, who fills much of the picture plane, wipes
perspiration from his face, while a boy stares
outward toward the viewer, implying our inclu-
sion in the scene. *After Church* represents a pivotal
moment in the artist's career, when abstracted
figures and large swaths of color create a tension
between representation and abstraction that
Bearden would continue to exploit.

From the start of his career, Romare Bearden's ambition equaled his copious talent, despite the limited exhibition opportunities available to African-American artists of his generation. This is apparent in the dramatic strength that marks *After Church*, one of several gouaches on brown paper Bearden painted in the early 1940s, after two important events that occurred in 1940. One was the artist's first solo exhibition, held May 4–11, at 306, an interracial gathering place for artists, writers, dancers, musicians, and other intellectuals in New York's Harlem neighborhood. The admiration the show received must have expanded Bearden's confidence in the power of his work. The second event was a trip during the Christmas holidays with the African American artist Charles Alston (1907–1977).[1] Returning to the American South after an absence of fifteen years, Bearden stopped at his North Carolina birthplace, which he had visited often in his youth.

In his statement for the 306 show, Bearden wrote:

> *I believe the function of the artist is to find ways of communicating, in sensible, sensuous terms, those experiences which do not find adequate expression in the daily round of living.... Art is an expression of what people feel and want.... This fact, plus horse-sense, resolves all questions as to ... the role of the artist in society.... For a painting to be "good" two things are necessary: that there be a communion of belief and desire between artist and spectator; that the artist be able to see and say something that enriches the fund of communicable feeling.*[2]

These words illuminate Bearden's heroic paintings of the early 1940s, which measured as much as 48 inches tall and set out motifs he would investigate repeatedly throughout his life. Subjects feature Christian iconography, such as the Visitation and Baptism, and important community rituals such as breaking bread and praying together, as suggested by *After Church*. The importance of this painting to Bearden is evinced by the fact that it was on view late in 1941 at the Downtown Gallery run by Edith Halpert (1900–1970), one of New York's most prestigious venues, in the exhibition *American Negro Art, 19th and 20th Centuries*. The show opened a few days after the bombing of Pearl Harbor, when art world news was of minor consequence. Like so many shows in which Bearden participated through 1945 and beyond, it was racially segregated. (In 1945 he was invited to join Kootz Gallery but was dropped three years later and lacked gallery representation through the 1950s.)

Bearden's art always rose above these limited circumstances. *After Church* reveals his broad knowledge of art history, juxtaposing as it does landscape backgrounds inspired by medieval religious paintings, the fragmented layering of cubist compositions, and the voluptuous forms of Mexican muralists. Moreover, his far-reaching intuitive talent is vividly present in the individual portraits within *After Church*, and in the power of each figure's interactive gestures. These qualities, along with the artist's distinctive palette and strong compositional struc-ture, all contribute to the ability of *After Church* to enrich that "fund of communicable feeling."[3]

Ruth Fine, *Independent Curator*, Philadelphia, Pennsylvania

The meaning and importance of *Dawn in Pennsylvania* do not derive solely from Edward Hopper's treatment of an almost empty railway platform with industrial buildings in the background, or from the painting's clichéd atmosphere of silence and solitude. The image thwarts any attempt at a convincing, visually justified narrative. It is remarkable because while maintaining its individual character it brings into focus the most interesting aspects of Hopper's oeuvre as a whole.

In terms of structure, the picture evinces his proclivity for multiplying frames: the frame of the painting is internally doubled by the lines of the platform, its roof, massive pillar, and post on the right. The result is a special role assigned to the platform, no longer a "non-place," to borrow the term coined by anthropologist Marc Augé, but a pictorial stage for viewing and—only potentially—approaching the cinema-screen-like image formed by the gloomy cityscape set against the dawning sky in the painting's background. The main "actors" that connect the platform/stage and the cityscape backdrop are the luggage cart to the right and the train car, which together also perform the role of stage "curtain." Neither element dominates—they maintain a productive, balanced tension between stasis and action, between the whole and the fragment, reminding viewers of the photographic and cinematic qualities of Hopper's work.

The fragmentary nature of the train stresses a quasi-photographic fixity, while also implying movement out of the frame at left and the vehicle's imminent disappearance. Moreover, as much as one wishes to recognize the familiar scene of a departing train, its almost perfectly symmetrical relation to the cart on the right perceptually holds it in its place. This tension between what film critic and theorist André Bazin (1918–1958) called the centrifugal cinematic screen and the centripetal logic of painting, along with the photographic effect of a freeze-frame, exemplifies the close connection of Hopper's painting with other media.

The uncanny aspect of *Dawn in Pennsylvania* is a combination of its internal coherence and external orientation, the degree to which it is haunted by traces of other Hopper works. First of all, the nocturnal *Nighthawks* (1942, Art Institute of Chicago) serves as a structural template for the overall composition of *Dawn in Pennsylvania*, including the wedge-shaped internal framing and the almost identical vertical element on the right. *Dawn in Pennsylvania* also connects to other railroad paintings by Hopper: like *Railroad Train* (1908, Addison Gallery of American Art, Andover, Massachusetts) it employs a fragmentary rendition of the main motif and a diagonal orientation; and its platform echoes the gray, empty band of wall in *Approaching a City* (1946, Phillips Collection, Washington, DC). Finally, the pattern of light on the pillar and platform recalls aspects of several quite different pictures, such as *Hotel by a Railroad* (1952, Hirshhorn Museum and Sculpture Garden, Washington, DC) and *New York Office* (1962, Montgomery Museum of Fine Arts, Alabama). Despite its apparent darkness, *Dawn in Pennsylvania* radiates references, illuminating Hopper's work as a consistent whole.

Filip Lipiński, *Assistant Professor*, Department of Art History, Adam Mickiewicz University, Poznań, Poland

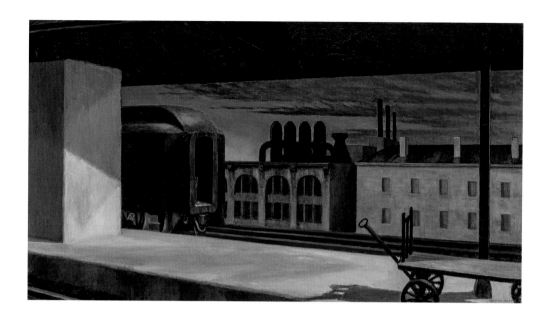

Edward Hopper (1882–1967)
Dawn in Pennsylvania, 1942

Oil on canvas, 24 ⅜ × 44 ¼ in. (61.9 × 112.4 cm),
Terra Foundation for American Art, Daniel J.
Terra Collection, 1999.77. © Heirs of Josephine
Hopper / Licensed by VAGA, New York, NY

Edward Hopper, one of the twentieth century's
most significant artists, produced seemingly
mundane yet mysterious and disquieting
images of American life. Throughout his career,
his compositional style and emphasis on
architectural structures over human figures
distinguished him from his contemporaries.

Dawn in Pennsylvania is a haunting vision of a
deserted railroad-station platform seen from
across railroad tracks. In the background, a row
of industrial buildings anchors the picture.
The back end of the static train car underscores
the stillness of the scene while conflicting light
sources, suggestive of both dawn and sunset,
reinforce its eeriness. With its broad horizontal
format, dramatic contrasts of light and shadow,
and illusionistic framing of a central depth
bound by flat façades, the painting evokes a
theatrical stage on which a narrative is about to
begin. Even the vacant railroad platform hints at
the rootlessness and anonymity of modern life.

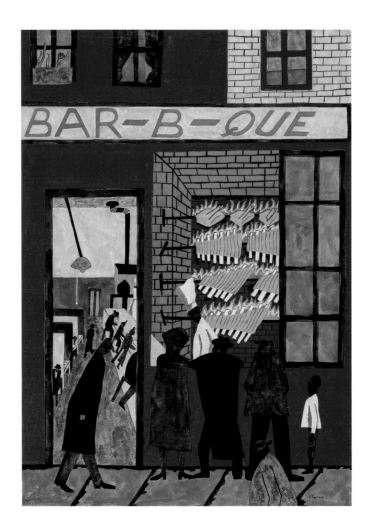

Jacob Lawrence (1917–2000)
Bar-b-que, 1942

> Gouache on wove paper, 30 ⅞ × 22 ½ in.
> (78.4 × 57.2 cm), Terra Foundation for American
> Art, Daniel J. Terra Art Acquisition Endowment
> Fund, 2013.1

The painter Jacob Lawrence is best known for his candid and expressive portrayals of twentieth-century African American life. *Bar-b-que* belongs to a group of strikingly modernist works set in Harlem that he made during a time when this large African American New York City neighborhood was renowned for its cultural vibrancy. The watercolor depicts a barbecue restaurant filled with customers. A white-hatted cook prepares flaming slabs of pork ribs and roasted chickens in a street-facing kitchen as several adults and a child stand transfixed at the window. *Bar-b-que* features a kind of eatery common in the black South transplanted to New York City—just one reflection of the Great Migration, when from roughly 1916 to 1970, some 6 million African Americans, including Lawrence's own family, left their rural Southern homes for cities in the North, Midwest, and West.

Renowned modernist Jacob Lawrence (1917–2000) spent six decades chronicling the African American struggle for economic justice and political freedom. In the Depression-era art workshops of Harlem, Lawrence worked with brown paper and color, learning to see patterned resemblances in the world around him. He developed a lifelong attachment to tempera paint and aqueous media, and a pictorial language that articulated the blunt emotional and physical realities of working-class life in the city's streets and tenements. The visual potency of Lawrence's compositions was matched by his power to synthesize and portray broad historical and economic trends. Given their bold figure-ground relationships, his subjects are usually immediately recognizable. Plumbing his content, however, is like solving a puzzle by discerning relationships between word, shape, and color.

Bar-b-que is one of thirty Harlem subjects Lawrence painted in 1942–43, including rent strikes, stairwells, toilets, schoolrooms, libraries, subway commuters, rooftops, bars and bootleg whiskey, free clinics, and pool rooms. Many bear concise captions that read like excerpts from the official publications of the New York City Housing Authority. In Bar-b-que, passersby dressed in Sunday finery stop on the sidewalk to look at a tall display of ribs and chickens turning on spits in an open window; through a narrow door we see the restaurant's full booths and bar stools—a vision of plenty and relaxation.

The carmine tiles of the rotisserie oven match the sizzling red letters on the restaurant sign spelling out the painting's title. Given its prominence, one may assume that the word is important, and, as with other juxtapositions of word and image in Lawrence's narratives, the subject of temporal elision or culturally specific encoding. The term "barbecue," for example, may derive from the Haitian Creole "barbacoa"—meat prepared over a framework of sticks; such open-flame cooking was practiced in West Africa by the ancestors of American slaves, and later became a frequent part of outdoor "Juneteenth" events celebrating the abolition of slavery in the rural South.

Like the lives of African Americans moving north to escape Jim Crow laws, this laden food culture has been reframed vertically in an urban, multistory brick structure with a storefront and upstairs apartments. The rhythmic cadences of the doorway and windows, articulated in high-keyed greens and blues that may suggest longed-for foliage and sky, provide relief to the relentless red-brown grid of the built environment. A pastoral green restaurant floor leads from the sidewalk, past the black clientele, and into a kitchen in which we can see a black chef, who may well be the proprietor.

Though Lawrence did not identify the restaurant or its owner, the September 5, 1942, edition of the Harlem newspaper Amsterdam News pictured one George Williams, the African American owner of a new barbeque place featuring "Dixie brown ribs" at the corner of 126th Street and Seventh Avenue (now Adam Clayton Powell Boulevard). At a time when the NAACP reported that only 2.3 percent of stores were owned by blacks and half of white-owned businesses in Harlem had no black employees, a depiction of a black-owned and -operated business would have been taken as a sign of economic empowerment.

Elizabeth Hutton Turner, University Professor, Modern Art, University of Virginia, Charlottesville, Virginia, USA

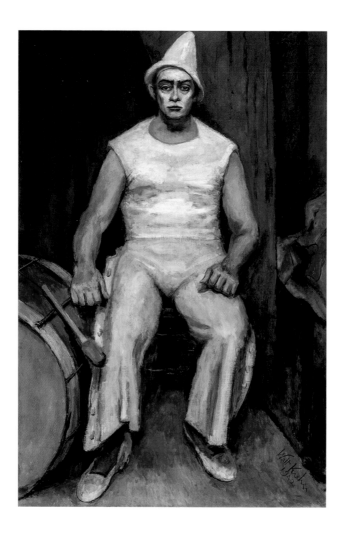

Walt Kuhn (1877–1949)
Clown with Drum, 1942

Oil on canvas, 60 ⅞ × 41 ⅜ in. (154.6 × 105.1 cm),
Terra Foundation for American Art, Daniel J.
Terra Collection, 1992.172

An illustrator, printmaker, painter, sculptor, and adviser to American art collectors, Walt Kuhn played a major role in selecting contemporary European artworks for the groundbreaking 1913 exhibition in New York City known as the Armory Show. By the early 1920s, however, his interest in European modernist trends had waned, and he began creating his signature paintings of New York's vaudeville and circus performers, such as this one. Donning the makeup and costume of a clown, Joe Pascucciello, a local boxer, modeled for the painting. Instead of capturing the entertainer in the act of performing, the work provides a glimpse behind the scenes. Seated with fists clenched and just barely fitting inside the picture, the clown projects a potential for action and demonstrates Kuhn's ability to transmit his sitters' emotional states with an immediacy and authenticity that critics praised.

Edward Hopper (1882–1967)
Sierra Madre at Monterrey, 1943

Watercolor with touches of wiping, over a charcoal underdrawing, on heavyweight textured ivory wove watercolor paper, 21 ¼ × 29 ¾ in. (54 × 75.6 cm), Terra Foundation for American Art, Daniel J. Terra Collection, 1994.18. © Heirs of Josephine Hopper / Licensed by VAGA, New York, NY

Although Hopper is known for oil paintings that evoke the alienation of twentieth-century American life, he was also a consummate watercolorist. One of a group of works he made during his first trip to Mexico, *Sierra Madre at Monterrey* shows the mountain range as the artist observed it from his hotel room. Most of his Mexico watercolors feature views taken from a lower vantage point and focus on the interaction of architecture and the surrounding landscape—a common theme in Hopper's work. Here, the buildings, depicted as a haphazard cluster of rooftops partially visible along the bottom, are dwarfed by the massive blue and green mountains. The work exemplifies Hopper's mature watercolor approach, in which he built up colors in layers and selectively scraped away the medium to create highlights, as seen in the peaks at center left.

Chris McAuliffe

Professor, Australian National University, Canberra

"Paid taxes. Made abstract painting."
Arthur Dove, diary entry, 1942.[1]

The telling of art's history is often shaped by the subtle imperatives of narrative form. It is reasonable to expect that a new American art would emerge in response to the urban and technological experiences of the early twentieth century. But is it also reasonable to assume that this new art would be modeled on the existing achievements of European artists, and that American artists would be judged in terms of their adoption of those precedents? The literature on early American abstraction speaks of artists traveling to Paris or Berlin "to absorb the lessons of European modernism,"[2] and of them managing the "anxieties" of navigating a period "presided over by the creative movements of Europe."[3] Art historians invoke a gold standard to be attained ("pure abstraction"), and a variety of subsidiary measures ("nonillusionistic," "virtually nonobjective painting") to be applied in order to distinguish "so-called" from "actual" abstraction. This ranking and winnowing obscures the many tentative, independent, and even idiosyncratic steps taken by American artists on the path toward abstraction.

While artists such as Patrick Henry Bruce (1881–1936), Arthur Dove (1880–1946), Marsden Hartley (1877–1943), Joseph Stella (1877–1946), and Max Weber (1881–1961) directly encountered the European avant-garde, they did not always affiliate wholeheartedly and consistently with the modernism of Paris, Berlin, and Milan. In the second decade of the twentieth century, these artists encountered the work of Paul Cézanne (1839–1906), as well as examples of fauvism, cubism, and futurism. They worked rapidly through these styles as if sounding out the vocabulary of the avant-garde. Ultimately, they forged hybrid and individual versions of emerging artistic languages in a dialogue between European innovations and entrenched American literary and philosophical traditions.

For American artists, the meaning of abstraction was shaped by the idealism espoused by the American transcendentalist writer Ralph Waldo Emerson (1803–1882). While their practices were diverse, their reflections on what they were doing often touched upon his distinction between materiality and concept, the division between intuition and formal intellection, and the connection between thinking the world and picturing it. In Weber's view, artists possessed "ideal, perceptive or imaginative faculties."[4] Shaped

1 **Joseph Stella (1877–1946), *Telegraph Poles with Buildings*, 1917.**
Oil on canvas, 36 ¼ × 30 ¼ in. (92.1 × 76.8 cm), 1999.139

by what Weber termed the "hand-mind" (making), the "eye-mind" (reflection), and the "feeling-mind" (emotion),[5] an artwork modeled an experience of the world perceived, felt, and intuited. For Hartley, abstraction was an art engaged with "the spirit substance in all things," propelled by "a new fire of affection for the living essence present everywhere."[6] For Dove, abstraction was as direct as the very process of painting—"Starting with nothing and building thereon"—and as expansive as the thought of Buddha, which was "as near abstraction as the human mind has arrived."[7]

Because American artists consistently positioned abstraction at the nexus of the material, the formal, and the ineffable, abstraction traversed the world, studio practices, and the ideal. Stella's *Telegraph Poles with Buildings* (Fig. 1) is grounded in the concrete landscape of American enterprise. But in his engagement with this environment, matters of structure and form were more important than naturalism. His abstraction commenced with the simplification of the motif onto a tightly patterned canvas.[8] Silhouetted buildings establish a strong graphic foundation, while the poles make a structure of uprights anchored to the top of the

canvas, and wires a swooping scaffold of lines connected to its left and right edges.

Shaped by the spirit, rather than the letter, of industrial modernity, *Telegraph Poles* dwells upon energy, manufacture, and communication. Rippling with iridescent waves of color and emanating an electric-blue aura, the large factory building is magical rather than material. Draping cables enfold the world below and reach beyond the limits of the canvas, suggesting networks and transmission. Stella claimed these material artifacts of modernity as poetic emblems of a technological sublime. Cables, he wrote, are "aerial guides leading to Immensity"[9]; they "dart like needles through space, knitting together the far and the near in harmonious unity"; they are a "link between the spiritual and material worlds."[10]

Telegraph Poles was shaped by Stella's encounter with Italian futurist art in Paris between 1911 and 1913. In futurism he found an ecstatic picturing of modern experience that matched the fervent vitality of the American poet Walt Whitman's (1819–1892) odes to urban America. Earlier, Stella had been less positive about the industrial scene. In 1908, making illustrations for a pioneering sociological survey of industrial Pittsburgh, he depicted jumbled slums in a miasma of black smoke, with telegraph poles askew overhead.[11] He likened Pittsburgh to the "most

2 **Max Weber (1881–1961), *Construction*, 1915**. Oil on canvas, 22⅞ × 27⅞ in. (58.1 × 70.8 cm), 1987.31

stirring infernal regions sung by Dante,"[12] his preference for moody literary allusion over reportage signaling the emergence of an abstract consciousness. By 1917, Stella's abstraction had become a more conscious dialogue with painterly options, as if he were testing the application of futurism's graphic rhythms and resonances to an American motif.

This attention to the meaning of abstraction in the United States—its relationship to existing experiences, ideas, and motifs—was integral to American artists' engagement with European modern art. Weber's *Construction* (Fig. 2), an adept exercise in analytical cubism, is evidence of his firsthand involvement with Pablo Picasso (1881–1973) in Paris between 1905 and 1913. But Weber's writings on abstraction reveal his determination to define it in terms relevant to an American conscious-ness. He celebrated the concreteness of things; through them, he wrote, "I feel tied to earth."[13] In their everyday materiality, "objects of use, houses, clothing, food, implements, utensils and their functions"[14] were the foundation of modern American life. While this might read as a demand for realism, Weber, like many of his American contempo-raries, made an idealist's distinction between visible reality and abstract thought: "Everything must be more than it is visibly."[15]

Idealism—or "mind sight," to use Weber's phrase—unearthed "the principles that underlie things."[16] But how would such immaterial concepts be communicated in a painting? Weber suggested the construc-tive analogy of a grand, universal mechanism; like the components of a machine, things—or the "units" of a painting—were "part of the whole spiritual, living, moving cosmos."[17] *Construction* openly displays the com-ponents of its painterly mechanism: planes are built in simple outline and given form with plank-like brushstrokes. They are knitted together with interpenetrating curves and vectors. Variations in tone and texture bluntly generate volume, shadow, and space.

In this display of components, structure, and process, *Construction* attends to what Weber called "the relationships of weight, measure, scale and direction and of the combination of planes, or of resistance when colored and exposed to light."[18] The painting is all density, mass, size, and vector, with only the faintest hints at represented objects. These material properties aren't made to stand for things; instead, they are "abstract elements or potential qualities in matter-form."[19] An abstract painting was not a blueprint of idealist principles, but it could show, in its making, how art could "suffer itself through materialism on to the beyond."[20] And the open, unresolved forms of the painting allowed viewers to "unmake and make [the painting] again with [their] eye-hands and mind-eyes."[21]

While Weber's rhetoric verges on the mystical, it points to a central concept in early American abstraction: the possibility that a painting

3 **Patrick Henry Bruce (1881–1936),** *Peinture***, 1917–18**. Oil and graphite on canvas, 25 ⅝ × 32 ⅛ in. (65.1 × 81.6 cm), 1999.21

might enact an encompassing idealism. Many artists were familiar with Emerson's writings and especially his division of humanity into "two sects: Materialists and Idealists; the first class founding on experience, the second on consciousness."[22] Weber's painting acknowledges material experience but models its incorporation by thought: it stands as an embodiment of Emerson's dictum that "Mind is the only reality."[23]

Patrick Henry Bruce was as reticent as Weber was effusive, as clinical as Weber was cosmic. Nevertheless, *Peinture* (Fig. 3) was, like Weber's *Construction*, a declaration that abstract art was essentially ideational—the plotting of a world conceived by the mind, rather than the fixing of a corner of nature on canvas. *Peinture* was the first in a sustained series of abstracted still lifes; microcosmic, table-top domains in which commonplace objects were components of complex spatial and geometric constructions. Everyday objects are recognizable—there is a book, a scroll of paper, a drinking straw, a ruler, furniture, and architectural templates—but they are presented as archetypes, as the plane, the cylinder, the pyramid, and the parallelogram.

In their different ways, Bruce's and Weber's exercises suggest that a principal task in abstract art was the development of convincing analogies

for idealist concepts. Bruce's world is Cartesian in spirit: forms are founded in geometry, delineated with a draftsman's perspective, seemingly plotted in space against a set of coordinates. A diversity of forms is disposed in a coherent world and integrated by pastel hues and a delicate overlay of pencil lines. As a kind of painted oxymoron—a precisely cluttered table—Bruce's *Peinture* suggests that he was perhaps the American artist most deeply connected with Parisian developments. Bruce resided in France for most of his career, and his pursuit of intimate and stable ensembles of objective form reflects the so-called *rappel à l'ordre* (return to order) of post–World War I France.

From tabletop to social metaphor, from canvas to "little visions of the great intangible," as Hartley put it, American abstract artists hypothesized equivalences between the artwork and the universal. In their enthusiastic experimentation, they proposed that the artworks embodied, communicated, or even fostered a heightened apprehension of nature. It was one thing for Hartley to declare that his abstract works put him "on the verge of understanding which is beyond knowledge,"[24] however, and another to present that in a painting, much less communicate it to the unenlightened viewer.

Claims for the heightened perceptual capacity of the artist had to be ratified as well as asserted. Here, Emerson's advocacy of intuition and of a defiantly independent consciousness established a useful foundation. To this was added, in the early twentieth century, the metaphysics of the popular French philosopher Henri Bergson (1859–1941). In his widely circulated texts, the emerging American avant-garde could read that "utilitarian symbols, the conventional and socially accepted generalities," stood as a veil between mind and reality. Art's "purity of perception" offered a "more direct vision of reality" and came closest to drawing aside that veil and inaugurating an experience in which "our soul would continually vibrate in perfect accord with nature."[25] According to Bergson, while idealism's "disinterestedness of sense and consciousness" made for "a certain immateriality of life … it is only through ideality that we can resume contact with reality."[26]

That final remark suggests the reflection on seeing and knowing that underpinned early abstraction. The veil to which Bergson referred was the realm of appearances, of empiricism's insistence that knowledge is derived from observation or, for artists, the tradition of naturalistic representation. To embrace "a certain immateriality of life" was to favor less tangible, less directly observable experience. But Bergson was also pointing to a more complex distinction between intelligence and intuition as conflicting forms of knowledge. In scholar Elizabeth Grosz's summation of Bergson's position, "What the intellect provides is a relative knowledge, a knowledge of things from a distance … a knowledge mediated by symbols,

representations, measurements, whereas intuition can provide an absolute analysis, which means one that is both simple and internal." Intuition was not a kind of emotional response but a mode of thinking: "a process of seeking the precise forms of concept, method, and representation that suits what is intuited in its simple immediacy." As such, "Intuition returns to the real the fullness and interconnectedness that intelligence subtracts from it."[27]

In his own passage toward abstraction, Arthur Dove wrestled with the same terms: the real, the intellectual, and the intuitive. It was a journey traced, hesitantly and on occasion skeptically, in letters and diaries, as well as artworks. "The first step," wrote Dove in 1913, "was to choose from nature's motif in color and with that motif to paint from nature, the form still being objective. The second step was to apply this same principle to form, the actual dependence on the object (representation) disappearing, and the means of expression becoming purely subjective."[28] In pursuing these steps—in the passage from seeing "nature's motif" to the business of putting together a picture—Dove's obligation to the

4 **Arthur Dove (1880–1946), *A Walk: Poplars*, 1912 or 1913**. Pastel on tan wove pumice paper, laid down on board, 21 ⅝ × 17 ⅞ in. (54.9 × 45.4 cm), Terra Foundation for American Art, Daniel J. Terra Collection, 1999.47

McAuliffe

5 **Marsden Hartley (1877–1943),** *Painting No. 50, 1914–15.* Oil on canvas, 47 × 47 in. (119.4 × 119.4 cm), 1999.61

picture's subject ("representation") diminished as his interest in the painting itself ("form") increased. As the presence of the painting superseded that of "nature's motif," Dove's subjectivity itself became the new motif. To redeploy Grosz's terms, his method commenced in representation but concluded in concept; knowledge, of both nature and the painting, would be intuited in its simple immediacy.

Dove's *A Walk: Poplars* (Fig. 4) speaks of that process, embodying its own becoming abstract, so that the relationship of reality, intellection, and intuition is evident. The title bluntly declares that being in nature drove the work. On a walk, nature is encountered at close quarters. This tightly cropped pastel is about nature's grain, not its mythic expanse. This looming, glowing tree trunk is, in Dove's vision, "Actuality! At that point where mind and matter meet."[29] In *A Walk*, the process of picturing nature— the medium, the color palette, the mark-making, and the structure of the composition—enact this meeting of mind and matter. Under-pinning this is a rhetoric of abstraction, an understanding of how form and process become a scaffold for meaning. There are equivalences: chalky pastels that evoke the velvety texture of poplar bark. There are forms that work as

analogies: ungrounded and irregular shapes that correspond to the shadowy variegation of undergrowth. There are metaphors: glowing layers of color, flecked with glimpses of underlying hues, suggest pulsing organic vitality.

It has been said of Dove that his art pivoted on the "interplay between direct observation of objects in the American landscape on one hand and the assimilation of European avant-garde ideas (often translated into an American idiom) on the other."[30] In fact, the interplay between Europe and America was more intricate than this. Hartley's *Painting No. 50* (Fig. 5) was one of a series shaped by romantic imaginings of Native American culture. Painted in Germany, and drawing on displays of Native American artifacts in a Berlin museum, the work is rooted in a European tradition: the literary figure of the noble savage romantic. Hartley was aware of the popular fascination with Wild West shows in Europe. So although he later proposed, in his own version of the noble savage myth, that Native American culture revealed "the poetic aspects of our original land,"[31] his painting was shaped by and spoke to the European context.

The abstraction of *Painting No. 50* likewise arises from a mix of European and American concerns. There is a determination to identify something essentially American; he painted hieratic symbols—some accurate, others concocted—incorporating sun, moon, water, and totemic figures that suggested a cosmological vision of North America. In common with emerging European theories of abstraction, Hartley saw totemic symbols as a powerfully simplified expression of collective belief, a model for the modern artist seeking to communicate essential spiritual values without recourse to utilitarian symbols. At the same time, he incorporated the intensely colored patterning of German folk art, as well as German military insignia. So *Painting No. 50* was universalizing in its evocation of the American Indian, the "one truly indigenous religionist and esthete of America,"[32] but diaristic in its assimilation of the art and military pageantry that Hartley encountered in Germany.

With hindsight, Hartley made the affirmation of his Americanness central to his identity as an artist. In his autobiography, he recalled his pivotal first encounter with the seascapes of the American painter Albert Pinkham Ryder (1847–1917) as a moment of intense realization:

> When I learned he was from New England the same feeling came
> over me in the given degree as came out of Emerson's essays
> when they were first given to me—I felt as if I had read a page of
> the Bible—in both cases. All my essential Yankee qualities were
> brought forth out of this picture and I needed to be stamped an
> American, this was the first picture that had done this—for it had

McAuliffe

6 **Arthur Dove (1880–1946),** *Flour Mill II*, **1938**. Oil and
wax emulsion on canvas, 26⅛ × 16⅛ in. (66.4 × 40.9 cm),
The Phillips Collection, Washington, DC.

in it everything that I knew and had experienced about my own
New England, even though I had never lived by the sea. It had in it
the stupendous solemnity of a Blake mystical picture and it had a
sense of realism besides that bore such a force of nature itself as to
leave me breathless.[33]

Embedded in Hartley's ecstatic self-mythology is a remarkable condensa-
tion of the foundations of American abstraction. There is the anchoring
of art in New England transcendentalism and the demand that its spirit
be discovered in painting. There is the repeated assertion of a regional
consciousness, one so innate that it was felt even when it hadn't been fully
lived. There is the fusion of the mystical and the real, of nature and the
spirit, of art and faith. There is the stupendously solemn grasping after an
experience that is both sublime and formal, somehow echoing Bergson's
intuitive knowledge. And finally, there is the invocation of a European
model, in Blake, but only after the American spirit through which it is
assessed was emphatically declared.

Becoming abstract, however powerful the influence of European art and thought, seems inseparable from asserting American identity. Dove's *Flour Mill II* (Fig. 6) pictures a farming community in upstate New York. In the painting, the material elements of the scene—the columnar mill, the brick warehouses at its base, the surrounding lots—are reduced to swatches of color. To the eyes of a European modernist, the American flour mill was a new architectural monument. Le Corbusier had earlier dubbed grain elevators "the magnificent FIRST-FRUITS of the new age."[34] For Dove, however, there is no modernist celebration of geometric mass, just an insistent, central vertical: the mill is the spine of the painting. At its base is a schematic assertion of sunlight and shadow, hue and tone— a blunt assertion of what a painter works with. In keeping with Dove's earlier model, the motif retreats as the means of expressing it become more subjective. Dispersed across an open and ungrounded visual field, only barely (almost arbitrarily) attached to the task of representation, Dove's forms point toward what was to become the dominant language of midcentury American abstraction.

Max Weber (1881–1961)
Construction, 1915

> Oil on canvas, 22 ⅞ × 27 ⅞ in. (58.1 × 70.8 cm),
> Terra Foundation for American Art, Daniel J.
> Terra Collection, 1987.31

A modernist painter, printmaker, sculptor, and writer, the Russian-born Jewish-American artist Max Weber lived and worked in New York City for most of his career. From 1905 to 1909 he was in Paris, where he associated with European avant-garde artists and intellectuals. Produced after his return to the United States, *Construction* is an abstract composition of intersecting planes and lines. Roughly applied strokes of mottled, neutral colors suggest three-dimensional forms that resolve and dissolve. Like many of his contemporaries, Weber was interested in the idea of a fourth dimension, famously articulated by the French philosopher Henri Bergson (1859–1941) in his conception of a dynamic, everchanging universe. Weber regarded the city as the quintessential manifestation of the relentless flux that characterized modernity. While not a depiction of a specific setting, *Construction* reflects the chaos and vitality of urban America.

Arthur Dove (1880–1946)
Nature Symbolized #3:
Steeple and Trees, 1911–12

> Pastel on board mounted on wood panel,
> 18 × 21 ½ in. (45.7 × 54.6 cm), Terra
> Foundation for American Art, Daniel J.
> Terra Collection, 1992.33

Arthur Dove (1880–1946)
Sails, 1911–12

> Pastel on composition board mounted on
> wood panel, 17 ⅞ × 21 ½ in. (45.4 × 54.6 cm),
> Terra Foundation for American Art, Daniel J.
> Terra Collection, 1993.10

One of the first American artists to abandon imitative representation, Arthur Dove created oil and pastel compositions in which dynamic shapes, lines, and colors evoke the essence—rather than the outward appearance—of natural forms. *Nature Symbolized #3: Steeple and Trees* and *Sails* belong to a series of ten pastels he made in 1911 and 1912 that were later dubbed the "Ten Commandments." They were shown together in 1912 at 291, the pioneering New York gallery run by the photographer Alfred Stieglitz (1864–1946). Among the first abstract artworks ever exhibited in the United States, Dove's pastels caused a sensation among American viewers who, until the Armory Show in New York the following year, were largely unaware of the abstract art then gaining recognition in Europe. With their organic imagery borrowed from nature and their expressive dynamism, these pictures presaged the emerging American modernism of the early twentieth century.

Joseph Stella (1877–1946)
Telegraph Poles with Buildings, 1917

> Oil on canvas, 36 ¼ × 30 ¼ in. (92.1 × 76.8 cm),
> Terra Foundation for American Art, Daniel J.
> Terra Collection, 1999.139

Born in Italy, Joseph Stella immigrated to the
United States in 1896. He produced works that
combined lyrical sensibility with modernist
themes and style, and soon became a leading
figure in New York City's avant-garde circles.
Telegraph Poles with Buildings is among the
earliest and most representational of a series of
works he dedicated to industrial subjects and
their brooding mystery. Dominating the
composition, the crosslike telegraph pole
at the center divides the scene vertically.
Lines of wire, sharply edged buildings, and
smokestacks complete the industrial vista,
devoid of human presence. On the right, the
structure's stark geometry provides a strong
contrast to the curls of smoke and clouds
surrounding the factory. Including both
abstract and representational elements, the
painting captures the combination of awe,
fascination, and even dread that the new
industrial landscape inspired in Stella and
his contemporaries.

Patrick Henry Bruce (1881–1936)
Peinture, 1917–18

Oil and graphite on canvas, 25 ⅝ × 32 ⅛ in.
(65.1 × 81.6 cm), Terra Foundation for American
Art, Daniel J. Terra Collection, 1999.21

The American expatriate Patrick Henry Bruce was a forerunner of abstract painting in the early twentieth century. Known for his streamlined still lifes, he explored the boundary between representation and abstraction. *Peinture* is considered one of the earliest in a series of tabletop arrangements of everyday items reduced to their most elemental forms. Geometric, sharply delineated shapes are set against four horizontal bands of black, turquoise, and lavender. While a straw and glass can be tentatively identified, other forms are mere fragments or generic volumes defined by colored shapes that appear to be simultaneously on top of the surface and to recede into the background. *Peinture* reflects the influence of Paul Cézanne (1839–1906) and Henri Matisse (1869–1954), yet is unlike either artist's work at that time. While hinting at Bruce's longstanding attraction to still-life painting, this precisely geometric work also reflects his journey toward pure abstraction.

"Caveman expression" is how Marsden Hartley described the paintings he exhibited in a Berlin gallery next to the Brandenburg Gate in October 1915.[1] Among them was *Painting No. 50*, a work executed in Berlin as one in a series employing Native American motifs. Just as European artists had looked to folk traditions and non-Western cultures in their pursuit of an imagined, "primitive" authenticity—Franz Marc (1880–1916) labeled painters like himself "The 'Savages' of Germany"[2]—Hartley turned to his home continent and its native people, whose artifacts he equated to prehistoric European cave painting.

In November 1914 Hartley had written to his New York art dealer Alfred Stieglitz (1864–1946), "I find myself wanting to be an Indian."[3] Born in Maine and raised in the East, he had had no direct contact with Native American culture, and it was not until he went abroad that it came to interest him, mainly through German colleagues such as August Macke (1887–1914), who had painted scenes with tipis and native riders on horseback.

In *Painting No. 50*, the tip of a white tipi pierces a black circle and meets that of a downward-pointing golden triangle. Below this juncture, the tipi's open flaps reveal a red double-pointed oval within which an arrowhead points upward, touching a circle divided in eight. The structure is similar to one in *Indian Composition* (c. 1914, Frances Lehman Loeb Art Center, Poughkeepsie, New York), but there the pointed oval contains a Christian cross, a starburst, and birds—symbols of the Holy Trinity. What might be a sexual allusion in *Painting No. 50* is recast as religious symbolism, a switch indicative of the multiplicity of meanings embedded in Hartley's devices.

In Hartley's personal iconography, the golden triangle stands for the male bonding between himself, the German sculptor Arnold Rönnebeck (1885–1947), and the Prussian officer Karl von Freyburg (1889–1914), whom Hartley idolized. More ambiguous are the large arced shapes that might be insect wings, canoes, or abstracted airplane wings. The yellow and blue "wing" at upper left harbors a small blue and red symbol that seems to represent an airplane. Two white crosses on the left red wing suggest German insignia, while the partial black-red concentric circle above them resembles a French military cockade—a Franco-German aerial dogfight? The divided white circle may stand for the eight-pointed star on Prussian military uniforms, or for the Buddhist *dharmachakra*, whose spokes allude to the Noble Eightfold Path.

This syncretism is characteristic of Hartley: he gives us an abstract composition whose decorative flatness borrows from Native American textiles and painted skins, whose bilateral symmetry was inspired by religious and esoteric symbolism, and whose mode of painting is indebted to modernism. Hartley made manifest what Wassily Kandinsky (1866–1944) called the "combinations of the abstract with the objective,"[4] which he argued were essential to "inner resonance."[5]

Dieter Scholz, *Curator of Modern Art*, Nationalgalerie,
Staatliche Museen zu Berlin, Germany

Marsden Hartley (1877–1943)
Painting No. 50, 1914–15

Oil on canvas, 47 × 47 in. (119.4 × 119.4 cm),
Terra Foundation for American Art, Daniel J.
Terra Collection, 1999.61

The pioneering modernist painter Marsden
Hartley created robust landscapes, still lifes,
figural images, and abstract compositions.
Influenced by Russian artist Wassily Kandinsky
(1866–1944) and inspired by American gallerist
and photographer Alfred Stieglitz (1864–1946),
Hartley produced paintings that include both
familiar and cryptic symbols and combine cubist
and expressionist elements. *Painting No. 50* is
part of the artist's *Amerika* series, painted while
he lived in Berlin on the eve of and early in World
War I (1914–18). It contains general references
to Native American culture—a tipi and canoes—
as well as military symbols. Striking primary
colors and bold patterning play an important
role in the composition's hieratic, symmetrical
structure. By conveying a sense of national
identity as well as the artist's familiarity with
contemporary modernist movements, the paint-
ing confirms Hartley's status as a German art
community insider while hinting at his isolation
as an American expatriate.

Charles Demuth (1883–1935)
Welcome to Our City, 1921

Oil on canvas, 25 ⅛ × 20 ⅛ in. (63.8 x 51.1 cm),
Terra Foundation for American Art, Daniel J.
Terra Collection, 1993.3

Charles Demuth was in the vanguard of a new painting style that came to be called precisionism and is best remembered for his abstract poster-portraits. In the 1920s he produced a series of geometric depictions of his native Lancaster, Pennsylvania, including *Welcome to Our City*. Here, flattened interlocking red planes evoke the brick of recent industrial buildings, while the tall, slightly tilted courthouse dome in the background alludes to Lancaster's history. Inspired by cubism and its reduction of forms to geometric components, Demuth also maintained close ties to New York City's Dada movement. A group of letters rendered in the stark style of commercial graphics may hint at a subversive message—an ironic comment on the painting's title and ambiguities inherent in modern American life. *Welcome to Our City* also demonstrates the artist's desire to establish the regional setting as a source of inspiration for a truly national art.

Yasuo Kuniyoshi (1889–1953)
***Boy with Cow**, 1921

Oil on canvas, 16 ⅛ × 20 in. (41 × 50.8 cm),
Terra Foundation for American Art, Daniel J.
Terra Art Acquisition Endowment Fund, 2017.1.
Art © Estate of Yasuo Kuniyoshi / Licensed by
VAGA, New York, NY

The Japanese-American artist Yasuo Kuniyoshi
was an acclaimed modernist painter, printmaker,
and photographer. Inspired by the landscape
and vernacular architecture of Maine, where
Kuniyoshi summered at the Ogunquit artists'
colony, *Boy with Cow* is one of several images
he painted of the subject during the 1920s. It
depicts a young boy about to lead a cow to shel-
ter in the face of an impending storm. Although
cows were rare in his native country, the artist
attributed his fascination with them to having
been born in a "cow year," according to the
Japanese lunar calendar. With its simplified
geometric forms, stylized rendering of anatomy,
and high horizon, the painting fuses Kuniyoshi's
interest in European modernism, American
folk art, and Japanese prints. Exemplary of his
first major period, *Boy with Cow* was included
in the Whitney Museum of American Art's
1948 Kuniyoshi retrospective, the institution's
first-ever retrospective given to a living artist.

Stuart Davis (1892–1964)
Super Table, 1925

Oil on canvas, 48 × 34 ⅛ in. (122.2 × 86.7 cm),
Terra Foundation for American Art, Daniel J.
Terra Collection, 1999.37. Art © Estate of Stuart
Davis / Licensed by VAGA, New York, NY

A leading American modernist and strong
advocate of cubism, Stuart Davis produced
flattened still-life paintings and city views that
blend abstraction with popular commercial
imagery. With its distorted planes, *Super Table*
challenges conventional notions of space and
directly alludes to synthetic cubism. Laid out on
a pink wooden table, a glass, draped fabric, and
notebook are reduced to geometric, linear motifs
stacked from the simplest to the most elaborate.
The work's invisible brushwork and cartoon-in-
spired style recall the mechanical perfection of
commercial posters and prints. Its monumental
size may suggest the intrusiveness and anonymity
of billboards. Uniquely American in its hard-edge
style and evocative of popular graphic imagery
and design, *Super Table* also alludes to the French
movement known as purism, whose adherents
painted still lifes in an ordered, classical manner.

Helen Torr (1886–1967)
Purple and Green Leaves, 1927

> Oil on copper mounted on board, 20 ¼ × 15 ¼ in.
> (51.4 × 38.7 cm), Terra Foundation for American
> Art, Daniel J. Terra Collection, 1999.142

During the 1920s, Helen Torr participated in the development of a distinctly American brand of modernism along with fellow artists and friends such as her husband, Arthur Dove, and Georgia O'Keeffe. Typical of Torr's flattened still-life paintings, *Purple and Green Leaves*, a simplified arrangement of tall, layered fronds, verges on the abstract. The image is singularly modern, but because Torr depicted the leaves as if framed in an arched recess space, it also suggests a medieval stained glass window. The glowing yellow and deep purple tints of the foliage, animated by faceted rays of color, lend the picture a mystical resonance. Likely featured in an exhibition of women artists that O'Keeffe organized at the Opportunity Gallery in New York City in 1927, the work demonstrates Torr's sensitivity to her natural environment and her efforts to reveal its invisible, transcendent essence.

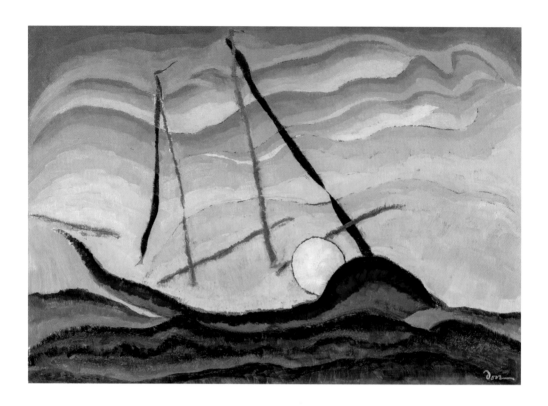

Arthur Dove (1880–1946)
Boat Going through Inlet, c. 1929

Oil on tin, 20 ⅛ × 28 ¼ in. (51.1 × 71.8 cm),
Terra Foundation for American Art, Daniel J.
Terra Art Acquisition Endowment Fund, 2015.6

The early modernist Arthur Dove portrayed the natural world as felt and experienced instead of merely seen. Preferring to call his works "extractions" rather than "abstractions," he presented the purest form of a scene in nature, distilling it down to its essentials. In *Boat Going through Inlet*, he conveyed the impact of water and wind on a small craft. He enjoyed a peripatetic life along the waters of Long Island Sound, even residing aboard a yacht for a time with his wife and fellow artist, Helen Torr. Dove's intimate knowledge of the sea is evident here; his treatment of atmospheric mist and vapor expresses the weight of the wind pushing across the boat's deck. Dove, ever the experimental artist, composed this work of gauzy coats of paint on tin with incised lines that reveal the metal beneath, a technique that suggests the glittering sheen of light reflecting off waves.

Arthur Dove spent much of his career on or near the water. Beginning in 1924, he and his wife, the artist Helen Torr (1886–1967), lived for nearly a decade on a boat moored at Halesite on the North Shore of Long Island. In 1938, after several years in Geneva, New York, they returned to Long Island and took up residence in Centerport. Dove regularly depicted his shoreline environs: boats on the water, views out to sea, sunrises and sunsets, circling gulls, storm-tossed waves, and beach grasses buffeted by the wind.

Like most of these pictures, *Boat Going through Inlet* renders its subject allusively. We confront not a view of the world empirically observed, but a visual conjuring of forces and phenomena. Thick bands of dark blue and brown curving across the bottom half of the canvas evoke the swell of water and the cut of the prow through the waves, while voluminous arcs of gray, light blue, and pink give form to radiating waves of light and unseen drafts of wind. The clouds of paint that enfold the rigging and crests of blue in the sky materialize the thick, water-laden heft of the atmosphere.

Dove regularly experimented with unconventional materials. *Boat Going through Inlet* is one of several works on metal grounds executed in the 1920s, along with *Telegraph Pole* (1929, Art Institute of Chicago) and *Sunrise in Northport Harbor* (1929, Wichita Art Museum, Kansas). It is painted on tin, and light catches on places where the metal is exposed, suggesting the glint of sunlight on water or the phenomenon known as St. Elmo's fire, a glow that appears at the top of ship masts in the presence of a strong electric field during a storm. This shimmering also calls to mind reflection as an operation instigated by rays of light bouncing off the surfaces of objects. By incarnating this optical function in his painting, Dove makes clear that his interest lies equally with his marine subject and with the means by which humans perceive and interact with things in the world, from boats at sea to light waves and meteorology. Each is evoked through sweeping and interconnecting bands of color, and by hinting at the conductive properties of the metal sheet.

Throughout his career Dove preferred the term "extraction" to "abstraction" when describing his art, and the blunt materiality of *Boat Going through Inlet* embodies this idea. The metal ground, the palpably present pigment, the literality of interaction with light, and the visible pencil drawing emphasizing the artist's hand—all suggest matter extracted from one context and reconfigured in another, something quite different from abstraction's usual distillation into essence or reduction to pure form. Dove's painting insistently retains a direct connection to the phenomenal world, while still radically transforming and reconstituting material existence. This places his work in a fascinating middle ground between reality and representation, life and art. Dove likely painted *Boat Going through Inlet* while living shipboard at Halesite. The very ground of his practice was an intermediary zone, comprising both land and sea. *Boat Going through Inlet* is thus a crossroads, a manifold pictorial assembly encompassing near and far, the visible and the unseen, the worlds of nature, humans, and machines—a humble painting of a boat on the water that gathers together all things under the sun.

Rachael Z. DeLue, *Professor of Art History*,
Princeton University, New Jersey

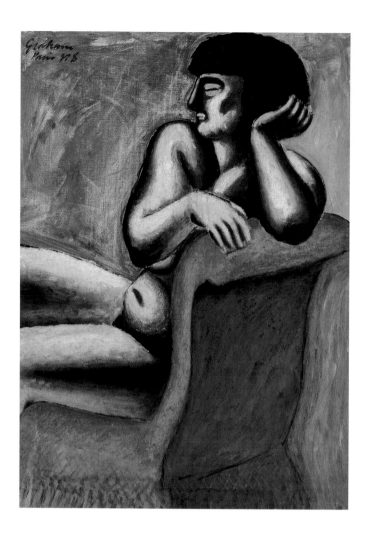

John Graham (1881–1961)
The Green Chair, 1928

Oil on canvas, 39 ½ × 28 ⅞ in. (100.3 × 73.3 cm),
Terra Foundation for American Art, Daniel J.
Terra Collection, 1999.60

Born Ivan Dombrowski in Kiev, Russia, the artist
and intellectual John Graham espoused the
expression of art through pure form. Admired
for his wide range of interests—from theoso-
phy to religion and mathematics—and for his
remarkable knowledge of art theory, he became
influential in the development of post–World

War II abstract expressionism. Painted and
exhibited for the first time in Paris in 1928 at the
Zborowski Gallery, *The Green Chair* is part of a
series of Graham's monumental nudes of the
1920s. Here, a stylized female figure, seated on
a chair, is seen in classic profile; the viewer is
prompted to interpret the painting formally. The
woman's masklike face recalls African sculpture,
which enjoyed wide appeal at that time. Graham
abstracted and compressed the human figure
to encourage archetypal associations that tie
together artistic traditions from the past with
forward-looking modernist trends.

John Storrs (1885–1956)
Politics, 1931

Oil on canvas, 40 × 40 in. (101.6 × 101.6 cm),
Terra Foundation for American Art, Daniel J.
Terra Art Acquisition Endowment Fund, 2008.1

A member of the first generation of American
modernists, John Storrs developed a style of
sculpture characterized by abstraction and
geometric simplicity. During the 1930s, Storrs
turned to painting, a medium in which he
explored nonrepresentational forms based on
controlled lines and pure shapes. *Politics* is one
such work. Flat, slab-like objects with complex
irregular edges are set against a pristine white
background. The composition hovers between
representation and abstraction, between archi-
tectural lines and biomorphic shapes; the
profile of a dark gray head on the left imbues
the painting with a sense of anxiety. *Politics* is
among the earliest of a group of mostly non-
objective paintings Storrs began in 1931. It
may comprise his most pointed comment on
contemporary affairs, with the shadowy head
perhaps representing the profile of populist
politicians spewing their hateful rhetoric.

John Marin (1870–1953)
Brooklyn Bridge, on the Bridge, 1930

Watercolor on paper, 21 ¾ × 26 ¾ in.
(55.2 × 67.9 cm), Terra Foundation for American
Art, Daniel J. Terra Collection, 1999.95

John Marin developed a distinctively modern watercolor style in the first decades of the twentieth century, producing bold, energetic depictions of New York City's contemporary architecture. All the elements in *Brooklyn Bridge, on the Bridge* seem to vibrate with nervous energy, as if to convey the frenzy of the metropolis. At the center of the composition are the recognizable Gothic-style arches and granite piers of the span, while straight and zigzagging lines suggestive of parallel cables, iron railings, or river waves are scattered throughout. Nearly abstract, this work belongs to a period in Marin's career when he developed a new sense of geometric structure by using fragmentation to create formal arrangements of line, plane, color, and shape. His rapid, explosive process seemingly confirmed the limits of representation and validated the contemporary artistic movements that influenced him.

John Marin (1870–1953)
Sailboat, Brooklyn Bridge,
New York Skyline, 1934

> Oil on canvas board, 14 × 17¾ in. (35.6 × 45.1 cm),
> Terra Foundation for American Art, Daniel J.
> Terra Art Acquisition Endowment Fund, 2006.1

One of America's most popular modernists, John Marin fashioned a personal vocabulary for expressing the vitality of urban landscapes in both oils and watercolors. *Sailboat, Brooklyn Bridge, New York Skyline* presents the city as an assemblage of colors and shapes that suggest the energy of the metropolis. His reduction of familiar forms to their essential lines and planes indicates an indebtedness to cubism that is personalized by his use of bright colors and dynamic brushwork. Trained as an architect, Marin frequently used devices within his compositions to frame or enclose forms. The image presents a series of frames-within-the-frame: the black outlines around the forms of the bridge, tugboat, and sailboat contain and control the explosive energy of the artist's lines and brushwork. To distinguish this work as an oil painting (rather than a watercolor), Marin applied a thin black wash to the simple wood molding of the frame and added elongated dabs of white at regular intervals.

Georgia O'Keeffe's flowers are the most difficult of her paintings to see. More than just familiar—as flowers in general are—her paintings have acquired an inconspicuousness: the overabundant merchandizing of these images has had the perverse effect of fueling the artist's fame while stifling scholarly discussion of her singular accomplishments. The widespread popularity of these paintings makes art historians and curators almost instinctually bypass them for serious, analytical discussion, while nonetheless capitalizing on their ability to draw attention and crowds. While O'Keeffe is that rare artist who is a woman yet not unknown, her work and career are often presented as America's twentieth-century pulp fiction.

From a Canadian viewpoint, O'Keeffe feels particularly familiar, given her profound influence on early Canadian modernists and her attitude toward nature, which resonates with the English Canadian idea of spiritual "wilderness" as a core cultural identity. Exhibited in Canada only in group shows until recently, O'Keeffe has been presented through this limited lens, with inevitable comparison to the forest paintings of British Columbia's Emily Carr (1871–1945). Less discussed is O'Keeffe's importance to the next generation of Canadian painters, such as Pegi Nicol MacLeod (1904–1949) and Marian Dale Scott (1906–1993), for whom O'Keeffe's flower paintings offered new ways of seeing.

To see these flowers today requires first unseeing what obscures them—in other words, freeing the images from the burden of commodification and prior interpretations, including O'Keeffe's own sustained resistance to any erotically evocative readings. These paintings offer that most elusive of artistic achievements: an image that is at once profound in its aesthetic simplicity and compelling in its ordinariness. It is predicated, as O'Keeffe insisted, on taking time to see: "Nobody sees a flower—really—it is so small—we haven't time—and to see takes time.... So I said to myself—I'll paint what I see—what the flower is to me."[1]

For the Art Gallery of Ontario's 2017 installation of the Tate Modern exhibition *Georgia O'Keeffe,* it was critical to add *Red Amaryllis* to the handful of flower paintings already touring with the retrospective. It was selected specifically to offer a foil to *Jimson Weed/White Flower No 1* (1932, Crystal Bridges Museum of American Art, Bentonville, Arkansas). Large, cool, and formal, *Jimson Weed* is the very opposite of *Red Amaryllis.*

Red Amaryllis is a small painting. The red is intensified by the halo of yellow and white. The layered petals, grounded by a hint of thick green stalk below, radiate to the edges of a canvas just beyond the size of a human face. The flower addresses the viewer with its brazen and redolent frontality. By 1937 O'Keeffe had been painting flowers for over a decade; she had magnified, zoomed in, and painted them large, scandalizing the audiences who first saw them. *Red Amaryllis* is exceptional precisely because of its size. Already confident in her ability to redefine monumentality, in this canvas the artist tests the limits of scale by compressing the resplendent blossom to harnesses its grandeur. Its smallness reveals O'Keeffe's radical vision.

Georgiana Uhlyarik, *Fredrik S. Eaton Curator, Canadian Art,*
Art Gallery of Ontario, Toronto

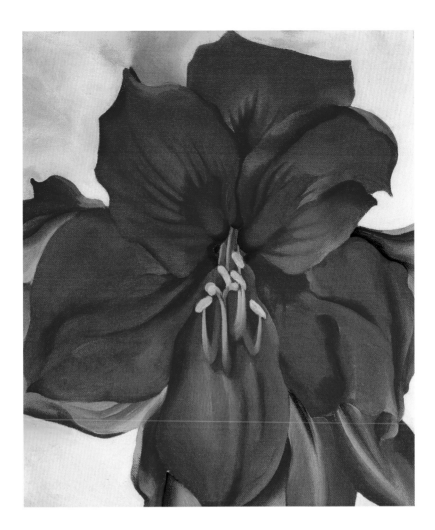

Georgia O'Keeffe (1887–1986)
Red Amaryllis, 1937

> Oil on canvas, 12 × 10 ⅛ in. (30.5 × 25.7 cm),
> Terra Foundation for American Art, Gift of Mrs.
> Henrietta Roig, C1984.1

Georgia O'Keeffe developed a singular modern-ist style that veered toward abstraction. She is best remembered for her studies of flowers and her views of Manhattan skyscrapers and the Southwestern landscape. In this painting, a sin-gle vibrant red blossom is seen close-up against an undefined yellow and white background suggestive of brilliant sunlight. Despite the work's small size, O'Keeffe gives a single blossom a commanding presence—enhanced by cropped framing. The velvety textures of the petals, rendered through the juxtaposition of softly modulated surfaces, illustrate the artist's careful observation of natural forms. *Red Amaryllis* differs from O'Keeffe's earlier, somewhat abstract flower paintings in its greater naturalism and realism. This shift may be in response to contem-porary interpretations of her abstract works as veiled expressions of her own sexuality, a reading O'Keeffe adamantly rejected.

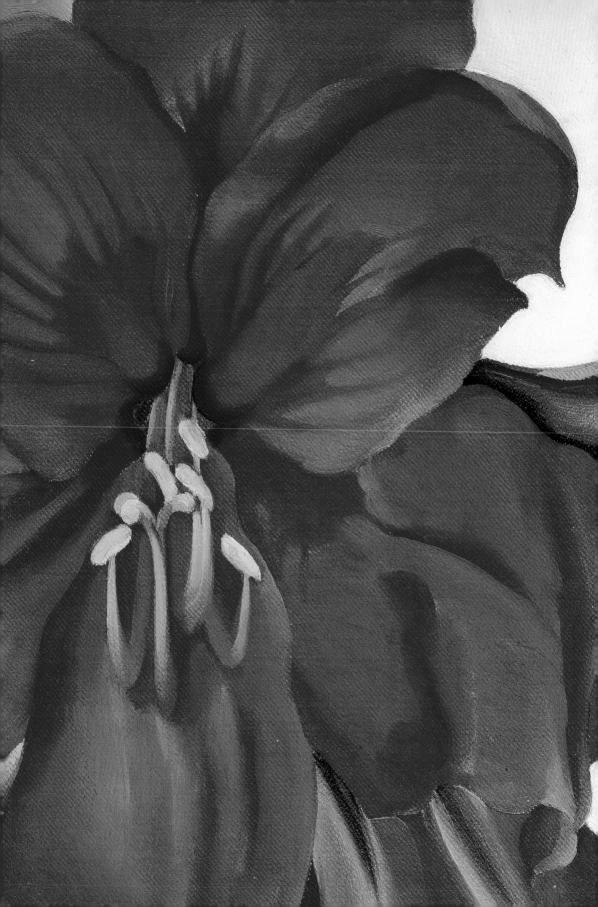

Albert Eugene Gallatin (1881–1952)
Room Space, 1937–38

> Oil on canvas, 30 ¼ × 25 ⅜ in. (76.8 × 64.5 cm),
> Terra Foundation for American Art, Daniel J.
> Terra Collection, 1999.56

A champion of abstract art, Albert Eugene
Gallatin belonged to a group of New York
City artists dubbed the Park Avenue Cubists,
united in their affluence and their advocacy
for cubist-inflected abstract painting. A simple
arrangement of fields of yellow, blue, brown,
and black with superimposed geometric
shapes, *Room Space* is typical of Gallatin's

spare compositions. The artist took up paint-
ing seriously in 1936, after many years as
an active collector of European modern art.
With its combination of vibrant hues and
dark neutral tones, the canvas is indebted
particularly to Dutch artist Piet Mondrian
(1872–1944), whose geometric and abstract
paintings feature bright primary colors, and
to the achromatic palette favored by Pablo
Picasso (1881–1973) and Juan Gris (1887–
1927). Gallatin dedicated his art, as he did his
collecting, to promoting abstraction during
a period when figurative art and nationalist
sentiment attracted greater critical attention.

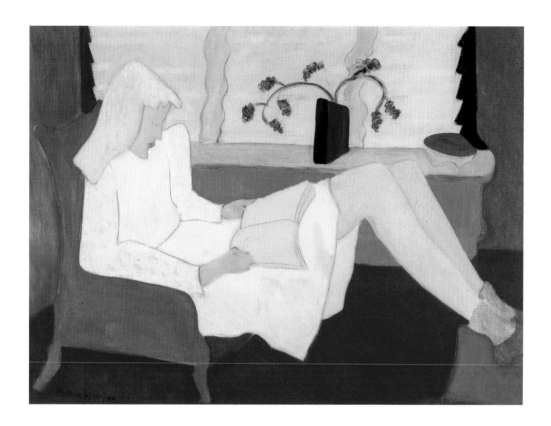

Milton Avery (1885–1965)
Adolescence, 1947

> Oil and graphite on canvas, 30 × 40 in.
> (76.2 × 101.6 cm), Terra Foundation for American
> Art, Daniel J. Terra Collection, 1992.3

Defying classification, Milton Avery developed a distinctive representational style in which domestic scenes are transformed into abstract, flat expanses of warm color. Although his use of arbitrary shades and simplified forms reveals his interest in the work of the French modernist Henri Matisse (1869–1954), Avery often denied the connection. Fifteen-year-old March (b. 1932), Avery's daughter and one of his favorite subjects, is the central figure of *Adolescence*. Her pale, featureless face contrasts with the glowing colors surrounding her. March's figure, the main focus of the painting, is intimately defined by her environment. Avery exaggerated the length of her legs and cropped her feet as if to underscore the peculiar combination of awkwardness and grace that characterizes the teen years. Aloof and absorbed in her reading, she is the personification of adolescent leisure.

Beauford Delaney (1901–1979)
Untitled (Village Street Scene), 1948

Oil on canvas, 29 × 40 in. (73.7 × 101.6 cm),
Terra Foundation for American Art, Daniel J. Terra
Art Acquisition Endowment Fund, 2018.2

Born in Knoxville, Tennessee, Beauford Delaney moved to New York City in 1929 and became captivated by the urban landscape. Seeking to convey the energy of modern life in his paintings, Delaney blended social realism's interest in the life of the streets with an expressionistic variant of abstract expressionism. *Untitled (Village Street Scene)* is emblematic of this distinctive interpretation of life in New York City. In 1936 Delaney moved to a studio on Greene Street in Soho and painted several versions of intersections similar to this one around his neighborhood. He relays the corner's noisy dynamism with vibrant colors, animated lines, and markers of the urban environment— street lamps, trash cans, and manhole covers. With its clarity of subject matter, assertive palette, and bold outlines, *Untitled (Village Street Scene)* is a buoyant interpretation of the artist's interest in the rhythms of urban life.

Philip Evergood (1901–1973)
Passing Show, 1951

> Oil on canvas mounted on Masonite, 65 ½ × 48 in.
> (166.4 × 121.9 cm), Terra Foundation for American
> Art, Daniel J. Terra Collection, 1992.34

In the early years of the Great Depression, Philip Evergood associated with members of the so-called Fourteenth Street school of artists and others who championed the lower classes through images that were often unsettling. These artists favored a highly graphic style of painting that reflects both their training as artist-reporters and their use of popular media images as sources.

Evergood's *Passing Show* juxtaposes a down-and-out African American man, seated on a street curb, with a crowd of fashionably dressed women passing in and out of a five-and-dime, a kind of inexpensive variety store once a fixture in urban America. The shop windows offer a disparate assortment of tools, kitchenware, and wigged mannequin busts that mimic the shoppers' garish makeup. Evergood used brittle lines and jarring colors to evoke the superficial allure of the "passing show" while emphasizing the man's exclusion from it. The painting reveals a humorous, ironic understanding of the delusions of modern consumer society.

George Tooker (1920–2011)
Highway, 1953

Egg tempera on gesso hardboard, 22 ⅞ × 17 ⅞ in. (58.1 × 45.4 cm), Terra Foundation for American Art, Daniel J. Terra Collection, 1992.134

George Tooker made paintings that combine meticulous representation and a sense of brooding mystery to comment on the human condition. His early works, including *Highway*, stress the loneliness and alienation of modern urban existence. In this haunting fantasy of a roadblock, three cars, their aggressive, fang-like grills mirroring their drivers' frustration, are immobilized by a mysterious authoritative figure brandishing a large red reflector. In the early 1950s, the United States contained about 6 percent of the world's population but 60 percent of all automobiles, the result of postwar prosperity and suburban development. Greatly increased traffic volume on the nation's highway system, which suffered from wartime neglect, resulted in frequent roadblocks. The highway and private automobile, emblems of individual freedom for many Americans during and after the 1950s, serve here as symbols of the social ills inherent in modern life: rampant materialism and the destruction of nature by development and attendant pollution.

George Tooker's small output of carefully planned and slowly made egg tempera paintings contrasts dramatically with what we have been taught is modern about modern art. He did not work large; if he made any completely abstract works, he did not save them; he did not improvise; he resisted art-world celebrity. A native New Yorker, Tooker insightfully translated both joyful and horrific experiences of the city at midcentury, then left it in 1960 to move to rural Vermont with his life partner, William Christopher (1924–1973). After converting to Catholicism in the 1970s, he made religious paintings for a church in Windsor, Vermont. He said little about the meaning of his imagery, preferring to allow the work to release its secrets and possibilities quietly, according to the perceptions and experience of viewers. This has only intensified its enigmatic aspects.

Most narratives of modernism willfully ignore the pluralist reality in which artists such as Tooker lived and worked. The archive provides ample evidence of a postwar scene that thrived on differences. Art is messy; it develops through complex relationships and is nurtured by shared conditions that yield shoots in unexpected places. On the surface, these signs of growth may seem unrelated but they are anchored by invisible, interconnected roots. In Tooker's art, qualities that have been positioned as irreconcilable are united: abstraction and representation, the sensual figure and the unrelenting grid. He looked hard at the pure abstraction that had developed through the Bauhaus and at the gestural abstraction of postwar expressionism, and he absorbed their lessons. He did not want to emulate their particular methods but appears to have learned much from their editorial strategies, which he astutely conflated with those of the fifteenth-century Italian artists Piero della Francesca (c. 1415–1492) and Fra Angelico (1395–1455). Tooker understood how these disparate approaches could intensify the psychological matrix within which he set his narratives.

Highway is a painting that shows how Tooker applied these lessons to his examination of urban spaces. He integrated what he saw as oppressive architecture and a confining geometry with the human body. Though in some paintings his figures are gloriously illuminated, as though transcending flesh, here they are earthbound and trapped. As though updating the fate of the damned in fifteenth-century Flemish and Italian paintings, Tooker compartmentalized the city's inhabitants into purgatorial cells.

The painting presents a set of contradictions. The scene is menacing and witty, claustrophobic and infinite, full of emphatic surface patterns and attentively illusionistic. For all of its controlled structure, it is seething with energy. The title implies a fast roadway, but what we see is a tightly bound section of paving constricted by blaring white arrows emphatically pointing into the earth and barriers painted with contrasting diagonal stripes. *Highway* suggests the dangerous thrill of a city's dizzying pace as an aggressive nightmare or fantasy. Yet it was based—like all of Tooker's urban images—on experiential encounters with objects, signs, and situations in New York. Together the geometry, lines, and arrows of his rigorous matrix drive the terror in *Highway* as much as the faceless authority figure and grimacing vehicles do. United, they work to provoke the viewer and evoke the anxiety that Tooker sensed in postwar American society.

Robert Cozzolino, *Patrick and Aimee Butler Curator of Painting,*
Minneapolis Institute of Art, Minnesota

Ed Paschke (1939–2004)
Topcat Boy, 1970

> Acrylic on canvas, 71 × 51 in. (180.3 × 129.5 cm),
> Terra Foundation for American Art, Daniel J. Terra
> Art Acquisition Endowment Fund, 2017.3

Born in Chicago in 1939, Ed Paschke studied at the School of the Art Institute in the 1960s while working as a commercial artist and experimenting with collage and film. Upon his exposure to Pop Art he began to incorporate images borrowed directly from popular print media into his work. As evidenced in his 1970 painting, *Topcat Boy*, Paschke's interest in cartoons, animation, posters, and tattoo art provided diverse source material for his colorful, playful, and often outlandish imagery.

Paschke drew on his experiences in the sleazy nightclubs and wrestling venues of Chicago, making their subcultures subjects of his Pop-informed art. He carefully recreated the look and feel of various media and often manipulated his source materials—adding a woman's face to the body of a doll, or hockey gloves and a Mexican *lucha libre* mask to the figure of the top-hatted man in *Topcat Boy*—to layer his canvases with a multitude of textures and psychedelic colors that enhance his sensational subjects.

Jamie Wyeth (b. 1946)
Kalounna in Frogtown, 1986

Oil on Masonite, 36 × 50 ⅛ in. (91.4 × 127.3 cm),
Terra Foundation for American Art, Daniel J.
Terra Collection, 1992.163

The son and grandson of important artists,
Jamie Wyeth started to paint at a very young
age. He continued their tradition of realist
painting and often found inspiration in rural
Pennsylvania and Maine. He is known for his
immersive approach to portraiture, trying to
"become" the person he depicts. A young boy,
seeming at once fragile and defiant, dominates
this large composition,. One hand is clenched
in a fist while the other is tense and open.
His name is Kalounna, and his parents, refu-
gees from Laos, worked as caretakers on the
Wyeth farm. His red T-shirt echoes the red
trailer truck to the right and red shutters in
the background. The shirt features the logo of
the popular television series *Dallas* and may
suggest the boy's desire to assimilate to his
newly adopted country. Painted in Frogtown,
Pennsylvania, this highly detailed canvas
evokes the tensions between nature and
machine, childhood and adolescence, and
native and foreign.

Introduction: Sarah Monks

1 The most complete account of Groombridge's career remains J. Hall Pleasants, "Four Late Eighteenth-Century Anglo-American Landscape Painters," *Proceedings of the American Antiquarian Society* 52 (1943), 215–38.

2 "The Exhibition," *Morning Chronicle and London Advertiser*, May 14–15, 1784.

3 "Royal Academy Exhibition," *London Courant Westminster Chronicle and Daily Advertiser*, April 30, 1782, and May 2, 1782; "Exhibition of Paintings, Sculpture &c. at the Royal Academy," *St James's Chronicle or the British Evening Post*, May 15–17, 1787.

4 See *London Gazette*, October 13–17, 1778, in which Groombridge is described as a surrendered fugitive, now in the King's Bench prison. In 1783–4, Groombridge sent landscapes to the Royal Academy (including a view of Dieppe, a common resort for fleeing debtors) from an address within the precincts of Newgate prison.

5 William Groombridge, *Sonnets, the two last in Commemoration of the late Wm Jackson, Esq.* (Canterbury, 1789).

6 See William Dunlap, *A History of the Rise and Progress of the Arts of Design in the United States*, 3 vols. (Boston: C. E. Goodspeed & Co., 1918 [1834]), vol. 2, 176–7.

7 The depicted steeple is most likely that of the Dutch Reformed Church in the Bronx. The large house at the painting's left-hand edge was long identified as the Morris-Jumel Mansion, where the painting was discovered in the early twentieth century, but this identification has rightly been dismissed: the Morris-Jumel Mansion's architectural form and style, and relationship to the river, differ from those in the painting; maps of the period show several large houses in north Manhattan.

8 See the so-called British Headquarters Map (c. 1782, The National Archives, UK, MR1/463), reproduced as *B F Stevens's Facsimile of the Unpublished British Head Quarters Coloured Manuscript Map of New York & Environs* (London: Malby & Sons, 1900).

9 See William Groombridge, *An Extensive River Landscape with Fishermen on the Banks* (1782, Christie's London, October 28, 2009, lot 105); *A View of Canterbury* (1787, Christie's London, December 9, 2015, lot 156); *A View of a Lake with Fishermen* (1788, Yale Center for British Art, New Haven).

10 See the Reginald Pelham Bolton Collection in the Dyckman Farmhouse Museum, New York.

11 Edward Hicks, *Memoirs of the Life and Religious Labors of Edward Hicks* (Philadelphia, 1851), 71.

12 Ibid., 36.

13 Quotes in this paragraph are ibid., 7.

14 Ibid., 31, 12.

15 See David Tathan, "Edward Hicks, Elias Hicks, and John Comly: Perspectives on the Peaceable Kingdom Theme," *The American Art Journal* 13, no. 2 (Spring 1981): 36–50.

16 See Ellwood Parry, "Edward Hicks and a Quaker Iconography," *Arts Magazine* 49, no. 10 (June 1975): 92–4.

17 See Joyce Hill Stoner, "Washington Allston: Poems, Veils, and 'Titian's Dirt,'" *Journal of the American Institute of Conservation* 29, no. 1 (Spring 1990): 1–12.

18 See *The Athenaeum: Journal of English and Foreign Literature, Science, and the Fine Arts*, no. 846 (January 13, 1844): 41; and Nathalia Wright, ed., *The Correspondence of Washington Allston* (Lexington, KY: University Press of Kentucky, 1993), 337.

19 Elizabeth Palmer Peabody, "Allston the Painter," *American Monthly Magazine*, n.s., 1 (May 1836): 435–46, and *Last Evening with Allston, and Other Papers* (Boston: D. Lothrop & Co, 1886), 46–7.

Perspective: Guillaume Faroult. John Singleton Copley, *Portrait of Mrs. John Stevens (Judith Sargent, later Mrs. John Murray)*, 1770–72.

1 Carrie Rebora Barratt, *John Singleton Copley in America* (New York: The Metropolitan Museum of Art, 1995), 232.

2 Elizabeth Eger and Lucy Peltz, *Brilliant Women: 18th-Century Bluestockings* (London: National Portrait Gallery, 2008), 59–61.

Introduction: François Brunet

1 See Albert Boime, *The Magisterial Gaze: Manifest Destiny and American Landscape Painting, 1830–1965* (Washington, DC: Smithsonian Books, 1992) and Andrew Wilton and Tim Barringer, *American Sublime: Landscape Painting in the United States, 1820–1880* (London: Tate Publishing, 2002).

2 James P. Ronda, *Finding the West: Explorations with Lewis and Clark*, (Albuquerque: UNM Press, 2006), 7.

3 Thomas Jefferson, *Notes on the State of Virginia*, (Boston: Lilly and Wait, 1832), 17.

4 Peter John Brownlee, *Manifest Destiny/Manifest Responsibility, Environmentalism and the Art of the American Landscape* (Chicago: Terra Foundation for American Art, 2008), 13.

5 Thomas Cole, "Essay on American Scenery," American Monthly Magazine 1 (January 1836): 1–12.

6 Diane Dillon, "Nature, Nurture, Nation, Appetites for Apples and Autumn during the Civil War," in Peter J. Brownlee et al., *Home Front: Daily Life in the Civil War North* (Chicago: University of Chicago Press, 2013), 150–151.

7 See the classic study by Angela Miller, *The Empire of the Eye: Landscape Representation and American Cultural Politics, 1825–1875* (Ithaca: Cornell University Press, 1993).

Perspective: Claudia Mattos-Avolese. Thomas Cole, *Landscape with Figures: A Scene from "The Last of the Mohicans,"* 1826.

1 *Picturing the Americas: Landscape Painting from Tierra del Fuego to the Arctic* was co-organized by the Art Gallery of Ontario, Pinacoteca de São Paulo, and the Terra Foundation for American Art. The exhibition traveled to the Art Gallery of Ontario, Crystal Bridges Museum of American Art (Bentonville, Arkansas), and the Pinacoteca de São Paulo.

Perspective: Alberto Nulman Magidin. William S. Jewett, *The Promised Land — The Grayson Family*, 1850.

1 "Grayson City," *Daily Alta California* 1, no. 114 (May 11, 1850).

2 Alonzo Phelps, Hubert H. Bancroft, George Davidson, O. P. Fitzgerald, and Joseph LeConte, *Contemporary Biography of California's Representative Men: With Contributions from Distinguished Scholars and Scientists* (San Francisco: A.L. Bancroft, 1881), 358.

3 "The Fine Arts," *California Farmer and Journal of Useful Sciences* 7, no. 9 (March 13, 1857).

4 Ibid.

Perspective: Richard Read. Fitz Henry Lane, *Brace's Rock, Brace's Cove*, 1864.

1 Clarence Cook, "Letters on Art—No. 4," *Independent*, September 7, 1854, repr. *American Art to 1900: A Documentary*, eds. Sarah Burns and John Davis (Berkeley, Los Angeles, London: University of California Press, 2009), 308. The author is grateful to the Terra Foundation for American Art for allowing him to study Lane's painting for several months by funding two university courses at the University of Western Australia, an international conference, and the exhibition *Continental Shift: Nineteenth-Century American and Australian Landscape Painting* at the Art Gallery of Western Australia, Perth, July 30, 2016–February 5, 2017. *Continental Shift* was co-organized by the Art Gallery of Western Australia and the Terra Foundation for American Art. See http://www.artgallery.wa.gov.au/exhibitions/continental-shift.asp and http://www.artgallery.wa.gov.au/exhibitions/symposium.asp.

2 Maurice Merleau-Ponty, *Phenomenology of Perception*, tr. Donald A. Lands (London and New York: Routledge, Taylor & Francis, 2012), 49.

Introduction: Sarah Burns

1 See Elizabeth Johns, *American Genre Painting: The Politics of Everyday Life* (New Haven: Yale University Press, 1991), especially Chapter 1, "Ordering the Body Politic," 1–23.

2 G[eorge]. M[urray]., "Review of the Third Annual Exhibition of the Columbian Society of Artists and the Pennsylvania Academy," *Port Folio* 2 (1813): 139–40.

3 Rowena Houghton Dasch, "'Now Exhibiting': Charles Bird King's Picture Gallery, Fashioning American Taste and Nation 1824–1861" (PhD diss., University of Texas at Austin, 2012), 187–193.

4 Coined by the influential journalist John L. O'Sullivan in 1845, the term "manifest destiny" expressed the widespread conviction that Euro-American settlers were by divine sanction destined to expand across and possess the entire continent.

5 There were also painters of frontier life, such as George Caleb Bingham (1811–1879) and William Tylee Ranney (1813–1857), who constructed a model of American identity based on rugged individualism, restless energy, and a will to dominate western lands.

6 "The National Academy of Design," *The Crayon* 6, no. 6 (June 1859): 191.

7 One of the most notable of these paintings is *A Ride for Liberty—The Fugitive Slaves*, c. 1862 (Brooklyn Museum of Art), which shows a black family on horseback in a desperate flight to reach the Union lines.

8 It is not known which of the two was the first one Johnson painted, though it was probably the white version, which is more of a study. Johnson said nothing about either painting. The Terra's painting was not exhibited during Johnson's lifetime and was sold out of his estate.

9 This was a crucial question after the war. Reconstruction (1866–77) in the South was accompanied by federal legislation that abolished slavery, made all black people full citizens, and gave black men the franchise. Yet by the end of that period the majority

of black people, most particularly in the South, had little to celebrate: their social and economic status was scarcely improved, and in the South oppressive new laws relegated them to menial labor and brutally enforced their segregation from white society.

10 Patricia Hills, "Painting Race: Eastman Johnson's Pictures of Slaves, Ex-Slaves, and Freedmen," in Teresa A. Carbone and Patricia Hills, *Eastman Johnson: Painting America* (New York: Rizzoli, 1999), 121.

11 It is estimated that as many as 750,000 lost their lives in the war—about 2 percent of the population—and thousands of survivors were permanently maimed.

12 These fairs operated under the aegis of the United States Sanitary Commission, organized by prominent citizens in the North and signed into law on June 18, 1861. The purpose of the USSC was to create a corps of volunteers charged with visiting Union Army camps and hospitals to ensure that they were adhering to proper hygienic standards. The sanitary fairs, run mostly by women, raised money for food, blankets, and medical supplies to supplement what the chronically overextended War Department was able to provide.

13 For additional details, see Sarah Burns, "Rending and Mending: The Needle, the Flag, and the Wounds of War in Lilly Martin Spencer's *Home of the Red, White, and Blue*," in Peter John Brownlee et al., *Home Front: Daily Life in the Civil War North* (Chicago: University of Chicago Press, 2013), 99–125.

14 Ralph Waldo Emerson, "Country Life," in *The Later Lectures of Ralph Waldo Emerson, 1843–1871*, vol. 2, eds. Ronald A. Bosco and Joel Myerson (Athens: University of Georgia Press, 2010), 55.

15 Diane Dillon, "Nature, Nurture, Nation: Appetites for Apples and Autumn during the Civil War," in Brownlee et al., *Home Front*, 135–37, 145.

16 Martha Hoppin, *The World of J.G. Brown* (Chesterfield, MA: Chameleon Books, 2010), 107.

17 Ibid., 107.

18 George William Sheldon, "Sketches and Studies," *Art Journal* (April 1880): 107.

19 "The Water Color Exhibition," *The Sun*, February 16, 1879.

Introduction: Frances Fowle

1 On American impressionists see William H. Gerdts, *American Impressionism* (New York: Abbeville Press, 1984); Kathleen Adler, Erica E. Hirshler, and H. Barbara Weinberg, *American Artists in Paris 1860–1900* (London: National Gallery, 2006); and Katherine M. Bourguignon, ed., *American Impressionism: A New Vision 1880–1910* (Paris: Hazan, 2014).

2 The remaining three artists in that group were Joseph R. DeCamp (1858–1923), Edward Simmons (1852–1931), and Willard Leroy Metcalf (1858–1925). On aesthetics and impressionism in Gilded Age painting see Sarah Burns and John Davis, eds., *American Art to 1900: A Documentary History* (Oakland: University of California Press, 2009), 941–1013.

3 Mark Twain and Charles Dudley Warner, *The Gilded Age: A Tale of Today* (Hartford: American Publishing Company, 1873).

4 On this period in New York, see Esther Crain, *The Gilded Age in New York, 1870–1910* (New York: Black Dog & Leventhal, 2016).

5 In 1888 the critic Sheridan Ford published a pamphlet, *Art: A Commodity*, exposing bad practices in the art market.

6 See Jennifer A. Thompson, "Durand-Ruel and America," in *Inventing Impressionism: Paul Durand-Ruel and the Modern Art Market* (London: National Gallery, 2015), 134–151. On the market for impressionism in Boston see Erica E. Hirshler, *Impressionism Abroad: Boston and French Painting* (London: Royal Academy of Arts, 2005), 17–39.

7 See, for example, the press response to the 2014 exhibition *American Impressionism: A New Vision 1880–1910*, National Galleries of Scotland, Edinburgh.

8 William Howe Downes, "The Spontaneous Gaiety of Frank W. Benson's Work," *Arts and Decoration* 1 (March 1911): 195, cited in Hirshler, *Impressionism Abroad*, 35.

9 See John Leslie Breck, *Studies of an Autumn Day*, 1891. Oil on canvas, 12 7/8 × 16 1/16 in. (32.7 × 40.8 cm). Terra Foundation for American Art, Daniel J. Terra Collection, 1989.4.3.

10 The Edinburgh painting was included in the exhibition *Van Gogh to Kandinsky: Symbolist Landscape in Europe 1880–1910*, National Galleries of Scotland, Edinburgh, July 14, 2012-October 14, 2012.

11 Monet in a letter to Gustave Geffroy, 1890, cited in John House, *Monet: Nature into Art* (New Haven: Yale University Press, 1986), 198.

12 As Nina Lubbren has pointed out, after the success of Monet's grain stack series, the haystack, a familiar aspect of the cycle of the seasons, visible in most European agrarian landscapes, became intimately associated with Giverny as part of a "place-myth." Katherine M. Bourguignon, ed., *Impressionist Giverny: A Colony of Artists, 1885–1915* (Chicago: Musée d'Art Américain, Giverny/Terra Foundation for American Art, 2007), 36.

13 Foreword, *1899 Memorial Exhibition of Paintings by John Leslie Breck* (Boston: St. Botolph Club, 1899).

14 Derrick R. Cartwright, *The City and the Country: American Perspectives 1870–1920* (Chicago: Musée d'Art Américain, Giverny/Terra Foundation for American Art, 1999), 18.

15 David Park Curry, *Childe Hassam: An Island Garden Revisited* (New York: W. W. Norton, 1990), 134.

16 Theodore Child, "The Paris Salon of 1887," *The Art Amateur* 6, no. 6 (May 1887): 126.

17 Cited in H. Barbara Weinberg, *Childe Hassam: American Impressionist* (New Haven: Yale University Press, 2004), 61.

18 Susan Hale, *Boston Transcript* 1887, Archives of American Art, [1993.20], Roll NAA1, Frame 489.

19 Patrice Havard, "Hier, aujourd'hui … mais demain?" in *Sapeurs-Pompiers de France*, no. 1093 (October 2016): 67.

20 Raymond H. Robinson, "The Families of Commonwealth Avenue," *Proceedings of the Massachusetts Historical Society*, Third Series, 93 (1981): 80.

Cosmopolitanism and the Gilded Age

21 On Haussmann and the "greening" of Paris, see Clare A. P. Willsdon, "Promenades et plantations: impressionism, conservation and Haussmann's reinvention of Paris" in F. Fowle and R. Thomson, eds., *Soil and Stone: Impressionism, Urbanism, Environment* (Aldershot, UK: Ashgate, 2003), 107–124.

22 Art historian William Gerdts has suggested that Chase was encouraged to paint such a con-temporary subject by his good friend Alfred Stevens (1823–1906), whose scenes of the Normandy coast may have been an initial source of inspiration. Even closer to the spirit of Chase's painting, however, are Eugène Boudin's (1824–1898) 1890s paintings of holidaymakers at Deauville and Trouville, which take in the vast expanse of sky and beach and employ the same pale, luminous tonality or "*peinture claire.*" See William H. Gerdts, *Lasting Impressions: American Painters in France 1865–1915* (Chicago: Musée d'Art Américain, Giverny/Terra Foundation for American Art, 1992), 76, and John House, *Impressionists by the Sea* (London: Royal Academy of Arts, 2007), 136.

23 White was also commissioned to build the club house for the Shinnecock Hills golf club, established the previous year.

24 Chase painted a more focused version of the breakwater in *The Lone Fisherman*, oil on panel, 15 × 11 7/8 in. (38.1 × 30.2 cm), Hood Museum of Art, Dartmouth College, P.940.40.

25 The canal created a link with Peconic Bay. In 1896, shortly before Chase produced this work, a further channel was excavated in an attempt to create a link to the Atlantic Ocean, but the attempt failed. See Nobel E. Whitford, *History of the Canal System of the State of New York*, vol. 1, chap. 12 (New York, 1905), http://eriecanal.org/texts/Whitford/1906/Chap12.html, accessed on 1 June 2017.

26 Cited in Erica Hirshler, "Old Masters Meet Modern Women," in Elsa Smithgall et al., *William Merritt Chase: A Modern Master* (Washington, DC: Phillips Collection, 2016), 25.

27 Anonymous critic, "Academy Sculpture and Painting," *New York Times*, 5 April 1892.

28 "The Fine Arts at the National Academy's Spring Exhibition," *The Independent*, April 14, 1892, 11.

29 On this project see Judith A. Barter, *Mary Cassatt: Modern Woman* (New York: Harry N. Abrams, 1998).

30 Cassatt to Bertha Palmer, 11 Oct 1892 in Nancy Mowll Mathews, *Cassatt and Her Circle: Selected Letters* (New York: Abbeville Press, 1984), 238, cited ibid., 88.

31 Clare A.P. Willsdon, *Impressionist Gardens* (Edinburgh, National Galleries of Scotland, 2010), 155.

32 Barter, *Mary Cassatt*, 86.

33 The Terra painting is noticeably more focused than the second version of *Summertime* (about 1894) in the Armand Hammer Foundation, Carpinteria, California.

Perspective: Sarah Cash. John Singer Sargent's oyster gatherer series, 1877.

1 Alvin Toffler, *Future Shock* (New York: Random House, 1970), 1.

Perspective: Elsa Smithgall. William Merritt Chase, *Spring Flowers (Peonies)*, by 1889.

1 *William Merritt Chase: A Modern Master* was co-organized by the Terra Foundation for American Art, the Phillips Collection (Washington, DC), the Museum of Fine Arts, Boston, and the Fondation Musei Civici di Venezia (Venice, Italy). The pastel appeared in the first two venues.

2 John La Farge, "Bric-À-Brac, Nikko, August 12," in *An Artist's Letters from Japan* (New York: Century Co., 1903), 149.

Perspective: Chen Yao. Childe Hassam, *Horse Drawn Cabs at Evening, New York*, c. 1890.

1 A.E. Ives, "Talks With Artists: Mr. Childe Hassam on Painting Street Scenes," *Art Amateur* 27 (October 1892): 116–117.

Perspective: Anne Lafont. Henry Ossawa Tanner, *Les Invalides, Paris*, 1896.

1 At the end of the nineteenth century Captain Albert Dreyfus, a French Jew, was found guilty

of treason; more than ten years later he was acknowledged to be innocent. The affair divided French intellectual life between those who advocated for Dreyfus and those who condemned him, often in anti-Semitic terms.

Introduction: David Peters Corbett

1 See Linda Merrill, *After Whistler: The Artist and His Influence on American Painting* (New Haven: Yale University Press, 2003).

2 In addition to *Carlyle's Sweetstuff Shop* (c. 1887), Whistler is represented in the Terra Foundation's collection with *A Brittany Shop with Shuttered Windows* (c. 1893), *A Chelsea Shop* (1894–95), and *Flower Shop, Dieppe* (1897 or 1899).

3 This connects to Bellows's many paintings of snow scenes in the city, such as *Blue Snow, the Battery*, 1910, Columbus Museum of Art, which won him popularity during his lifetime.

4 See Richard Haw, *The Brooklyn Bridge: A Cultural History* (New Brunswick, NJ: Rutgers University Press, 2005); and Sarah Kate Gillespie et al., *Icon of Modernism: Representing the Brooklyn Bridge, 1883–1950* (Athens, GA: Georgia Museum of Art, University of Georgia, 2016).

5 See "Interpretation," Ernest Lawson, *Brooklyn Bridge*, 1917–20. https://collection. terraamericanart.org/view/objects/asitem/search $0040/1/dateBegin-asc/alphaSort-asc?t:state: flow=3128d31d-42ad-4f1f-b0e1-4de8e8b48e45.

6 William R. Everdell, *Rowboats to Rapid Transit: A History of Brooklyn Heights* (Brooklyn, NY: Brooklyn Heights Association, 1973).

7 On this compositional device in Marsh's paintings, including *Pip and Flip*, see Carmenita Higginbotham, "At the Savoy: Reginald Marsh and the Art of Slumming," *Bulletin of the Detroit Institute of Arts*, vol. 82, no. 1/2 (2008): 16–29.

8 Robin Jaffee Frank, *Coney Island: Visions of An American Dreamland, 1861–2008* (New Haven: Yale University Press, 2008), especially 96–99.

9 See Karen Lucic, *Charles Sheeler in Doylestown: American Modernism and the Pennsyl-* *vania Tradition* (Allentown, PA: Allentown Art Museum, 1997). See also Karen Lucic, "The Present and the Past in the Work of Charles Sheeler" 2 vols. (PhD diss., Yale University, 1989).

10 See Wanda Corn, "Home, Sweet Home," chap. 6 in *The Great American Thing: Modern Art and National Identity, 1915–1935* (Berkeley: University of California Press, 1999).

Perspective: Hélène Valance. William Glackens, *Bal Bullier*, c. 1895.

1 Rodolphe Darzens, *Nuits à Paris* (Paris: E. Dentu, 1889), 207–211.

Perspective: Alberto Harambour. Rockwell Kent, *Cranberrying, Monhegan*, c. 1907.

1 Rockwell Kent, *Wilderness: A Journal of Quiet Adventure in Alaska* (New York: G. P. Putnam's Sons, 1920), 82.

Perspective: John Fagg. Robert Henri, *Figure in Motion*, 1913.

1 Quoted in Joseph J. Kwiat, "Robert Henri and the Emerson–Whitman Tradition," *PMLA* 71, no. 4 (September 1956): 617–636, 619.

2 Guy Pène du Bois, *Artists Say the Silliest Things* (New York: American Artists Group, 1940), 86.

3 "The Teachings of Robert Henri: The Alice Klauber Manuscript," in Bennard Perlman, *Robert Henri: His Life and Art* (New York: Dover, 1991), 144.

4 October 25, 1908. See http://www.delart. org/collections/john-sloan/diaries/.

5 Henri quoted in Ruth L. Bohan, "Robert Henri, Walt Whitman and the American Artist," *Walt Whitman Quarterly Review* 29 (2012): 137.

6 Emma Goldman, "The Hypocrisy of Puritanism," in *Anarchism and Other Essays* (New York: Mother Earth Publishing Association, 1911), 175–76.

7 Marguerite Mooers Marshall, "Is the Modern Woman Beautifully Dressed? What

Artists Say About It," *New York Evening World*, March 15, 1912.

Perspective: Anna Hudson. Walter Ufer, *Builders of the Desert*, 1923.

1 "Artist's Corner," Taos Valley News, February 26, 1918, *Chicago Times*, as quoted by Dean A. Porter in "A Biography of Walter Ufer," in *A Place in the Sun: The Southwest Paintings of Walter Ufer and E. Martin Hennings* (Norman, OK: University of Oklahoma Press, 2016), 35.

2 E.L., "Some Prize Winners in the Pennsylvania Academy Annual Exhibition," *The Art News* 22, no. 18 (February 9, 1924): 2.

3 See http://www.webpages.uidaho.edu/~rfrey/PDF/329/IndianDances.pdf.

4 See http://www.encyclopedia.com/history/dictionaries-thesauruses-pictures-and-press-releases/american-indian-defense-association/ and http://newmexicohistory.org/people/all-indian-pueblo-council-and-the-bursum-bill.

5 See http://taos.org/what-to-do/taos-pueblo/ and http://whc.unesco.org/en/list/492.

Perspective: Richard J. Powell. Archibald J. Motley, Jr. *Between Acts*, 1935.

1 Alain LeRoy Locke, "The Negro Takes His Place in American Art," in *The Negro and His Music/Negro Art: Past and Present* (1936; repr., New York: Arno Press/New York Times, 1969), 69–70.

2 Ibid.

Perspective: Mark Rawlinson. Charles Sheeler, *Bucks County Barn*, 1940.

1 Henry McBride, "Charles Sheeler's Bucks County Barns" in McBride, *The Flow of Art: Essays and Criticisms of Henry McBride* (New York: Atheneum, 1975), 155.

2 John Szarkowski, *William Eggleston's Guide* (New York: Museum of Modern Art, 1976), 7.

Perspective: Ruth Fine. Romare Bearden, *After Church*, 1941.

1 I am grateful to Mary Schmidt Campbell for her June 17, 2017, email, in which she supplied the timing of Bearden's 1940 trip South.

2 "Artist's Statement" in *Romare Bearden: Oils, Gouaches, Watercolors, Drawings 1937–1940* (New York: 306, 1940), [n.p.].

3 Ibid.

Introduction: Chris McAuliffe

1 Arthur Dove. *Diary, 1942*. Arthur and Helen Torr Dove papers, 1905–1975, 1920–1946. Archives of American Art, Smithsonian Institution.

2 Barbara Haskell, *Marsden Hartley* (New York: Whitney Museum of American Art/New York University Press, 1980), 9.

3 Hilton Kramer, "Hartley's Abstract Interlude," *Arts Magazine* 29, no. 7 (1955): 9.

4 Max Weber, "The Fourth Dimension From a Plastic Point of View," *Camera Work* 31 (1910): 25.

5 Max Weber, *Essays on Art* (New York: William Edwin Rudge, 1916), 8. This volume consists of a series of essays Weber wrote in fall 1914 and self-published in 1916.

6 Marsden Hartley, "[Statement]," *Camera Work* 45 (1914): 17.

7 Arthur Dove, *Abstraction Essay, 19—*. Arthur and Helen Torr Dove papers, Archives of American Art.

8 In a related study, Stella depicted a denser web of wires and greater detail in the insulators and relays, which were both stripped out of the final painting. See *Telegraph Pole*, 1917, gouache on paper, 25 × 19 ¾ in. 63.5 × 50.2 cm, in John Baur, *Joseph Stella* (New York: Whitney Museum of American Art, 1963), 24.

9 Joseph Moser, *Visual Poetry: The Drawings of Joseph Stella* (Washington, DC: Smithsonian National Museum of American Art, 1990), 65.

10 Ibid., 64.

11 Stella's drawing *Painters Row, Workers Houses* (1908) is reproduced along with photographs of worker housing. See Russell Sage Foundation, *The Pittsburgh Survey*, ed. Paul Underwood Kellog, vol. 1, *The Pittsburgh District: Civic Frontage* (New York: Survey Associates, 1914) between pages 132–133.

12 Quoted in Stephen May, "Joseph Stella's Pittsburgh," *Carnegie Magazine* 58 (1991), http://www.info-ren.org/projects/btul/exhibit/stell31.html, accessed 11 July 2017.

13 Weber, *Essays*, 34.

14 Ibid., 31.

15 Ibid., 26.

16 Ibid., 35.

17 Ibid., 32.

18 Ibid., 69.

19 Ibid.

20 Ibid., 53.

21 Ibid., 39.

22 Ralph Waldo Emerson, *The Complete Essays and other Writings*, Brooks Atkinson (ed.), (New York: The Modern Library, 1950), 87.

23 Ibid., 89

24 Letter from Hartley to Alfred Stieglitz, November 8, 1914, quoted in Haskell, *Marsden Hartley*, 44.

25 Henri Bergson, "What is the Object of Art?" [Excerpts from his *On Laughter*], *Camera Work* 37 (1912): 24.

26 Ibid.

27 Elizabeth Grosz, *The Nick of Time: Politics, Evolution, and the Untimely* (Durham: Duke University Press, 2004), 237.

28 Letter from Dove to Duncan Phillips, October 3, 1913, cited in Sasha M. Newman, *Arthur Dove and Duncan Phillips: Artist and Patron* (New York: George Braziller, 1981), 28.

29 Newman, *Arthur Dove and Duncan Phillips*, 37.

30 Ibid., 36.

31 Marsden Hartley, "The Red Man," in his *Adventures in Art* (New York: Bone and Liveright, 1921), 14.

32 Ibid., 15.

33 Marsden Hartley, *Somehow a Past* (Cambridge, MA: MIT Press, 1997), 67.

34 Le Corbusier, *Towards a New Architecture*, tr. Frederick Etchells (New York: Dover, 1970), 31. Le Corbusier illustrated nine North American grain elevators in the first section of his "Three Reminders to Architects," under the heading "Mass."

Perspective: Dieter Scholz.
Marsden Hartley, *Painting No. 50*, 1914–15.

1 Marsden Hartley, letter to Alfred Stieglitz, Berlin, November 8, 1915, in *My Dear Stieglitz: Letters of Marsden Hartley and Alfred Stieglitz 1912–1915*, ed. James Timothy Voorhies (Columbia: University of South Carolina Press, 2002), 201.

2 Franz Marc, "Die 'Wilden' Deutschlands," in *Der Blaue Reiter*, ed. Wassily Kandinsky and Franz Marc (Munich: R. Piper, 1912), 5–7.

3 Marsden Hartley, letter to Alfred Stieglitz, Berlin, November 12, 1914, ibid., 172.

4 Wassily Kandinsky, "Über die Formfrage," ibid., 97.

5 Ibid., 80, 86, 88.

Perspective: Georgiana Uhlyarik.
Georgia O'Keeffe, *Red Amaryllis*, 1937.

1 Georgia O'Keeffe, *Georgia O'Keeffe* (New York: Viking Press, 1976), n.p.

Contributors

A historian of images and American culture, **François Brunet** teaches at Université Paris Diderot. His publications include *La photographie: Histoire et contre-histoire* (2017) and *Images of the West: Survey Photography in French Collections, 1860–1880* (2007). He recently edited *Circulation*, volume four in the *Terra Foundation Essays* series (2017).

Sarah Burns, Professor Emeritus of Art History, Indiana University, Bloomington, is the author of *Inventing the Modern Artist: Art and Culture in Gilded Age America* (1996) and *Painting the Dark Side: Art and the Gothic Imagination in Nineteenth-Century America* (2004) and co-editor of *American Art to 1900: A Documentary History* (2009).

Sarah Cash is Associate Curator of American and British Paintings at the National Gallery of Art. Her previous positions include Curator of American Art at the Corcoran Gallery of Art, Washington, DC; Director of the Maier Museum of Art, Randolph College, Lynchburg, Virginia; and Assistant Curator, Amon Carter Museum of American Art, Fort Worth, Texas.

Chen Yao received her PhD from Peking University in 2015 and joined the College of Architecture and Art, Hefei University of Technology, China, as an assistant professor. Her research interests include American impressionism and realism. In 2016 she was selected for the Middle-aged and Young Chinese Scholars Overseas Research Program.

David Peters Corbett is Director of the Centre for American Art at the Courtauld Institute, University of London. A former Terra Foundation Senior Fellow at the Smithsonian American Art Museum, he has written on George Bellows, the Ashcan school, and American and British art of the nineteenth and twentieth centuries.

Robert Cozzolino is Patrick and Aimee Butler Curator of Paintings at the Minneapolis Institute of Art, Minnesota. He has been called the "curator of the dispossessed" for championing underrepresented artists and uncommon perspectives on well-known artists. A native of Chicago, he earned his PhD (2006) from the University of Wisconsin, Madison.

Eunyoung Cho is Professor of Art History at Wonkwang University, South Korea. She received her PhD from the University of Delaware and has held fellowships from the Luce Foundation, the Smithsonian Institution, and the National Endowment for the Humanities. A specialist in American interchanges with Asian art, she has taught and lectured in Korea, Japan, and China.

John Davis is Provost and Under Secretary for Museums and Research at the Smithsonian Institution, Washington, DC. Previously he served on the faculty of Smith College, Northampton, Massachusetts, for twenty-five years. From 2015 to 2017 he was Executive Director of the Paris office of the Terra Foundation for American Art.

Rachael Z. DeLue is Professor of Art History at Princeton University, New Jersey. She studies American visual culture, with emphasis on intersections among art, science, and the history and

theory of knowledge. She serves as the Editor-in-Chief of the Terra Foundation Essays series, and edited its first volume, *Picturing* (2016).

John Fagg teaches in the School of English, Drama and American and Canadian Studies at the University of Birmingham, UK. His article "Chamber Pots and Gibson Girls: Clutter and Matter in John Sloan's Graphic Art" (2015) received the Terra Foundation International Essay Prize and the Arthur Miller Centre Essay Prize.

Guillaume Faroult is Senior Curator at the Musée du Louvre, Paris. A specialist in eighteenth-century French, British, and American paintings, he has organized many exhibitions and in 2012 co-curated *Thomas Cole and the Narrative Landscape*, the first in a series of collaborative exhibitions at the Louvre devoted to American art.

Ruth Fine is an independent curator in Philadelphia who spent four decades at the National Gallery of Art, Washington, DC, as a curator specializing in modern prints and drawings. She has organized exhibitions on American artists from John Marin to Norman Lewis, served on the Terra Foundation for American Art Board, and is Chair of the Roy Lichtenstein Foundation Board.

Frances Fowle is Reader in History of Art at the University of Edinburgh, UK, and Senior Curator at the National Galleries of Scotland. She has published widely on nineteenth-century art and co-curated *American Impressionism: A New Vision 1880–1900*, organized in collaboration with the Terra Foundation for American Art in 2014.

After running the Institut National d'Histoire de l'Art's journal *Perspective*, **Anne Lafont** became Professor (Directrice d'études) at the École des Hautes Études en Sciences

Sociales (EHESS), Paris. She is researching early modern art and visual culture of the Black Atlantic and her upcoming volume is *L'art et la race. L'Africain (tout) contre l'œil des Lumières*.

Alberto Harambour is Associate Professor at the Universidad Austral de Chile, Valdivia, and investigator at the Research Center Dynamics of High Latitude Marine Ecosystems (FONDAP-IDEAL). He earned his PhD from the State University of New York, Stony Brook, and specializes in Latin American postcolonial social history.

Anna Hudson is an art historian, curator, and educator specializing in Canadian art and visual culture. She is currently leading Mobilizing Inuit Cultural Heritage, a federally supported research grant, and continues to study the area of her 1997 doctoral dissertation, *Art and Social Progress: The Toronto Community of Painters (1933–1950)*.

Go Kobayashi is Professor in the Depart-ment of American and British Cultural Studies at Kansai University in Osaka, Japan. His research and pedagogical interests include American realism, the impact of new technologies on vision and visuality, and the rise of hyperrealism and cultural capitalism in the global era.

Filip Lipiński is Assistant Professor in the Department of Art History at Adam Mickiewicz University, Poznań, Poland. His book on Edward Hopper—*Hopper wirtualny. Obrazy w pamiętają - cym spojrzeniu*—was published in 2013, and his articles have appeared in the *Oxford Art Journal*, *Artium Quæstiones*, and the *RIHA Journal*.

Clara Marcellán is Assistant Curator at the Museo Thyssen-Bornemisza, Madrid, Spain, where she focuses on European and American nineteenth-century painting. She has coordinated several exhibitions, including *Berthe Morisot* (2011) and *American Impressionism*

(2014). She holds a bachelor's degree in art history from Madrid's Universidad Autónoma.

Chris McAuliffe is Professor of Art (Practice-led Research) at the School of Art and Design, Australian National University, Canberra, and former director of the Ian Potter Museum of Art, the University of Melbourne. In 2011–12 he was Gough Whitlam and Malcolm Fraser Visiting Professor of Australian Studies at Harvard University, Cambridge, Massachusetts.

Yuko Matsukawa is Professor of English at Seijo University in Tokyo. Her research explores intersections between American literature, orientalism, and Asian American culture. Her publications include the co-edited volume *Re/collecting Early Asian America* (2002) and essays on Henry James, Lilla Cabot Perry, Constance Fenimore Woolson, and Winnifred Eaton.

Claudia Mattos-Avolese is Professor of Art History at the Universidade de Campinas, Brazil, specializing in nineteenth- and twentieth-century Brazilian art. She holds a PhD from Freie Universität Berlin, Germany, and has held fellowships at the Courtauld Institute in London (2001), the Getty Research Institute in Los Angeles (2012), and the Rockefeller Center at Harvard (2017).

Sarah Monks is Lecturer in Art History at the University of East Anglia, UK. She is a historian of British and American art, c. 1650–1850, and has published on a range of artists of this period including Benjamin West, John Singleton Copley, and J. M. W. Turner.

Alberto Nulman Magidin is a Mexican art historian, curator, and filmmaker whose research interests include the history of landscape practices and the arts in Mexico and California during the nineteenth century.

His documentaries explore the crossroads between art, science, and the history of the Americas.

Hideko Numata is Chief Curator of Yokohama Museum of Art in Japan. She specializes in Japanese and Western paintings and prints of the nineteenth and twentieth centuries with a focus on cross-cultural influences and relationships. She has curated many exhibitions, including *Edgar Degas* (2010) and *Mary Cassatt Retrospective* (2016).

Valéria Piccoli is Chief Curator at the Pinacoteca de São Paulo, Brazil. She holds a PhD in art history from the Universidade de São Paulo, Brazil. Her research focuses on nineteenth and early twentieth-century Brazilian art. She co-curated the traveling exhibition *Picturing the Americas: Landscape Painting from Tierra del Fuego to the Arctic* (2015–2016).

Richard J. Powell is the John Spencer Bassett Professor of Art and Art History at Duke University, Durham, North Carolina. He has written on many topics in American art, organized numerous art exhibitions, and was Editor-in-Chief of *The Art Bulletin*, the leading English-language journal in art history (2007–2010).

Mark Rawlinson is Associate Professor of History of Art at the University of Nottingham, UK. He is the author of *Charles Sheeler: Modernism, Precisionism and the Borders of Abstraction*, published in 2007 by I. B. Tauris & Co Ltd. He has curated several exhibitions and was recently awarded an Ansel Adams Fellowship at the Center for Creative Photography, Arizona (2017).

Richard Read is Emeritus Professor and Senior Honorary Research Fellow at the University of Western Australia, Perth. He

wrote the first book on British art critic Adrian Stokes and has published on the relationship between literature and the visual arts, nineteenth and twentieth-century art, and complex images in global contexts.

Christopher Riopelle is Curator of Post-1800 Paintings at the National Gallery, London. He has held curatorial positions at the J. Paul Getty Museum, Los Angeles, California, and the Philadelphia Museum of Art, Pennsylvania. His interests include Jean-Auguste-Dominique Ingres, Pierre-Auguste Renoir, the landscape oil sketch, and the international spread of modernism around 1900.

Dieter Scholz is Curator of Modern Art at the Nationalgalerie, Staatliche Museen zu Berlin, Germany. He studied in Tübingen and Hamburg and earned his PhD from Johann Wolfgang Goethe-Universität in Frankfurt am Main (1994). He previously worked at the Museum Kunstpalast in Düsseldorf. He curated the exhibition *Marsden Hartley: The German Paintings, 1913–1915* (2014, Berlin; Los Angeles).

Elsa Smithgall is a curator at The Phillips Collection, Washington, DC, specializing in late nineteenth and early twentieth-century American and European art. She has been a curator or contributing curator of over 20 acclaimed special exhibitions, and her writings have appeared in numerous publications, including *William Merritt Chase: A Modern Master* (2017).

Elizabeth Hutton Turner is University Professor at the University of Virginia. Formerly a senior curator at The Phillips Collection, Washington, DC, she organized exhibitions on European and American modernism, and in 2013–14 served as Vice President for Collections and Curatorial Affairs at the Terra Foundation for American Art.

Originally from Romania, **Georgiana Uhlyarik** is Fredrik S. Eaton Curator, Canadian Art, at the Art Gallery of Ontario, Toronto. Her recent projects include collaborations with the Tate Modern; the Jewish Museum, New York; the Terra Foundation for American Art, and the Pinacoteca de São Paulo. She teaches in the Graduate Program, Art History, University of Toronto.

Hélène Valance is Assistant Professor at the Université de Franche-Comté, Besançon, France. Her book *Nuits Américaines: l'art du nocturne aux Etats-Unis, 1890–1917* received the 2015 Olga Fradiss book prize and will be translated and published by Yale University Press in 2018.

Credits

Eastman Johnson, *Fiddling His Way*, 1866. Courtesy: Chrysler Museum of Art, Norfolk, VA

Claude Monet, *Haystacks: Snow Effect*, 1891, National Galleries of Scotland. Courtesy: National Galleries of Scotland, Edinburgh

Mary Cassatt, *Modern Woman*, n.d. Courtesy: Ryerson and Burnham Libraries, Art Institute of Chicago

Rockwell Kent, *Cranberrying, Monhegan*, c. 1907. Rights courtesy of Plattsburgh State Art Museum, State University of New York, USA, Rockwell Kent Collection, Bequest of Sally Kent Gorton. All rights reserved.

Arthur G. Dove, *Nature Symbolized #3: Steeple and Trees*, 1911–12. Courtesy: The Estate of Arthur G. Dove / Terry Dintenfass, Inc.

Arthur G. Dove, *Sails*, 1911–12. Courtesy: The Estate of Arthur G. Dove / Terry Dintenfass, Inc.

Arthur G. Dove, *A Walk: Poplars*, 1912 or 1913. Courtesy: The Estate of Arthur G. Dove / Terry Dintenfass, Inc.

Yasuo Kuniyoshi, *Boy with Cow*, 1921. Art © Estate of Yasuo Kuniyoshi / Licensed by VAGA, New York, NY

Thomas Hart Benton, *Slaves*, 1925. Art © T.H. Benton and R.P. Benton Testamentary Trusts / UMB Bank Trustee / Licensed by VAGA, New York, NY

Stuart Davis, *Super Table*, 1925. Art © Estate of Stuart Davis / Licensed by VAGA, New York, NY

Arthur G. Dove, *Boat Going thru Inlet*, c. 1929. Courtesy: The Estate of Arthur G. Dove / Terry Dintenfass, Inc.

Reginald Marsh, *Chicago*, 1930. © 2018 Estate of Reginald Marsh / Art Students League, New York / Artists Rights Society (ARS), New York

John Marin, *Brooklyn Bridge, on the Bridge*, 1930. © 2018 Estate of John Marin / Artists Rights Society (ARS), New York

Reginald Marsh, *Pip and Flip*, 1932. © 2018 Estate of Reginald Marsh / Art Students League, New York / Artists Rights Society (ARS), New York

John Marin, *Sailboat, Brooklyn Bridge, New York Skyline*, 1934. © 2018 Estate of John Marin / Artists Rights Society (ARS), New York

Georgia O'Keeffe, *Red Amaryllis*, 1937. © 2018 Georgia O'Keeffe Museum / Artists Rights Society (ARS), New York

Arthur G. Dove, *Flour Mill II*, 1938. Courtesy: The Estate of Arthur G. Dove / Terry Dintenfass, Inc.

Weegee (Arthur Fellig), *Coney Island Beach*, 1940. © Weegee (Arthur Fellig) / International Center of Photography / Masters / Getty Images

Romare Bearden, *After Church*, 1941. Art © Romare Bearden Foundation / Licensed by VAGA, New York, NY

Jacob Lawrence, *Bar-b-que*, 1942. © 2018 The Jacob and Gwendolyn Knight Lawrence Foundation, Seattle / Artists Rights Society (ARS), New York

Edward Hopper, *Dawn in Pennsylvania*, 1942. © Heirs of Josephine Hopper / Licensed by VAGA, New York, NY

Edward Hopper, *Sierra Madre at Monterrey*, 1943. © Heirs of Josephine Hopper / Licensed by VAGA, New York, NY

Milton Avery, *Adolescence*, 1947. © 2018 The Milton Avery Trust / Artists Rights Society (ARS), New York

George Tooker, *Highway*, 1953. © Estate of George Tooker. Courtesy: DC Moore Gallery, New York

Terra Collection Initiatives 2006–18

Since 2006, the Terra Foundation has used its collection to create exhibitions in partnership with museums throughout the world. These collaborative projects are called Terra Collection Initiatives.

2006

Winslow Homer: Poet of the Sea

Co-organized by the Terra Foundation for American Art / Musée d'Art Américain Giverny and the Dulwich Picture Gallery, London

FEBRUARY 22–MAY 21, 2006
Dulwich Picture Gallery, London, UK

JUNE 18–SEPTEMBER 24, 2006
Musée d'Art Américain Giverny, France

PUBLICATIONS
Sophie Lévy, ed., *Winslow Homer: Poet of the Sea* (Giverny: Musée d'Art Américain Giverny; Chicago: Terra Foundation for American Art, distributed by University of Chicago Press, 2006).
Also published in a French edition.

American Artists and the Louvre

Co-organized by the Musée du Louvre, Paris, and the Terra Foundation for American Art

JUNE 14–SEPTEMBER 18, 2006
Musée du Louvre, Paris, France

PUBLICATIONS
Elizabeth Kennedy and Oliver Meslay, eds., *American Artists and the Louvre* (Chicago: Terra Foundation for American Art; Paris: Éditions Hazan; Paris: Musée du Louvre Éditions, 2006). *Also published in a French edition.*

2007

Art in America: 300 Years of Innovation

Co-organized by the Solomon R. Guggenheim Foundation and the Terra Foundation for American Art

FEBRUARY 9–APRIL 5, 2007
National Art Museum of China, Beijing

APRIL 30–JUNE 30, 2007
Shanghai Art Museum / Shanghai
Museum / Shanghai Museum of Contem-
porary Art, China

JULY 23–SEPTEMBER 9, 2007
Pushkin Museum of Fine Arts,
Moscow, Russia

OCTOBER 15, 2007–APRIL 27, 2008
Guggenheim Museum, Bilbao, Spain

PUBLICATION

Susan Davidson, ed., *Art in America:
300 Years of Innovation* (in Chinese and
English) (Chicago: Terra Foundation
for American Art; New York: Merrell
Publishers Limited; New York: Solomon
R. Guggenheim Foundation, 2007). *Also
published in Russian and Spanish editions.*

**Impressionist Giverny:
A Colony of Artists, 1885–1915**
*Organized by the Terra Foundation
for American Art / Musée d'Art Américain
Giverny*

APRIL 1–JULY 1, 2007
Musée d'Art Américain Giverny, France

JULY 22–OCTOBER 14, 2007
San Diego Museum of Art, California, USA

MAY 3–JULY 27, 2008
Florence Griswold Museum,
Old Lyme, Connecticut, USA
(as *Impressionist Giverny:
American Painters in France,
1885–1915*)

AUGUST 23, 2008–JANUARY 4, 2009
Albany Institute of History
and Art, New York, USA
(as *Impressionist Giverny: American
Painters in France, 1885–1915*)

PUBLICATIONS

Katherine M. Bourguignon, ed.,
*Impressionist Giverny: A Colony
of Artists, 1885–1915* (Chicago:
Terra Foundation for American
Art; Giverny: Musée d'Art
Américain Giverny, distributed by
University of Chicago Press, 2007).
Also published in a French edition.

2008

**Manifest Destiny /
Manifest Responsibility:
Environmentalism and
the Art of the American
Landscape**
*Co-organized by the Loyola Museum
of Art, Chicago, and the Terra Foundation
for American Art*

MAY 17–AUGUST 10, 2008
Loyola University Museum of Art,
Chicago, Illinois, USA

PUBLICATION
Peter John Brownlee, ed., *Manifest Destiny / Manifest Responsibility: Environmentalism and the Art of the American Landscape* (Chicago: Terra Foundation for American Art; Chicago: Loyola University Museum of Art, 2008).

JULY 18–SEPTEMBER 20, 2009
Williams College Museum of Art, Williamstown, Massachusetts, USA

OCTOBER 9, 2009–JANUARY 3, 2010
Peggy Guggenheim Collection, Venice, Italy

FEBRUARY 14–MAY 9, 2010
Museum of Fine Arts, Houston, Texas, USA

PUBLICATION
Nancy Mowll Mathews, ed., *Prendergast in Italy* (New York: Merrell Publishers Limited, in association with Terra Foundation for American Art and Williams College Museum of Art, 2009).

2009

The Eight and American Modernisms

Co-organized by the Milwaukee Art Museum, New Britain Museum of American Art, and the Terra Foundation for American Art

MARCH 6–MAY 24, 2009
New Britain Museum of American Art, Connecticut, USA

JUNE 6–AUGUST 23, 2009
Milwaukee Art Museum, Wisconsin, USA

PUBLICATION
Elizabeth Kennedy, ed., *The Eight and American Modernisms* (Chicago: Terra Foundation for American Art, distributed by the University of Chicago Press, 2009).

Prendergast in Italy

Co-organized by the Terra Foundation for American Art and the Williams College Museum of Art

2010

Monet and the Artists of Giverny: The Beginning of American Impressionism

Co-organized by the Bunkamura Museum of Art, Tokyo, and the Terra Foundation for American Art

OCTOBER 9–NOVEMBER 28, 2010
Kitakyushu Municipal Museum of Art,
Kitakyushu, Japan

DECEMBER 7, 2010–FEBRUARY 17, 2011
Bunkamura Museum of Art,
Tokyo, Japan

FEBRUARY 25–APRIL 10, 2011
Okayama Prefectural Museum of Art,
Okayama, Japan

PUBLICATION
Katherine M. Bourguignon and
Shunsuke Kijima, *Monet and the Artists
of Giverny: The Beginning of American
Impressionism* (in Japanese and English)
(Fukuoka, Japan: The Nishinippon
Shimbun, 2010).

2011

**A New Look: Samuel F. B. Morse's
"Gallery of the Louvre"**
*Organized by the Terra Foundation
for American Art*

MARCH 1–JUNE 12, 2011
Yale University Art Gallery,
New Haven, Connecticut, USA

JULY 3, 2011–JULY 8, 2012
National Gallery of Art,
Washington, DC, USA

JULY 4, 2012–SEPTEMBER 22, 2013
Pennsylvania Academy of Fine Arts,
Philadelphia, USA

MEDIA
*A New Look: Samuel F. B.
Morse's "Gallery of the Louvre,"*
30-minute DVD produced by Sandpail
Productions, Inc., Los Angeles, CA,
for the Terra Foundation for American
Art, 2011).

**An American Experiment: George
Bellows and the Ashcan Painters**
*Co-organized by the National Gallery,
London, and the Terra Foundation for
American Art*

MARCH 3–MAY 30, 2011
The National Gallery, London, UK

PUBLICATION
Katherine M. Bourguignon and
Christopher Riopelle, eds., *An American
Experiment: George Bellows and the Ashcan
Painters* (London: National Gallery
Company, distributed by Yale University
Press, 2011).

2012

**American Encounters: Thomas Cole
and the Narrative Landscape**
*Co-organized by the Musée du Louvre,
the High Museum of Art, Crystal Bridges
Museum of American Art, and the Terra
Foundation for American Art*

JANUARY 14–APRIL 16, 2012
Musée du Louvre, Paris, France

(as *New Frontier: Thomas Cole et la nais-sance de la peinture de paysage en Amérique*)

MAY 12–AUGUST 13, 2012
Crystal Bridges Museum of American Art, Bentonville, Arkansas, USA

SEPTEMBER 22, 2012–JANUARY 6, 2013
High Museum of Art, Atlanta, Georgia, USA

PUBLICATIONS
Guillaume Faroult, ed., *Thomas Cole: La Croix dans la contrée sauvage* (in French) (Paris: Musée du Louvre Éditions; Paris: Somogy Éditions d'Art, 2011). *Also published in an English edition.*

A Will of Their Own: Judith Sargent Murray and Women of Achievement in the Early Republic
Co-organized by National Portrait Gallery and the Terra Foundation for American Art

APRIL 20, 2012–SEPTEMBER 2, 2013
National Portrait Gallery, Washington, DC, USA

American Encounters: Genre Painting and Everyday Life
Co-organized by the Musée du Louvre, the High Museum of Art, Crystal Bridges Museum of American Art, and the Terra Foundation for American Art

JANUARY 19–APRIL 22, 2013
Musée du Louvre, Paris, France (as *New Frontier II. L'Art américain entre au Louvre: Aux sources de la peinture de genre américain*)

MAY 11–AUGUST 12, 2013
Crystal Bridges Museum of American Art, Bentonville, Arkansas, USA

SEPTEMBER 14, 2013–JANUARY 12, 2014
High Museum of Art, Atlanta, Georgia, USA

PUBLICATIONS
Peter John Brownlee, ed., *American Encounters: Genre Painting and Everyday Life* (Chicago: Terra Foundation for American Art, distributed by University of Washington Press, 2012). *Also published in a French edition.*

Art Across America
Organized by the Los Angeles County Museum of Art, the Museum of Fine Arts Houston, the Philadelphia Museum of Art, and the Terra Foundation for American Art

FEBRUARY 4–MAY 12, 2013
National Museum of Korea, Seoul, South Korea

JUNE 7–SEPTEMBER 1, 2013
Daejeon Museum of Art, Daejeon, South Korea

2013

PUBLICATION

Kim Woolim, Kim Jinmyung, and
Yang Songhyok, eds., *Art Across
America* (in Korean and English)
(Seoul: National Museum of Korea,
2013).

**Through American Eyes:
Frederic Church and
the Landscape Oil Sketch**

*Co-organized by the National
Gallery, London, and the
Terra Foundation for American Art*

FEBRUARY 6–APRIL 23, 2013
The National Gallery, London, UK

MAY 11–SEPTEMBER 8, 2013
Scottish National Gallery,
Edinburgh, Scotland, UK

PUBLICATION

Katherine M. Bourguignon and
Christopher Riopelle, eds., *Frederic
Church and the Landscape Oil
Sketch* (London: National Gallery
Company, distributed by
Yale University Press, 2013).

**Home Front: Daily Life in
the Civil War North**

*Co-organized by the Newberry
Library and the Terra Foundation
for American Art*

SEPTEMBER 26, 2013–MARCH 24, 2014
The Newberry Library,
Chicago, Illinois, USA

PUBLICATION

Peter John Brownlee, Sarah Burns,
Diane Dillon, Daniel Greene, and Scott
Manning Stevens, *Home Front: Daily
Life in the Civil War North* (Chicago:
University of Chicago Press, 2013).

2014

America: Painting a Nation

*Organized by the Los Angeles County Museum
of Art, the Museum of Fine Arts Houston, the
Philadelphia Museum of Art, and the Terra
Foundation for American Art, in collabora-
tion with the Art Gallery of New South Wales*

NOVEMBER 9, 2013–FEBRUARY 8, 2014
Art Gallery of New South Wales, Sydney,
Australia

PUBLICATION

Chris McAuliffe and Angela L. Miller,
America: Painting a Nation (Sydney:
Art Gallery of New South Wales, 2013).

American Encounters: Anglo-American Portraiture in an Era of Revolution

Co-organized by the Musée du Louvre, the High Museum of Art, Crystal Bridges Museum of American Art, and the Terra Foundation for American Art

JANUARY 31–APRIL 28, 2014
Musée du Louvre, Paris, France (as *New Frontier III: Portraits anglo-américains à l'heure de la Révolution*)

MAY 17–SEPTEMBER 15, 2014
Crystal Bridges Museum of American Art, Bentonville, Arkansas, USA

SEPTEMBER 28, 2014–JANUARY 18, 2015
High Museum of Art, Atlanta, Georgia, USA

PUBLICATION
Kevin M. Murphy, ed., *American Encounters: Anglo-American Portraiture in an Era of Revolution* (Bentonville, AR: Crystal Bridges Museum of American Art, distributed by University of Washington Press, 2014). *Also published in a French edition.*

American Impressionism: A New Vision, 1880–1900

Co-organized by the Musée des impressionnismes Giverny and the Terra Foundation for American

Art, in collaboration with National Galleries of Scotland, Edinburgh, and the Museo Thyssen-Bornemisza, Madrid

MARCH 28–JUNE 29, 2014
Musée des impressionn-ismes Giverny, France (as *L'impressionnisme et les américains*)

JULY 19–OCTOBER 19, 2014
National Galleries of Scotland, Edinburgh, Scotland, UK

NOVEMBER 4, 2014–FEBRUARY 1, 2015
Museo Thyssen-Bornemisza, Madrid, Spain (as *Impresionismo Americano*)

PUBLICATIONS
Katherine M. Bourguignon, ed., *American Impressionism: A New Vision, 1880–1900* (Edinburgh: National Galleries of Scotland; Madrid: Museo Thyssen-Bornemisza; Paris: Éditions Hazan with Musée des impressionnismes Giverny, 2014). *Also published in French and Spanish editions.*

2015

Samuel F. B. Morse's "Gallery of the Louvre" and the Art of Invention

Organized by the Terra Foundation for American Art

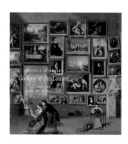

JANUARY 24–MAY 4, 2015
The Huntington Library, Art Collections,
and Botanical Gardens, San Marino,
California, USA

MAY 23–AUGUST 23, 2015
Amon Carter Museum of American Art,
Fort Worth, Texas, USA

SEPTEMBER 16, 2015–JANUARY 10, 2016
Seattle Art Museum, Washington, USA

JANUARY 23–APRIL 18, 2016
Crystal Bridges Museum of American Art,
Bentonville, Arkansas, USA

JUNE 18–SEPTEMBER 18, 2016
Detroit Institute of Arts, Michigan, USA

OCTOBER 8, 2016–JANUARY 8, 2017
Peabody Essex Museum, Salem,
Massachusetts, USA

FEBRUARY 17–JUNE 4, 2017
Reynolda House Museum of American Art,
Winston-Salem, North Carolina, USA

JUNE 17–OCTOBER 15, 2017
New Britain Museum of American Art,
Connecticut, USA

PUBLICATION
Peter John Brownlee, ed., *Samuel F. B.
Morse's "The Gallery of the Louvre" and the
Art of Invention* (Chicago: Terra Foundation
for American Art, distributed by Yale
University Press, 2014).

American Encounters:
The Simple Pleasures of Still Life
*Co-organized by the Musée du
Louvre, the High Museum of Art, Crystal
Bridges Museum of American Art, and
the Terra Foundation for American Art*

FEBRUARY 4–APRIL 27, 2015
Musée du Louvre, Paris, France
(as *New Frontier IV: Fastes et fragments.
Aux origines de la nature morte américaine*)

MAY 16–SEPTEMBER 14, 2015
Crystal Bridges Museum of American Art,
Bentonville, Arkansas, USA

SEPTEMBER 26, 2015–JANUARY 31, 2016
High Museum of Art, Atlanta, Georgia, USA

PUBLICATION
Stephanie Mayer Heydt, ed., *American
Encounters: The Simple Pleasures of Still Life*
(Atlanta, GA: High Museum of Art, distrib-
uted by University of Washington Press,
2014). *Also published in a French edition.*

Picturing the Americas:
Landscape Painting from Tierra
del Fuego to the Arctic
*Co-organized by the Art Gallery of Ontario,
Pinacoteca de São Paulo, and the Terra
Foundation for American Art*

JUNE 20–SEPTEMBER 7, 2015
Art Gallery of Ontario, Toronto, Canada

NOVEMBER 6, 2015–JANUARY 18, 2016
Crystal Bridges Museum of American Art,
Bentonville, Arkansas, USA

FEBRUARY 27–MAY 29, 2016
Pinacoteca de São Paulo, Brazil

PUBLICATIONS
Peter John Brownlee, Valéria Piccoli, and
Georgiana Uhlyarik, eds., *Picturing the
Americas: Landscape Painting from Tierra del
Fuego to the Arctic* (Toronto: Art Gallery of
Ontario, in association with Yale University
Press, 2015). *Also published in Spanish and
Portuguese editions.*

**William Merritt Chase:
A Modern Master**
*Co-organized by the Phillips Collection,
the Museum of Fine Arts, Boston, the
Fondazione Musei Civici di Venezia, and
the Terra Foundation for American Art*

JUNE 4–SEPTEMBER 11, 2016
The Phillips Collection, Washington, DC, USA
OCTOBER 9, 2016–JANUARY 16, 2017

Museum of Fine Arts, Boston, Massa-
chusetts, USA (as *William Merritt Chase*)

FEBRUARY 11–MAY 28, 2017
Cà Pesaro, Venice, Italy (as *William
Merritt Chase (1849–1916): un pittore
tra New York e Venezia*)

PUBLICATION
Elsa Smithgall, Katherine M.
Bourguignon, John Davis, Giovanna
Ginex, and Erica E. Hirshler, *William
Merritt Chase: A Modern Master* (New
Haven, CT: Yale University Press, 2016).
Also published in an Italian edition.

**Continental Shift: Nineteenth-
Century American and Australian
Landscape Painting**
*Co-organized by the Art Gallery of
Western Australia, the Ian Potter Museum
of Art at the University of Melbourne,
the Terra Foundation for American Art,
and the University of Western Australia*

JULY 30, 2016–FEBRUARY 5, 2017
Art Gallery of Western Australia, Perth,
Australia

MARCH 14–JUNE 11, 2017
Ian Potter Museum of Art, University
of Melbourne, Australia
(as *Not as the Songs of Other Lands:
Nineteenth-Century Australian and
American Landscape Painting*)

PUBLICATION
Meighen Katz, *Not as the Songs of Other
Lands: Nineteenth-Century Australian
and American Landscape Painting*
(Melbourne, Australia: Ian Potter
Museum of Art, The University of
Melbourne, 2017).

2016

**America's Cool Modernism:
O'Keeffe to Hopper**

*Co-organized by the Ashmolean Museum
of Art and Archaeology at the University of
Oxford and the Terra Foundation for
American Art*

MARCH 23–JULY 22, 2018
Ashmolean Museum of Art and
Archaeology, University of Oxford, UK

PUBLICATION
Katherine M. Bourguignon, ed., *America's
Cool Modernism: O'Keeffe to Hopper*
(Oxford: Ashmolean Museum, 2018).

**Pathways to Modernism: American
Art, 1865–1945**

*Co-organized by the Art Institute of
Chicago, the Shanghai Museum, and the
Terra Foundation for American Art*

SEPTEMBER 27, 2018–JANUARY 6, 2019
Shanghai Museum, China

PUBLICATION
Peter John Brownlee and Sarah Kelly
Oehler, eds., *Pathways to Modernism:
American Art, 1865–1945.* (Shanghai:
Shanghai Fine Arts Publisher, 2018).

About the Foundation

For over thirty years, the Terra Foundation for American Art has been committed to supporting innovative programs and initiatives designed to engage audiences around the globe in a lively dialogue on the visual arts of the United States. This publication offers a novel platform for international exchange, complementing the foundation's existing programs.

The Terra Foundation for American Art is dedicated to fostering exploration, understanding, and enjoyment of the visual arts of the United States for national and international audiences. Recognizing the importance of experiencing original works of art, the foundation provides opportunities for interaction and study, beginning with the presentation and growth of its own art collection in Chicago. To further cross-cultural dialogue on American art, the foundation supports and collaborates on innovative exhibitions, research, and educational programs. Implicit in such activities is the belief that art has the potential both to distinguish cultures and to unite them.

For information on grants, programs, and publications at the Terra Foundation for American Art, visit terraamericanart.org. For more information on the Terra Foundation collection, visit collection.terraamericanart.org.

A digital companion to *Conversations with the Collection* features exclusive content, including deep-zoom images; links to interpretative texts, artist biographies, and provenance; and original interpretive videos and other rich media resources for selected artworks, all of which can be accessed online at conversations.terraamericanart.org.

Terra Foundation for American Art

Elizabeth Glassman, *President and
 Chief Executive Officer*
Amy Zinck, *Executive Vice President*
Anne Munsch, *Chief Financial Officer*

**Conversations with the Collection:
A Terra Foundation Collection Handbook**

Edited by Katherine M. Bourguignon
and Peter John Brownlee

Julie Boulage, *Curatorial Associate*
Shari Felty, *Assistant Registrar*
Charles Mutscheller, *Manager of Communications*
Taylor L. Poulin, *Curatorial Associate*
Cathy Ricciardelli, *Director of Registration*
Francesca Rose, *Program Director, Publications*
Julie Warchol, *Curatorial Associate (until 2017)*

Susan Tallman, *Editor*
Prudence Crowther, *Copy Editor*
Shelly Roman, *Editorial Consultant*
Practise, *Design Direction* (James Goggin and
 Shan James, with William Sumrall)
Pat Goley, Professional Graphics, Inc.,
 Color Separations
Michael Tropea, *Photographer*
Bonnie Rimer, *Consulting Conservator*
Nick Gracilla, Neoteric Design,
 Digital Companion Development
Mark Skala, Skalawag Productions,
 Videography
Jon Linton, Studio 424,
 Artwork Exploration Tool

© 2018, Terra Foundation for American Art

ISBN 978-0-932171-65-8 (paperback)
ISBN 978-0-932171-66-5 (e-book)

Library of Congress Cataloging-in-Publication Data can be
obtained at the Library of Congress.

Published by the Terra Foundation for American Art
120 East Erie Street, Chicago, Illinois, 60611, United States
terraamericanart.org

Typeset in Whitman (Kent Lew, Font Bureau, 2004–08)
Printed by Die Keure, Bruges, Belgium
Bound by Brepols, Turnhout, Belgium
Distributed by University of Chicago Press

Cover: Arthur Dove, *Boat Going through Inlet*, c. 1929
(detail, see p. 262).